PITTSBURGH
THEN & NOW

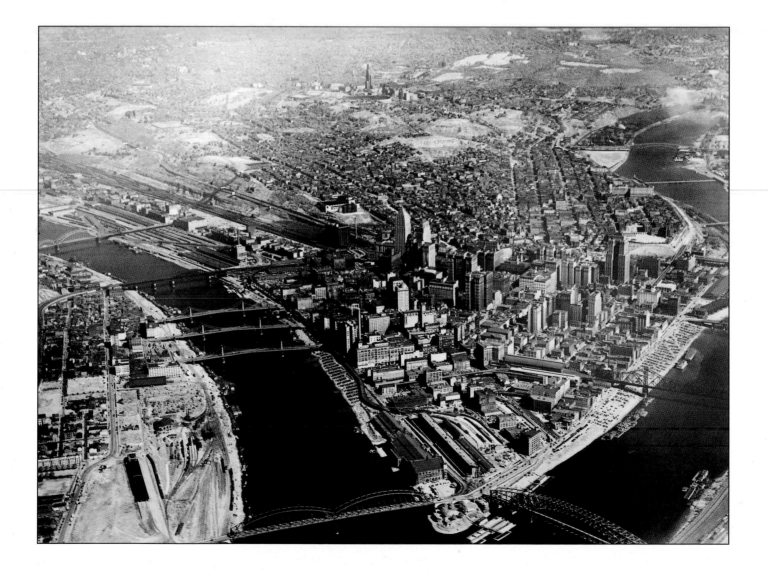

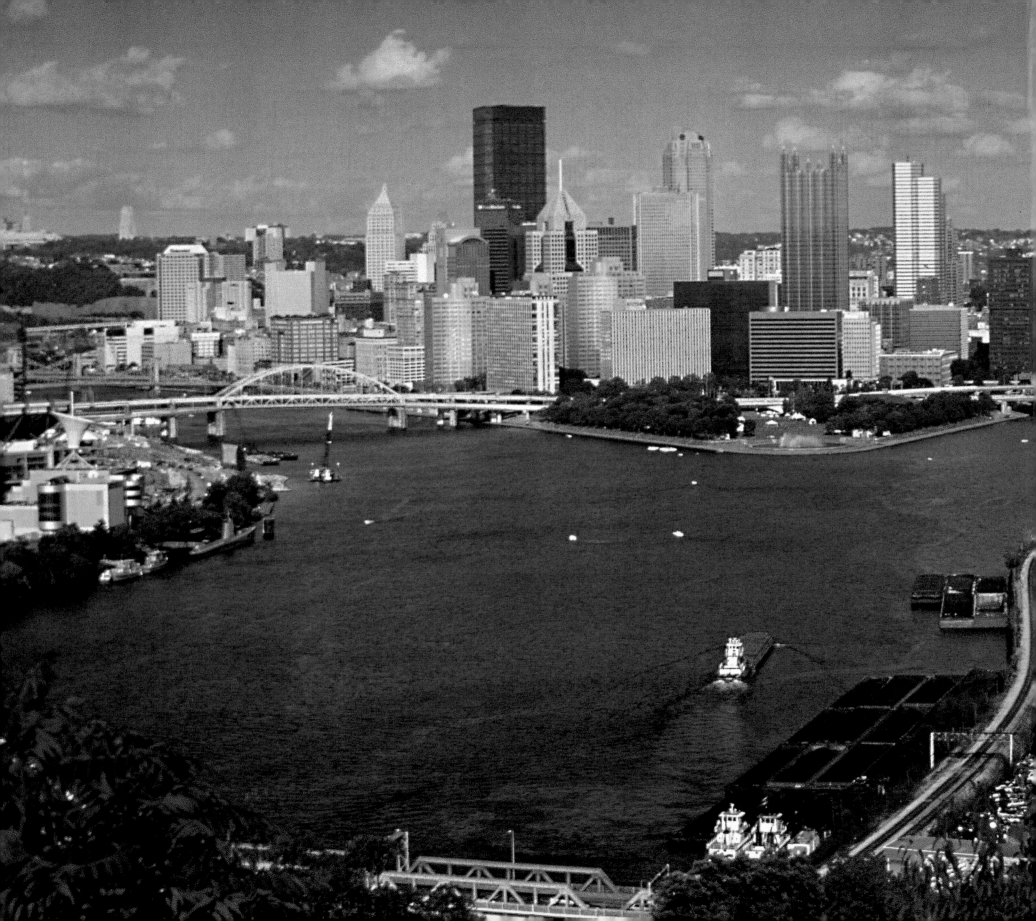

PITTSBURGH THEN & NOW

WALTER C. KIDNEY

THUNDER BAY
P·R·E·S·S
San Diego, California

Thunder Bay Press
An imprint of the Advantage Publishers Group
5880 Oberlin Drive, San Diego, CA 92121-4794
www.thunderbaybooks.com

Produced by PRC Publishing Limited,
an imprint of Anova Books Company Ltd.,
151 Freston Road, London, W10 6TH, U.K.

ISBN-13: 978-1-59223-141-6
ISBN-10: 1-59223-141-1

Library of Congress Cataloging-in-Publication Data
Kidney, Walter C.
 Pittsburgh then & now / Wallter C. Kidney.
 p. cm
 ISBN 1-59223-141-1
 1. Pittsburgh (Pa.)--Pictorial works. 2. Pittsburgh (Pa.)--History--Pictorial works. I. Title: Pittsburgh then and now. II. Title.
F159.P643.K56 2003
974.8'86'00222--dc22
 2003070306

Printed and bound in China

4 5 6 7 09 08 07 06

ACKNOWLEDGMENTS

Several of my colleagues at the Pittsburgh History & Landmarks Foundation contributed information (especially in the "Now" captions), obtained photographs, offered advice, helped with mapping the locations of all the "Now" photographs, and generally expedited things. My thanks, then, go to Louise King Sturgess, executive director/editor; Frank Stoker, assistant archivist; Al Tannler, historical collections director; and Mary Ann Eubanks, education coordinator.

As to picture sources and their personnel, we owe thanks to Miriam Meislik, associate archivist/photograph curator, Archives Service Center, University of Pittsburgh; Marilyn Holt, Barry Chad, and Gilbert Pietrzak of the Pennsylvania Department of the Carnegie Library of Pittsburgh; Rebekah A. Johnston, coordinator, Photographic Services, Historical Society of Western Pennsylvania; and William Rydberg, PHOTON.

PICTURE CREDITS
The publisher wishes to thank the following for kindly supplying the photographs that appear in this book:

Then Photographs:
Carnegie Library of Pittsburgh: 6, 10, 12, 14, 22 (inset), 28 (left), 32, 34, 46, 48, 52, 58, 86, 88, 92, 94, 100, 108, 112, 114, 114 (inset), 126, 126 (inset), 134, and 138. Historical Society of Western Pennsylvania: 28 (right), 30, 56, and 136. Library of Congress: 24, 38, 42, 62 (inset), 66, 78, 80, 96, 98, and 122. Pittsburgh History & Landmarks Foundation: 8, 16, 18, 20, 36, 40, 54, 60, 62, 64, 68, 70, 72, 76, 82, 90, 102, 106, 110, 116, 124, 128, 130, 132, 140, and 142. Underwood & Underwood/CORBIS: 44. University of Pittsburgh Archives: 22, 26, 50, 74, 84, 104, and 120. University of Pittsburgh Archives (Industrial Society): 118.

Now Photographs:
All photographs were taken by Simon Clay (© Anova Image Library) with the exception of the photographs on the following pages: Pages 61 (inset) and 143: courtesy William Rydberg, PHOTON. Pages 65 and 107: courtesy Pittsburgh History & Landmarks Foundation.

For cover photo credits, please see back flap of jacket.

Pages 1 and 2: An overview of the city taken in 1937 (photo: Pittsburgh History & Landmarks Foundation), and a similar view taken today (photo: William Rydberg, PHOTON); see pages 142 and 143 for further details.

INTRODUCTION

Pittsburgh and nature have had a peculiar relationship from the beginning. Two rivers, the Allegheny coming from the north and the Monongahela coming from the south, join at the Pittsburgh Point to form the Ohio, which flows westward about 980 miles to the Mississippi. The three rivers are framed by plains, hills, and bluffs, and between the tributary rivers are plateaus and ravines, all remnants of an ancient river delta. Differences of level within the city amount to about 500 feet. The present composition of the terrain is due to events long past and widely dispersed, and to talk of them requires a description of plate tectonics, a journey over time from below the equator to the fortieth north parallel, a few Ice Ages, and the formation of a ten-foot coal seam.

From this geography, Pittsburgh history has emerged. Summing it up, we might begin with the clash in 1754 of English- and French-speaking peoples at the Point, leading to the French and Indian War and eventual victory for the English-speakers. Then, the naming by the victorious General John Forbes of a fort and a garrison town in 1758 after William Pitt the Elder, earl of Chatham and prime minister of Great Britain. The role of Pittsburgh around 1800 was "Gateway to the West," a place for building and outfitting flatboats and keelboats. The maiden journey from Pittsburgh of the *New Orleans*, the first Western River steamboat, in 1811. The discovery of the coal and other minerals that led to a growing industrial presence, beginning with glassmaking in 1797. The processing of iron, at first smelted elsewhere, but from 1859 smelted in Pittsburgh itself. The first coming of all-rail transportation from Philadelphia to the east in 1852 and continuing westward. Events promoted by rivers and coal. And in 1907, the annexation to Pittsburgh of its neighbor, Allegheny City, now Pittsburgh's North Side.

Nature gave opportunities to Pittsburgh, but Pittsburgh in the nineteenth and twentieth centuries was hardly in harmony with nature. The bituminous coal that gave the region its power laid a heavy coating of soot over everything, coming from locomotives, steamboats, industrial fires, and domestic fires. The beehive coke oven, which produced hot-burning blast-furnace fuel, released a multitude of volatiles into the air well into the 1920s. Such an ordinary commodity as drinking water was dangerous until around 1910. And of course taming the terrain was a struggle, an affair of bridges, tunnels, retaining walls, inclined planes first for coal and later for hill-dwellers, the erection of notorious public steps that climbed a hundred feet or so, and the grading and paving of many little streets. In many cases on the slopes a street would exist only on paper, with a flight of steps of planks or concrete as the means of ascent. But there *was* something undeniably romantic about the terrain, about the vast spaces of the river valleys seen from a hilltop, and the growth of wild vegetation wherever allowed. Sheltered by the changing contours of the land, many Pittsburgh neighborhoods were able to thrive and retain their rich ethnic characters.

Toward 1900 the City Beautiful movement that was capturing the national imagination began influencing the development of Oakland, several miles east of downtown. Mary Schenley, Pittsburgh's most famous expatriate, donated 300 acres of land for a major urban park, and Andrew Carnegie, rich in steel money, donated funds for a magnificent cultural institution. Franklin Nicola bought and sold land so as to encourage the development of the Oakland Civic Center, a whole new campus for the University of Pittsburgh, and the model residential neighborhood of Schenley Farms. Edward Manning Bigelow, the city's director of public works, created a direct road to Pittsburgh's developing East End, a park system, and a much-needed water filtration system.

The celebrated Pittsburgh Renaissance of the 1950s revived a city neglected in the Depression and then hard-driven by war. It cleaned up the air and the rivers and gave the city a new image, even while Jones & Laughlin, within sight of downtown, was erecting a giant open-hearth plant.

The bright new image of Pittsburgh, however, was attained at some cost. Handsome old buildings and even whole neighborhoods were demolished in order to rebuild according to new theories of housing, merchandising, and traffic management. In 1964 the Pittsburgh History & Landmarks Foundation was founded to prove that rebirth could be achieved through restoration and adaptive reuse.

Entering the twenty-first century, Pittsburgh is reinventing itself once again. Now that the air is clean and heavy industry is gone, the ailanthus and her companions have volunteered enthusiastically to cover the hillsides and river edges. Deer and wild turkey inhabit woods within a mile of the Golden Triangle, Pittsburgh's central business district, and peregrine falcons nest on the Gulf Tower, one of the city's skyscrapers. About 330,000 people live within the fifty-five square miles of the city limits, working out to eleven people per acre: almost sylvan. Pittsburgh is gaining a reputation as a "green" city, not only because of the wooded landscape, but because of the environmentally friendly buildings that are being constructed. Funds are being raised to restore the city parks, develop the riverfronts, and light the bridges. A center for business, education, health and human services, and arts and culture, for many Pittsburgh is a desirable place to be.

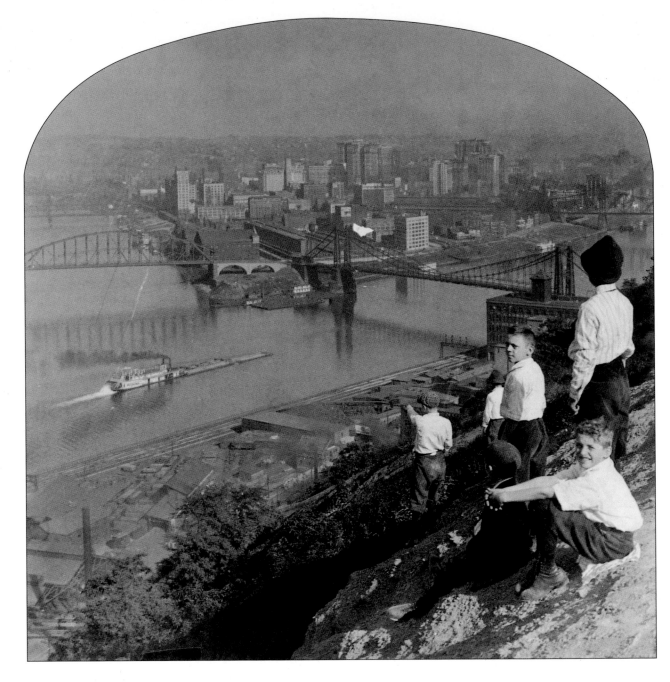

Young Pittsburghers of 1917 look over their city from the edge of Mount Washington. They see the Allegheny River, coming in from the north and east on the left; the Monongahela, coming in from the south and east on the right; and their formation of the Ohio at the Pittsburgh Point. The Point area itself is made up of piecemeal industrial development, but beyond are the business towers at the heart of commercial Pittsburgh. The highest among those visible are the First National Bank and the Henry W. Oliver Building, both about 350 feet high. The steam stern-wheel towboat, pushing its barges, is a familiar sight along what has always been a busy river and river port.

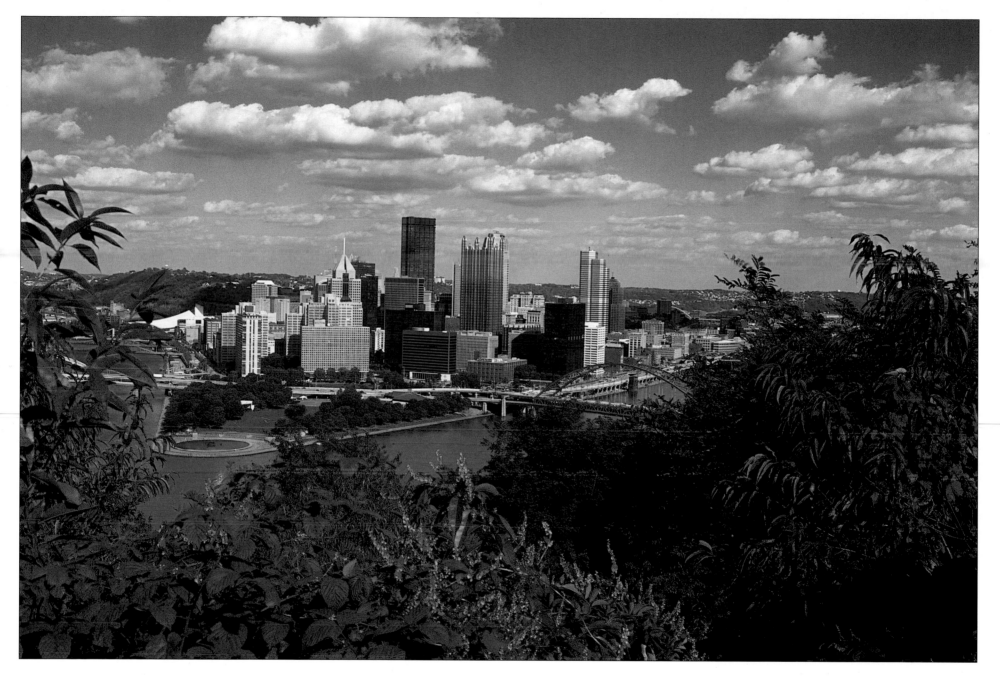

Much has changed in the Golden Triangle. The Point is now a park, the old bridges are gone, and the meeting of the rivers is marked by a fountain that was built in 1974. Beyond Point State Park, new towers mark the Pittsburgh Renaissance, which began in the 1950s. One building is undisputedly the tallest: the 841-foot United States Steel Building (now U.S. Steel Tower), finished in 1971. Today's skyline owes its appearance to Harrison & Abramovitz; Skidmore, Owings & Merrill; Philip Johnson; HOK; and other prominent American architectural firms.

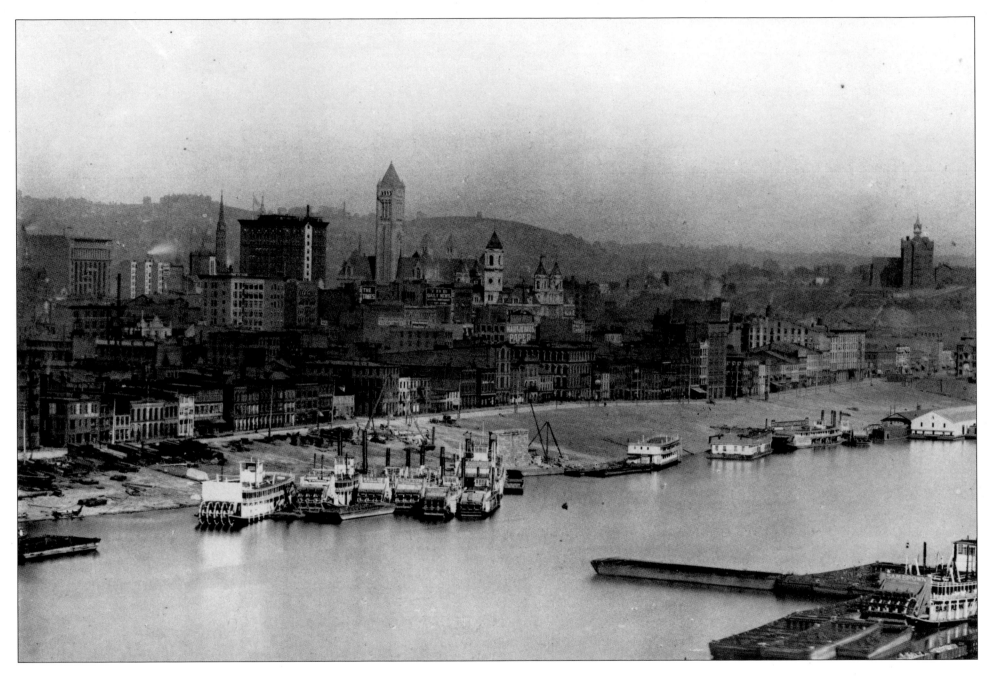

A closer look at the Triangle in 1899 shows a downtown in transition. The simple, slender tower of H. H. Richardson's Allegheny County Courthouse dominates the town as it has since 1888, but the steel-framed, elevator-serviced skyscraper is coming to rival its height: the Carnegie Building (to the left of the courthouse) and the Park Building (further left). Duquesne University's Administration Building and Chapel of 1884 stand on the bluff at the far right. The Monongahela Wharf, stone-paved and sloping to the river, offers its usual motley display of drays, towboats, and wharf boats. In the foreground, on the south side, there are more of the same, including tied-up coal barges.

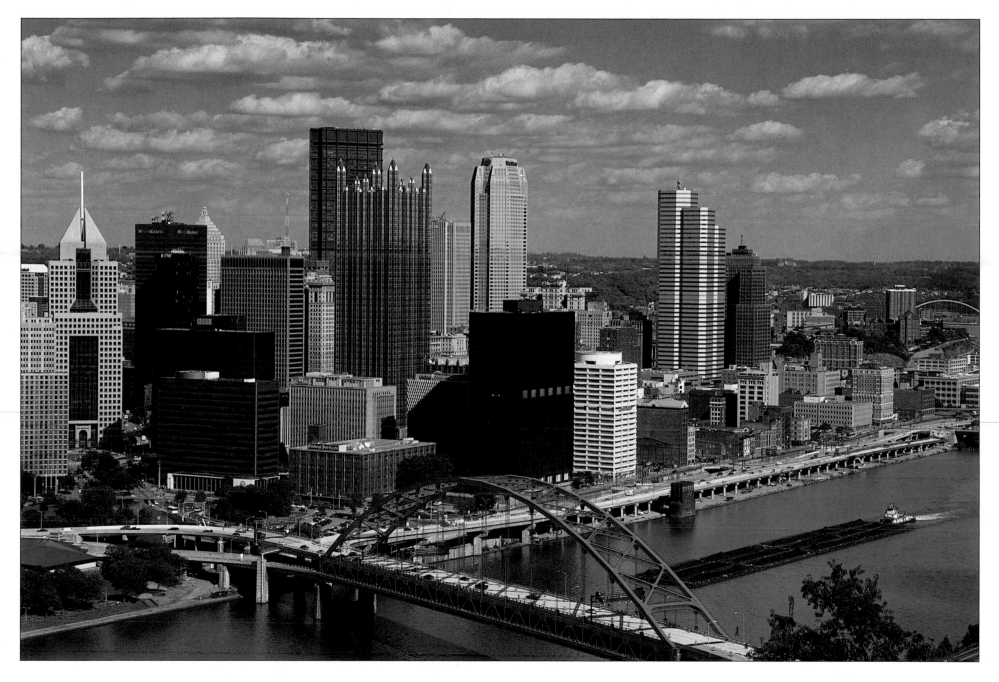

In this modern view much has changed. Most notably, the courthouse tower is hidden by newer construction. At center left, the U.S. Steel Building peeks above the forty-story glass tower of PPG Place. One Mellon Center (adjacent to the courthouse) is the city's second-tallest structure. One Oxford Centre, a cluster of octagonal shapes, stands in front of the Grant Building, a set-back skyscraper of the 1920s. The Monongahela Wharf has changed from a sloping, paved embankment to a double-decked roadway system. A river tow, these days powered by a twin-screw diesel boat, is about to pass under the Fort Pitt Bridge of 1958, the westernmost Monongahela River bridge.

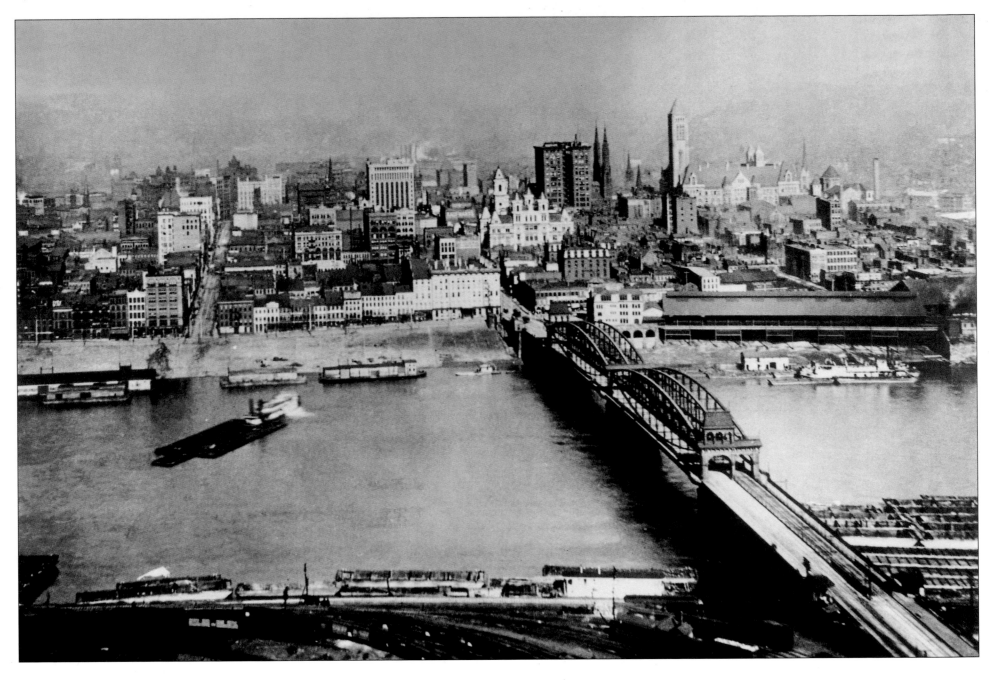

This is another 1900-period view of the Triangle. The Smithfield Street Bridge of 1883 still has its original portals, but has been widened to the right. Just beyond the bridge is the Baltimore & Ohio passenger station of 1888, which lasted until 1955. Further down Smithfield Street is the towered and turreted Fourth Avenue Post Office of 1891. Near the Allegheny County Courthouse and Jail appear the spires and central cupola of St. Paul's Roman Catholic Cathedral, which remained until 1904. In the foreground are the tracks of the Pittsburgh & Lake Erie Railroad.

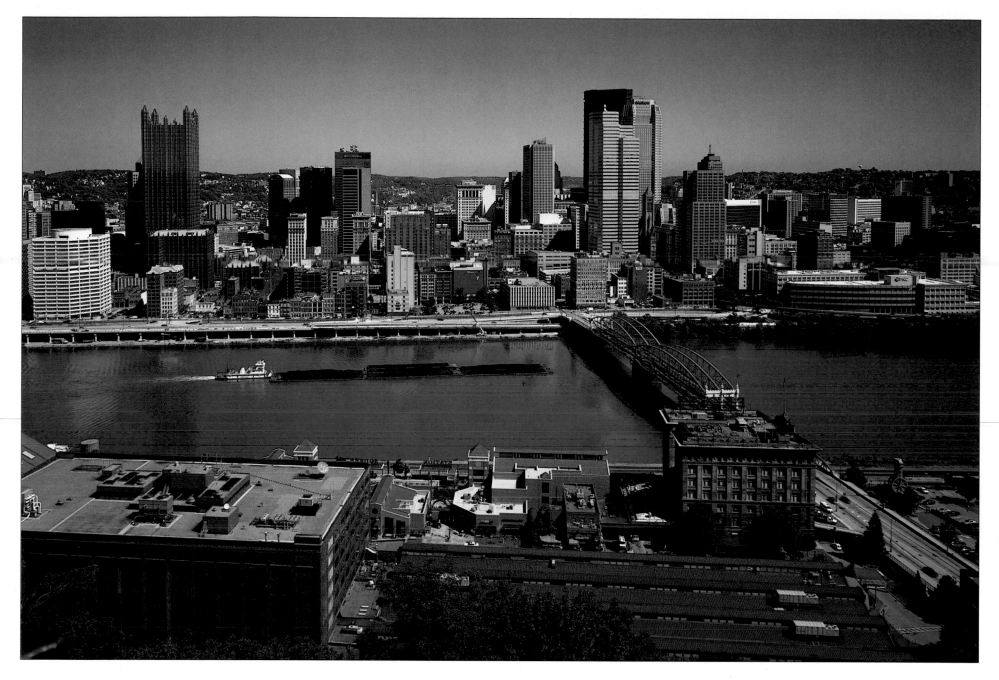

The sheer scale of twentieth-century development downtown can now be seen, as the Allegheny County Courthouse edges into view in between the Oxford Centre tower, to its left, and the Grant Building, to its right. The Baltimore & Ohio passenger station of 1888 was taken down in 1955.

However, Station Square, a mixed-use, adaptive reuse of the P&LE site, is shown in the foreground. At the far right, across the Monongahela River, is PNC Firstside Center, a Green banking service facility completed in 2000.

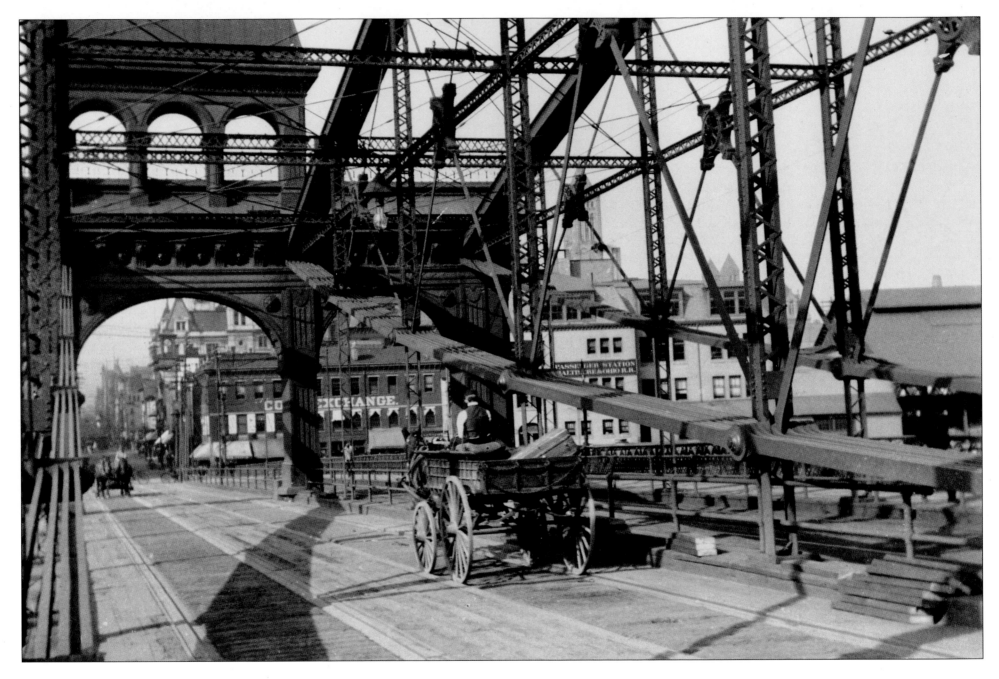

The Smithfield Street Bridge is the third on the site, successor to Pittsburgh's first river bridge, which was built in 1818. The principle is that of the lenticular truss, in which an arch and a catenary cancel out each other's forces with the aid of considerable cross-bracing. Here is a view of the original part, finished in 1883, with a widening in 1891 for streetcars to the right. The engineer was Gustav Lindenthal, a local man who went on to gain distinction in New York City as commissioner of bridges. The same was true of the engineer whose Smithfield Street Bridge preceded this one: John Augustus Roebling, who built a suspension bridge here in 1846 and went on to achieve fame as the designer of the Brooklyn Bridge.

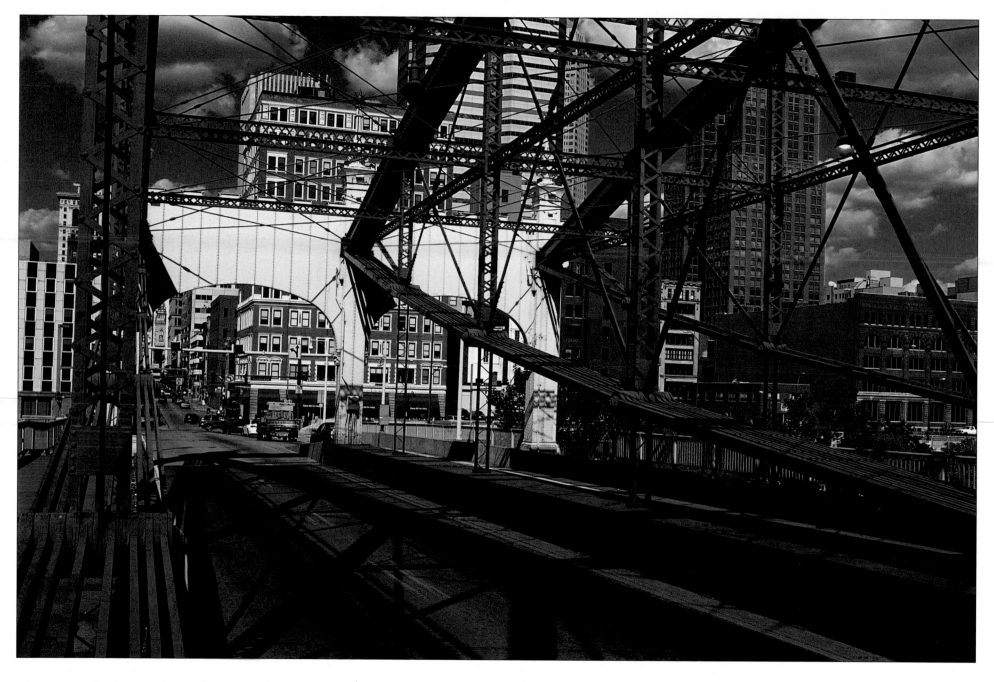

There was a further modest widening of the Smithfield Street Bridge in 1911, and in 1915 entirely new portal fronts were added: lighthearted essays in a free Gothic by the city architect Stanley Roush, which included torchlike lamps, finials that were more Art Nouveau than Gothic, and grotesques showing workmen with pickaxes and gearwheels, appropriate symbols for the "Workshop of the World." During a reconstruction in 1934, the bridge railings were rebuilt in aluminum. The paint colors are now a compromise restoration: dark delft blue trusses and cinnamon floor structure as in 1883, buttermilk-yellow portals as in 1915.

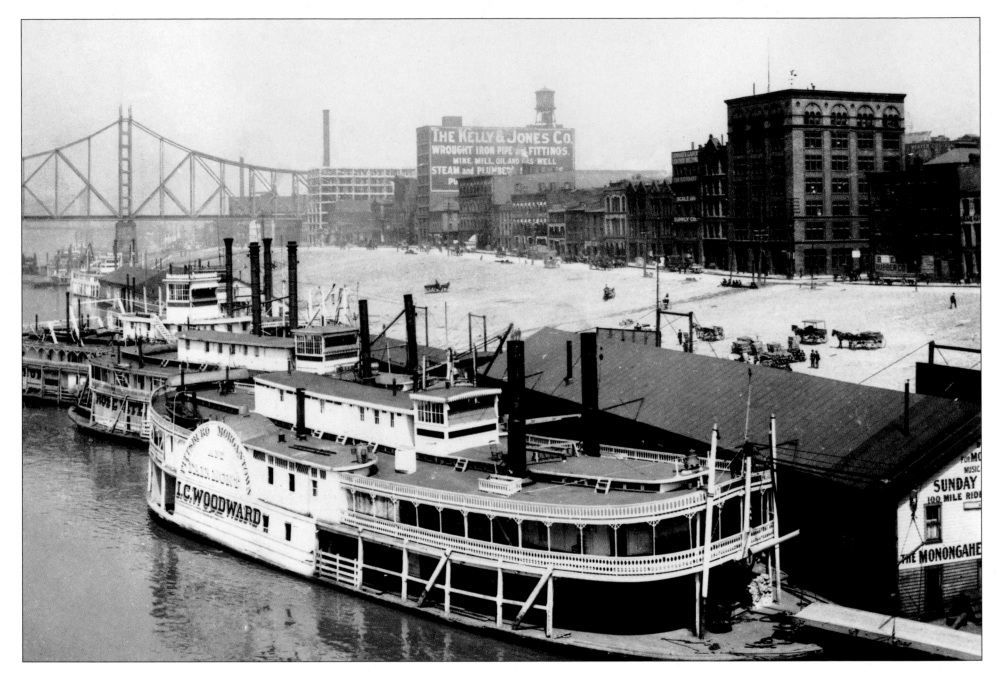

Packet boats and excursion boats are tied up to the Monongahela Wharf, circa 1910. (The *I. C. Woodward* ran to Morgantown between 1902 and 1913.) In the background is the Wabash Bridge, a cantilever bridge that brought the ephemeral Pittsburgh-Wabash Terminal Railway into town as a challenge to the Pennsylvania Railroad. The bridge lasted until 1948. The Conestoga Building of 1890, designed by H. H. Richardson's Pittsburgh heirs Longfellow, Alden & Harlow, dominates the block of mid-Victorian buildings facing Water Street.

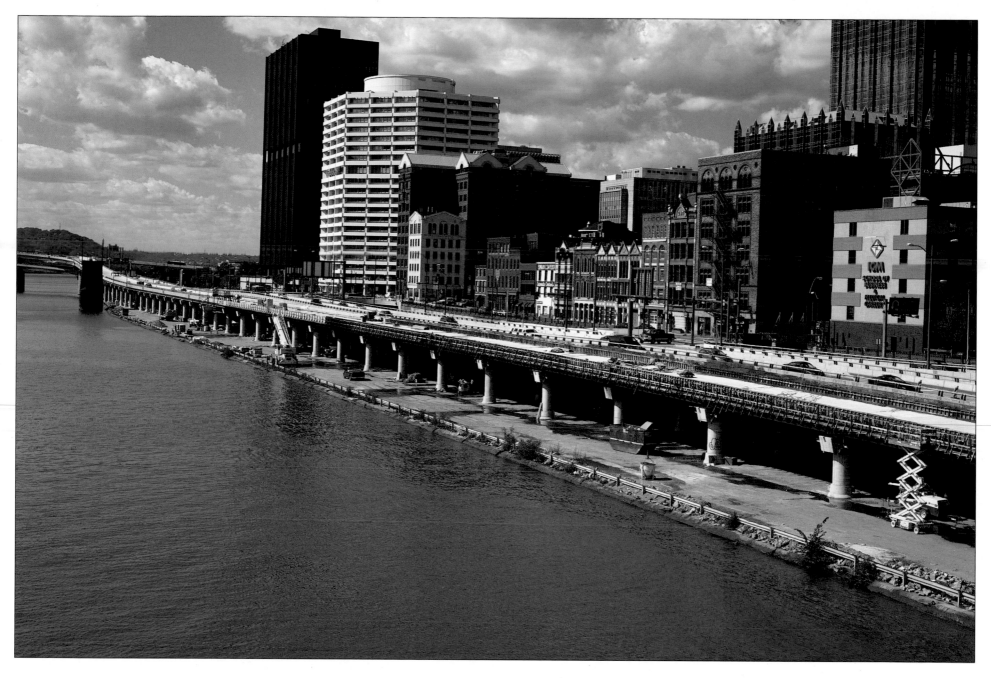

In 1938 the crest of the Emsworth Dam, six miles down the Ohio River from Pittsburgh, was raised from 703 to 710 feet above sea level and so as a result was the river level at the Triangle. The Monongahela Wharf was rebuilt in 1940 as a flat expanse of concrete with an elevated roadway supplementing the width of Water Street, which was renamed Fort Pitt Boulevard. Further road construction at both wharf and street levels has complicated things, though some Art Deco railings from 1940 have survived. The Conestoga Building and its neighbors, dwarfed by new construction, give a human scale to the city.

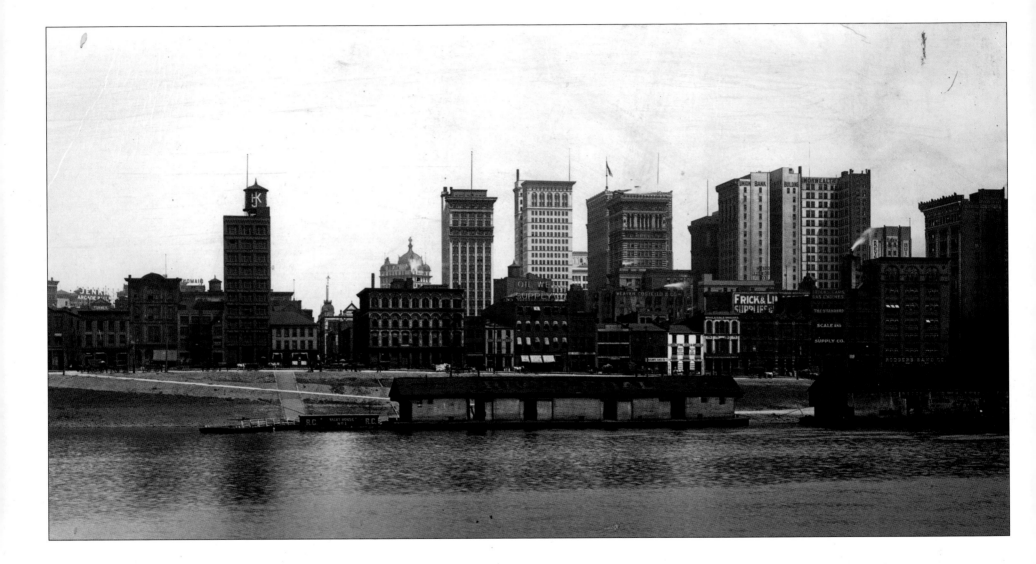

This is Water Street in 1912. Compared with the tall new Fourth Avenue buildings on the skyline further inland, bright in their granite and terra cotta, the lower and darker ones that line Water Street seem vestiges of another age. The older buildings from after the fire of 1845, which took out a third of the Triangle, offer a range of styles: plain vernacular, Italianate, Queen Anne, and Romanesque. The four-story building at the center belongs to the Monongahela River Consolidated Coal and Coke Company, "the Combine." This was a group of about a hundred entities involved in the shipping of coal that was successful between 1899 and 1915, at which point it suddenly went out of business due to competition from the railroads.

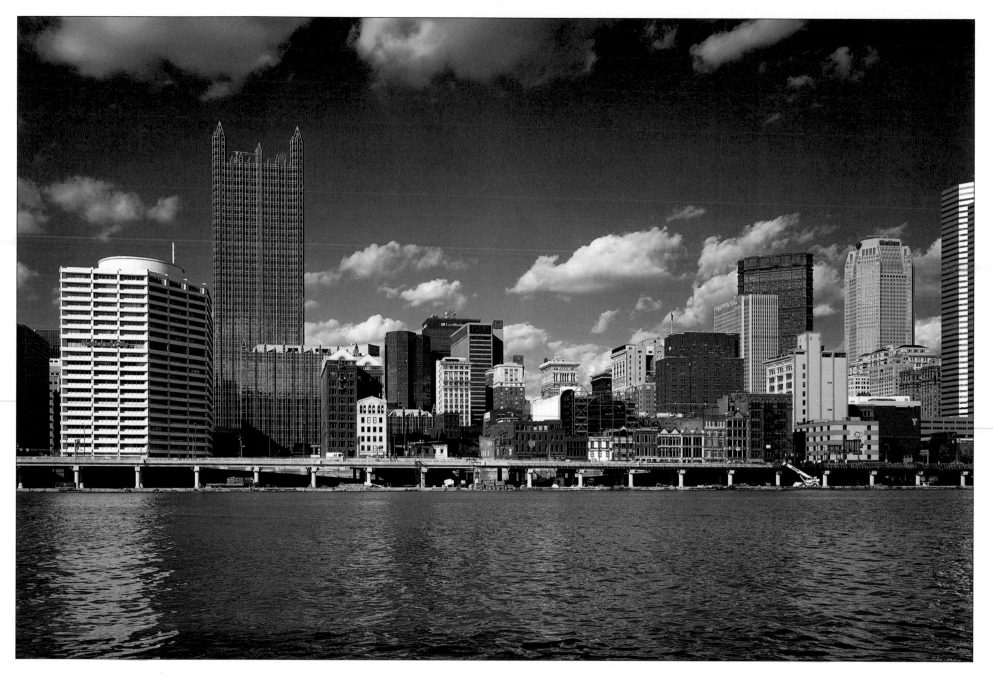

This view from across the Monongahela River roughly reveals the architectural history of the Triangle, with the buildings getting newer and higher the further one looks inland: from the small-scaled Victorian waterfront buildings to the light and fancy terra cotta of the 1900s, the composed masses and mellow brick of the 1920s, and the undetailed glass-box aesthetic of modernism. Tallest in this photo is PPG Place, completed in 1984 and designed by John Burgee and Philip Johnson, clad in PPG Solarban 550 Window Glass. To the far right is the U.S. Steel Tower, built of Cor-Ten steel and designed by Harrison & Abramovitz. To the left of PPG is National City's Riverfront Center, designed for National Steel in 1983 by Skidmore, Owings & Merrill.

Apart from any buried foundation work here or there, the little building on the right is the sole eighteenth-century architectural survivor in downtown Pittsburgh: Bouquet's Redoubt, also called the Blockhouse. As it happened, no shot has ever been fired at it in anger. Built in 1764 by Colonel Henry Bouquet, it missed the French and Indian War and the Pontiac Uprising of 1763. Neither the Revolution nor the Whiskey Rebellion of 1794 approached it. Its greatest peril came from the Pennsylvania Railroad in the mid- and late-nineteenth century as the Duquesne freight depot grew around it. Here it is in 1893, when it had been converted into part of a home.

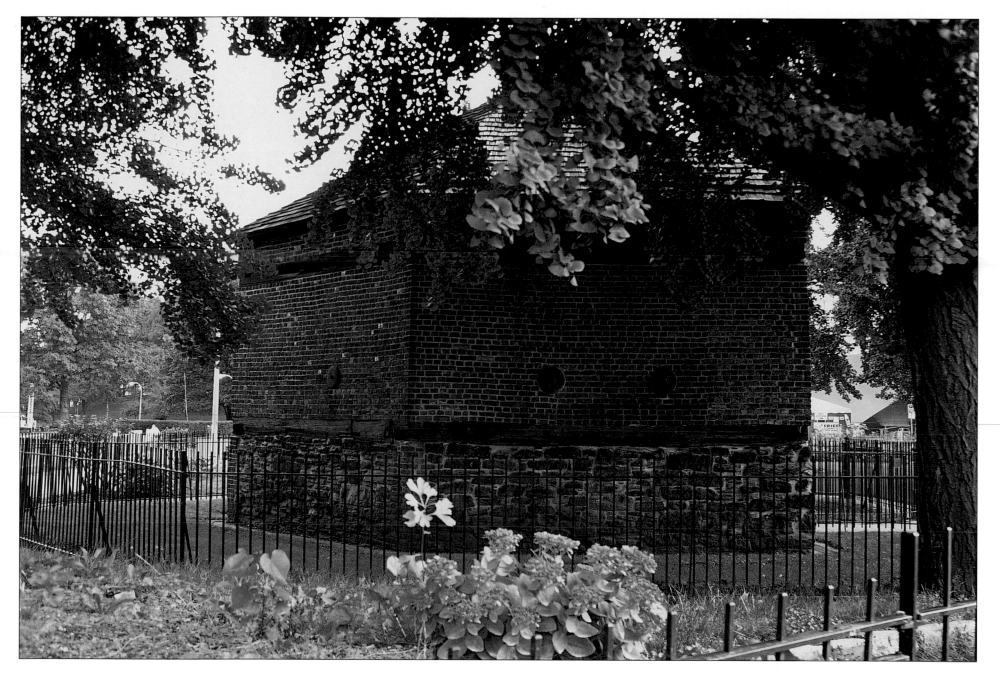

Mary Schenley, who had eloped to England, had not been back to Pittsburgh since 1850, but she seems to have had a soft spot for the city. Made aware of the situation of the Blockhouse, she bought it in 1894 and gave it to the Daughters of the American Revolution. It was freed of its additions and to some extent restored, but remained almost hidden by the railroad buildings until they were cleared away around 1950. Point State Park grew around it in the next two decades. Among other things, replicas of two bastions of Fort Pitt were built, and landscape architects Griswold, Winters & Swain restricted plantings in the park to species that were in this region during Colonial times.

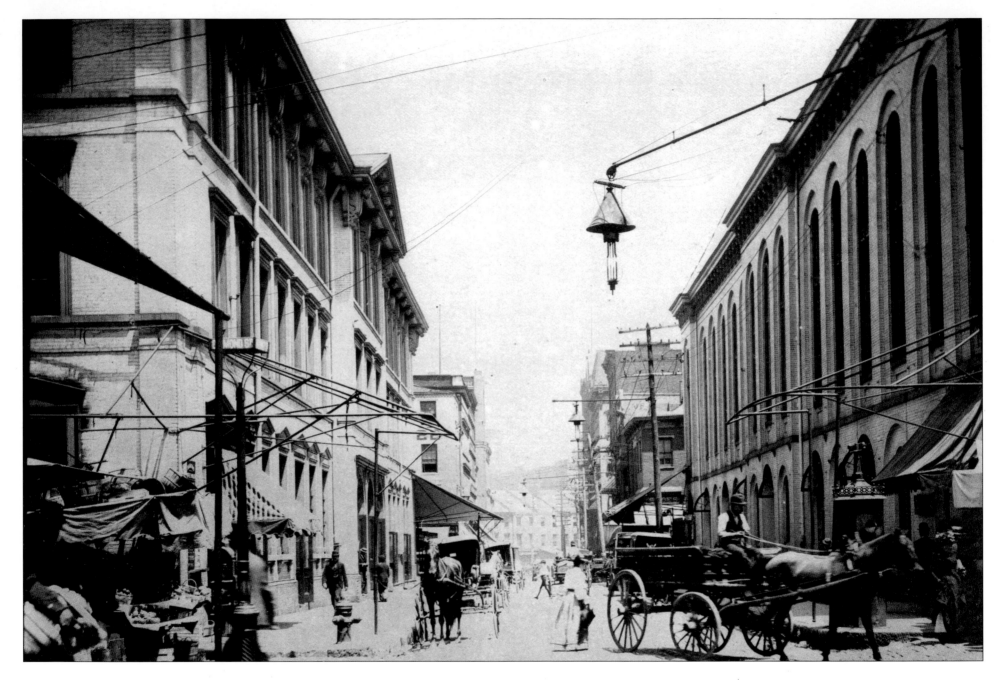

The trading settlement that was called Pittsburgh after 1758 was surveyed in 1784 for the Penn family, who were still proprietors of the area. Surveyors George Woods and Thomas Vickroy provided, among other things, for a large market square. Known originally as the Diamond—an Irish usage—it contained the first little Allegheny County Courthouse as well as market stalls. Then, in the 1850s, it was built up with two structures: the Market House (left) and the City Hall in 1854 (right). This view from 1893 is looking down Market Street toward Liberty Avenue.

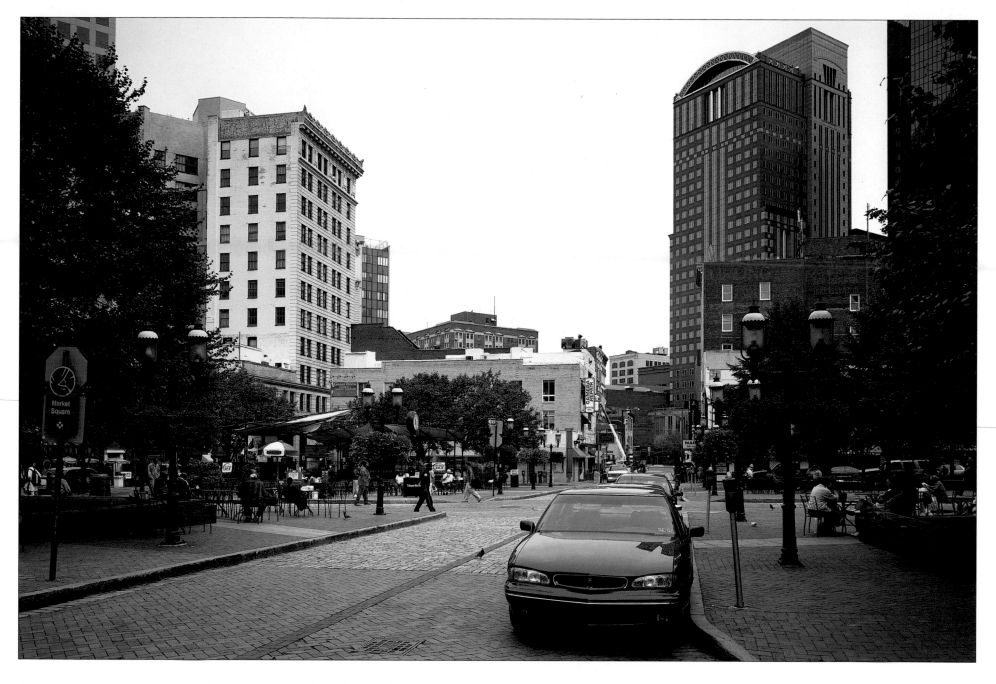

The old Diamond and crossroads are more open these days and have become one of Pittsburgh's most popular places to relax. Market Square contains a miscellany of construction, from postfire buildings from around 1850 to outlying portions of the cold crystalline architecture of PPG Place. In between are a host of mercantile fronts. Rising above and beyond Market Square on the left is the former Diamond National Bank of 1905 with its copper cheneau on the cornice. Toward the right is the thirty-two-story Dominion Tower with its "bridge" motif at top, designed in 1984 by Kohn Pedersen Fox for Consolidated Natural Gas. Two PNC Plaza, designed in 1973 by SOM associate Natalie de Blois for Equibank, is just visible at the far right.

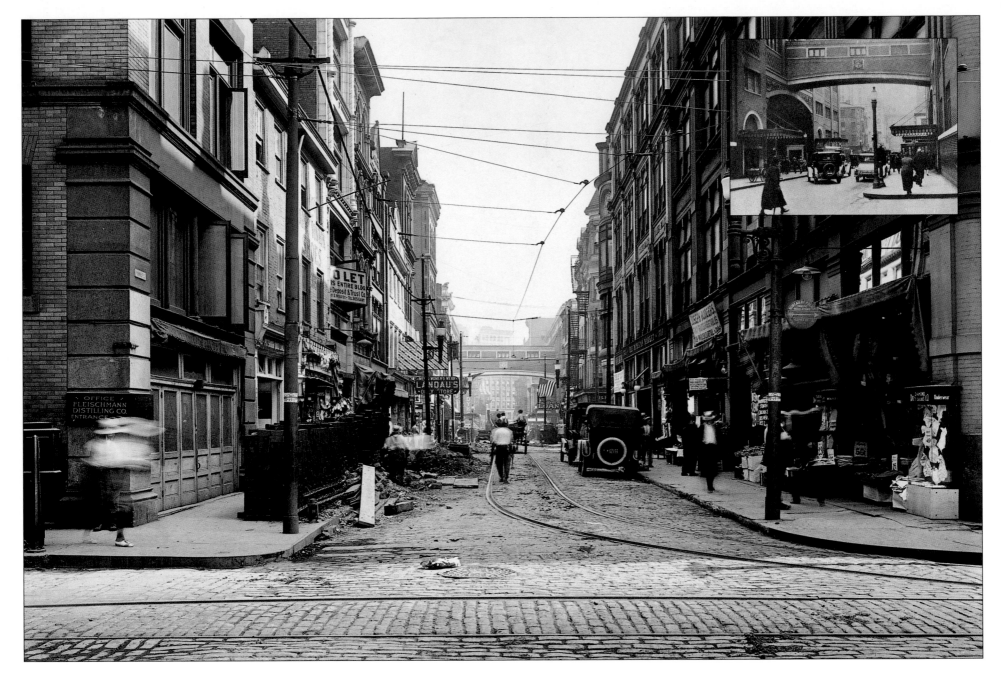

Here is a 1917 view looking northward along Market Street from Third Avenue. Most of the architecture is Victorian, and one or two buildings may even have survived the fire of 1845. Market Street is spanned by the footbridge of the new Diamond Market House, which arched over both Diamond and Market Streets (inset, c. 1929), and far away is the diagonal of Liberty Avenue.

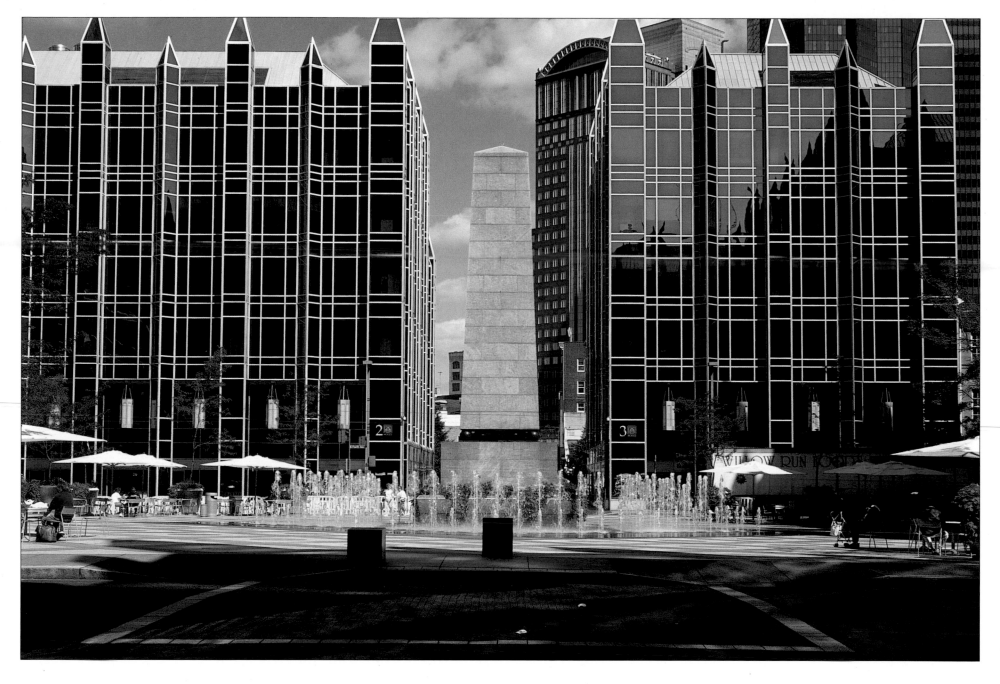

Today Market Street is closed off in part, and a new plaza has come into existence as part of the PPG Place development. The contrast between the two squares is striking. Market Square, mostly grass and trees and about 300 feet on each side, is an informal, active commercial area; the central plaza of PPG Place, a little smaller, was conceived as a cool, unified architectural statement but has been transformed into habitable space with a spectacular choreographed fountain that converts into an ice-skating rink in the winter. Pittsburgh journalist Peter Leo called the central obelisk, with its ball-like supports, "the Tomb of the Unknown Bowler."

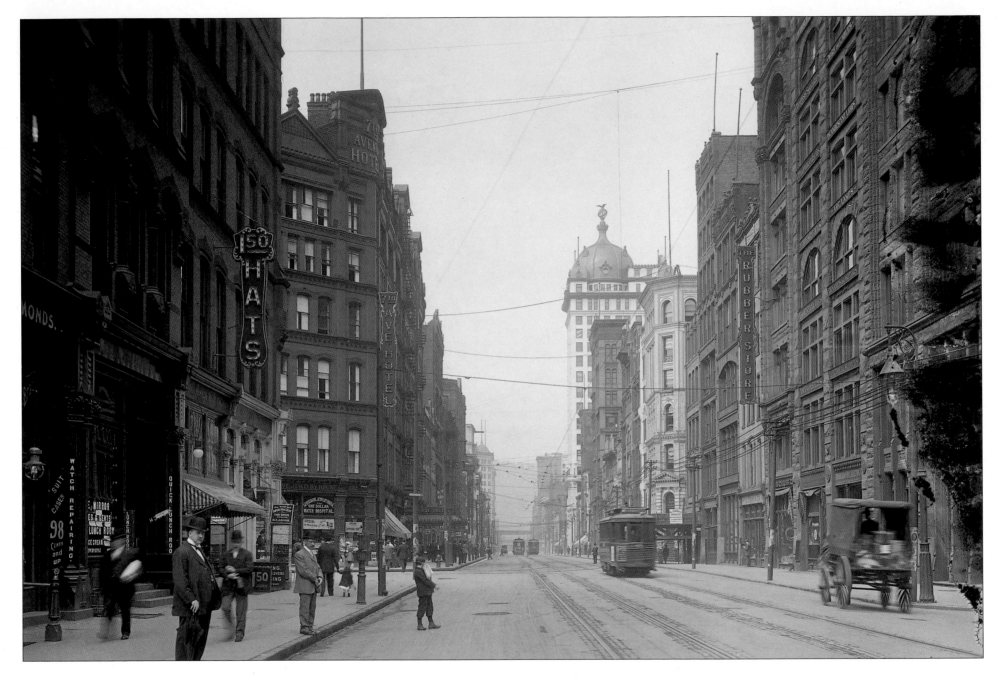

Liberty Avenue looking west, around 1910. The Woods-Vickroy survey of 1784 created two street grids in the Triangle, a larger one with streets parallel or perpendicular to the Monongahela River and a smaller one with streets parallel or perpendicular to the Allegheny River. Liberty Avenue was the junction, like a seam connecting two pieces of tartan. The awkwardness that resulted is evident to the left: in the left foreground is a portion of the Triangle Building of the 1870s, and down from it is the obtuse angle of the Seventh Avenue Hotel. Across Liberty is the Richardson Romanesque Ewart Building, built in 1891 for a wholesale grocer, and the Keenan Building of 1907, with its Prussian helmet.

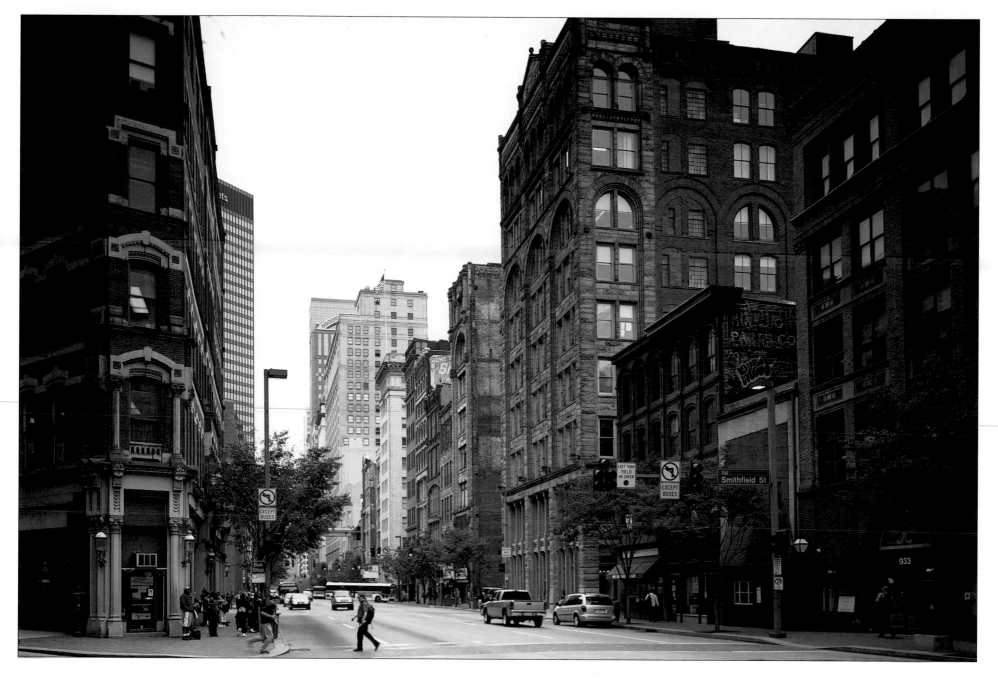

Here the Triangle Building is in full view and the Keenan Building is hidden from view. Many things are the same along this stretch of Liberty Avenue, at least on the surface. Victorian commercial architecture predominates: a little cast-iron Italianate, Gothic, and the 1890-period Richardson Romanesque that the courthouse building made fashionable. The buildings to the right are now part of the Pittsburgh Cultural District, a concentration of theaters, arts organizations, restaurants, and loft apartments mingling with commerce.

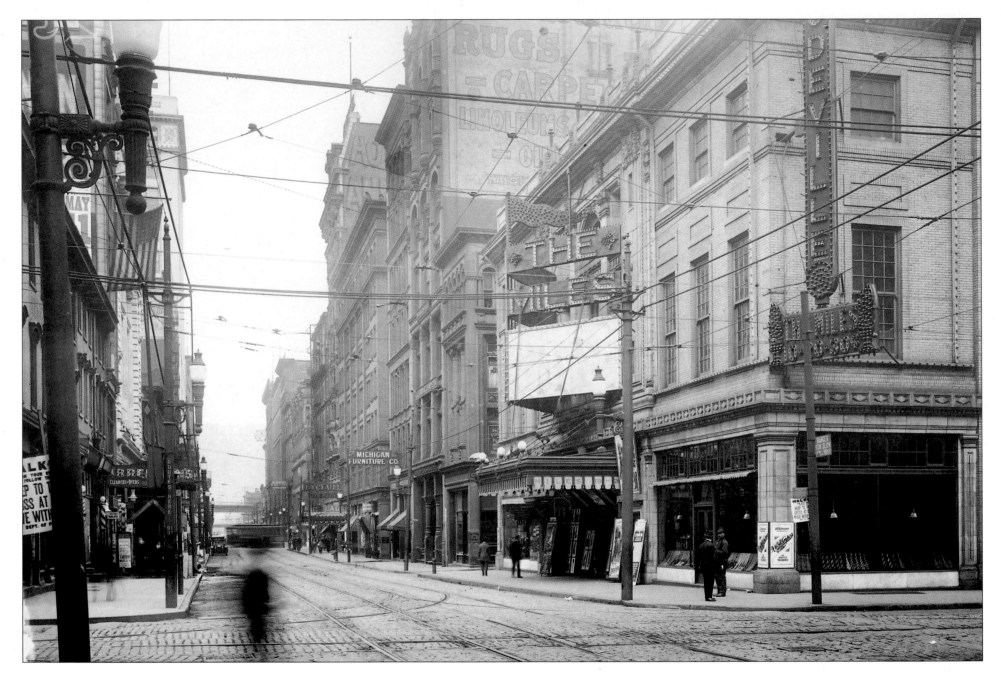

Parallel to Liberty Avenue and closer to the Allegheny River is Penn Avenue, a street that is rather narrow and is one-way sometimes, but that connects the Triangle with a multitude of easterly neighborhoods: the Strip, Lawrenceville, Bloomfield, Friendship, East Liberty, Point Breeze, Homewood, and over the city line to Wilkinsburg. This is Penn Avenue in 1915 looking west past the intersection with Seventh Street. The Miles was a vaudeville house, one of the five theaters in a four-block area mostly occupied by commerce.

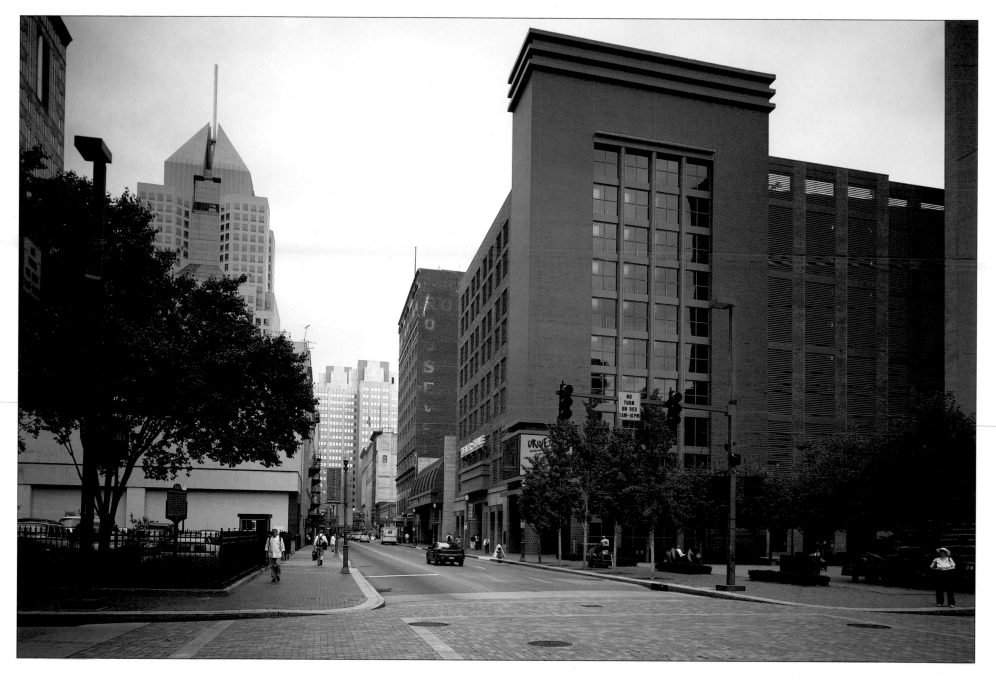

In place of the Miles Theater is Katz Plaza of 1999, landscaped by Daniel Urban Kiley with sculpture by Louise Bourgeois. It is a remarkable refuge, with linden trees, a bronze fountain cascade twenty-five feet high, and three pairs of benches in the form of eyeballs. Michael Graves, architect for Katz Plaza, also designed the colorful Theater Square Building, which opened in 2003, and the adjacent O'Reilly Theater, which opened in 1999 for the Pittsburgh Public Theater. Theater Square includes a cabaret theater, a satellite studio for WQED-FM, a box office, and a parking garage. On the left side of the street is the rear of Heinz Hall, home to the Pittsburgh Symphony Orchestra. In the distance is Fifth Avenue Place, with its distinctive split top.

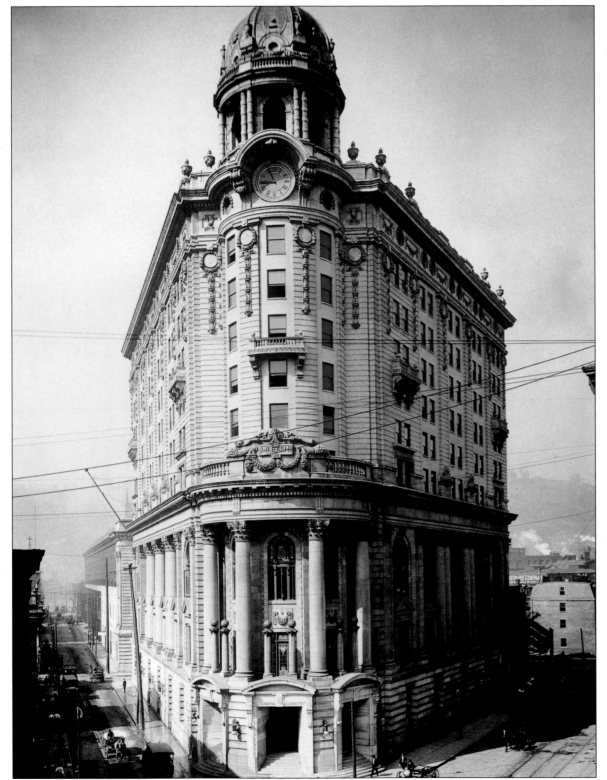

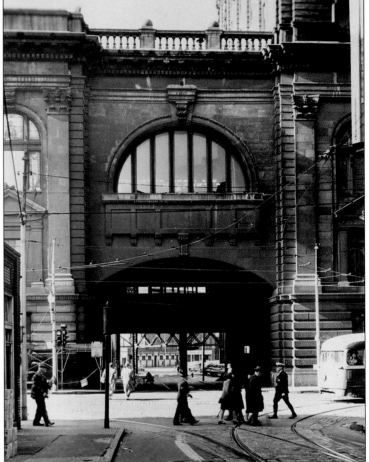

The Wabash-Pittsburgh Terminal Railway was a vainglorious attempt to gain the sort of access to the Triangle that the Pennsylvania Railroad, its subsidiaries, and the Baltimore & Ohio had theretofore been enjoying. Realizing the dream of George Jay Gould required a branch off an existing main line sixty miles away, two long tunnels with bad ventilation, a two-track bridge over the Monongahela, a yard area with a constricted throat, storage tracks thirty-five feet above the streets, a narrow trainshed, and this grandiose structure in the Beaux-Arts style, with an entrance on Liberty Avenue. Starting operations in 1904, the Wabash was in receivership in 1908. The terminal building, designed by Theodore Link of St. Louis, was demolished in 1955.

The one-story, hipped-roof Gateway Center "T" station (in the photo at right) marks the site of the Wabash-Pittsburgh Terminal. The station is one of four downtown entrances to Pittsburgh's subway. Gateway Four, shown here in two views, rises dramatically behind the station. The 1960 skyscraper designed by Harrison & Abramovitz adds a note of elegance to Gateway Center, when compared with the three stolid buildings of the 1950s reflected in its glass facade. Gateway centers One, Two, and Three, designed by Eggers & Higgins, were the first skyscrapers to go up during Pittsburgh's celebrated renaissance.

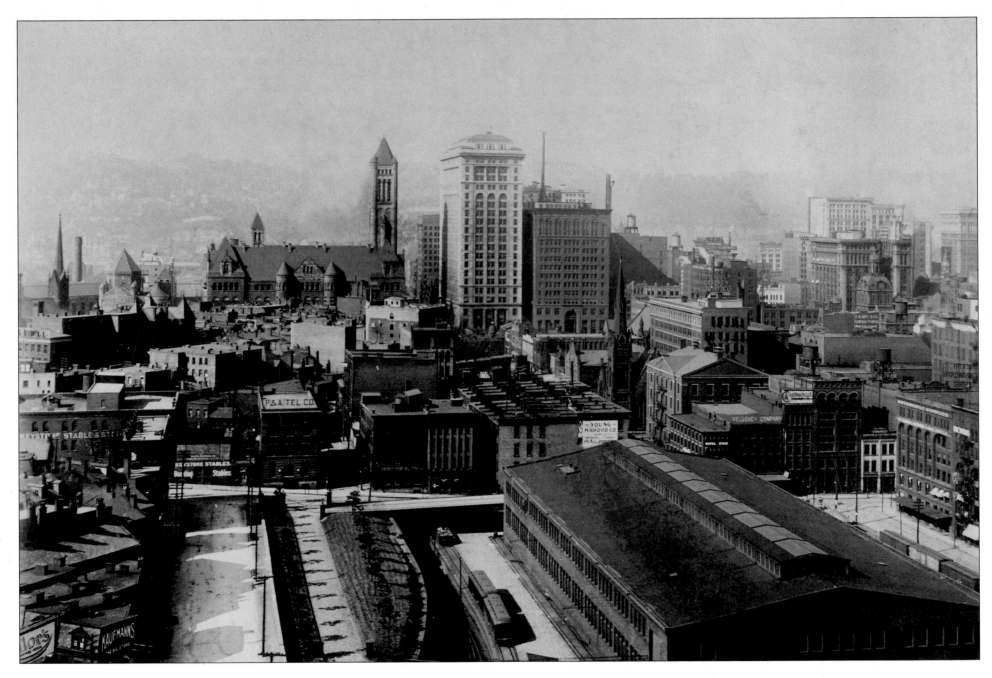

This is a view southward from Union Station, around 1910, as the Allegheny County Jail had the additions completed in 1908. The courthouse tower no longer dominates the scene, being boldly confronted by the Frick Building of 1902 directly across Grant Street. Grant Street itself is still an aborted thoroughfare, with a Pennsylvania Railroad freight shed across its axis and no modern development as of yet.

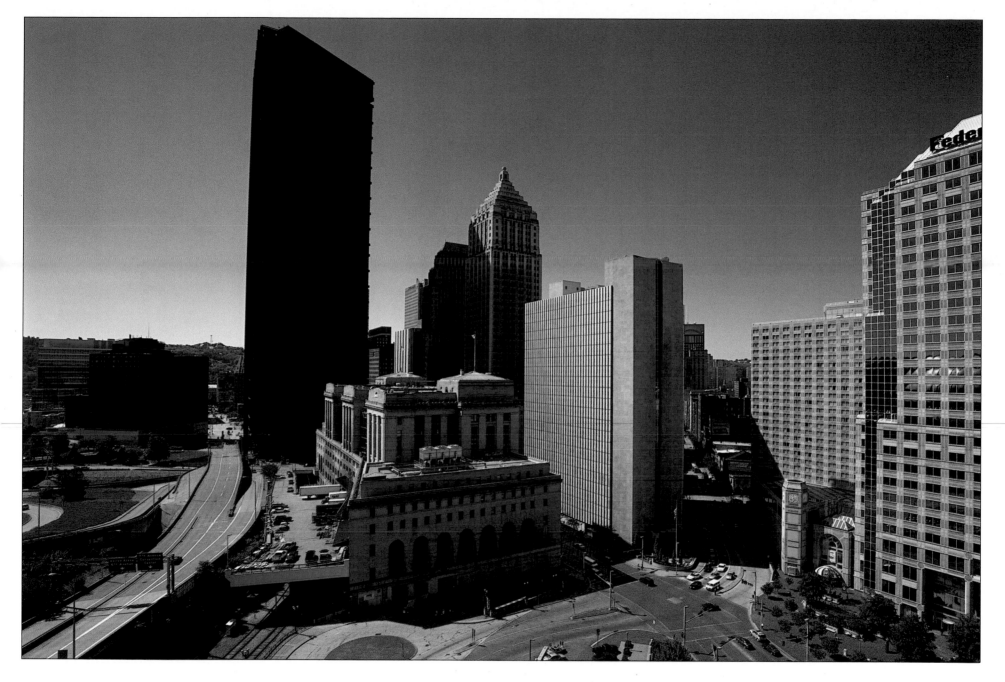

The scale of the southward vista from Union Station (now the Pennsylvanian) has been greatly augmented, and almost nothing can be recognized from the previous scene; indeed, only one corner of the courthouse is visible in both. The tallest building is the U.S. Steel Tower. Toward the right, crowned by a ziggurat, is the Gulf Building, now Gulf Tower, which in 1932 was the tallest building in Pittsburgh at 582 feet. To its left is the Koppers Building of 1929. In the foreground is the U.S. Post Office and Courts Building of 1934, which occupies some of the land where the freight station had been. Opposite that rises the modern slab of the William S. Moorhead Federal Building, and to its right is the Federated Tower of 1987.

The second Allegheny County Courthouse (at the extreme right) was a Greek Revival work of 1842 that burned in 1882. Here it is in its last days, seen from Grant Street, which has a small-town look. The courthouse stands noticeably above the street on a vestige of "the Hump," a natural rise of land that had been giving Pittsburghers trouble with its steep gradients throughout the nineteenth century. The Hump was attacked in fitful campaigns between 1836 and 1913, when its nuisance was settled once and for all and the street grade was brought down to its current level. Modern development along Grant Street followed the final 1913 push.

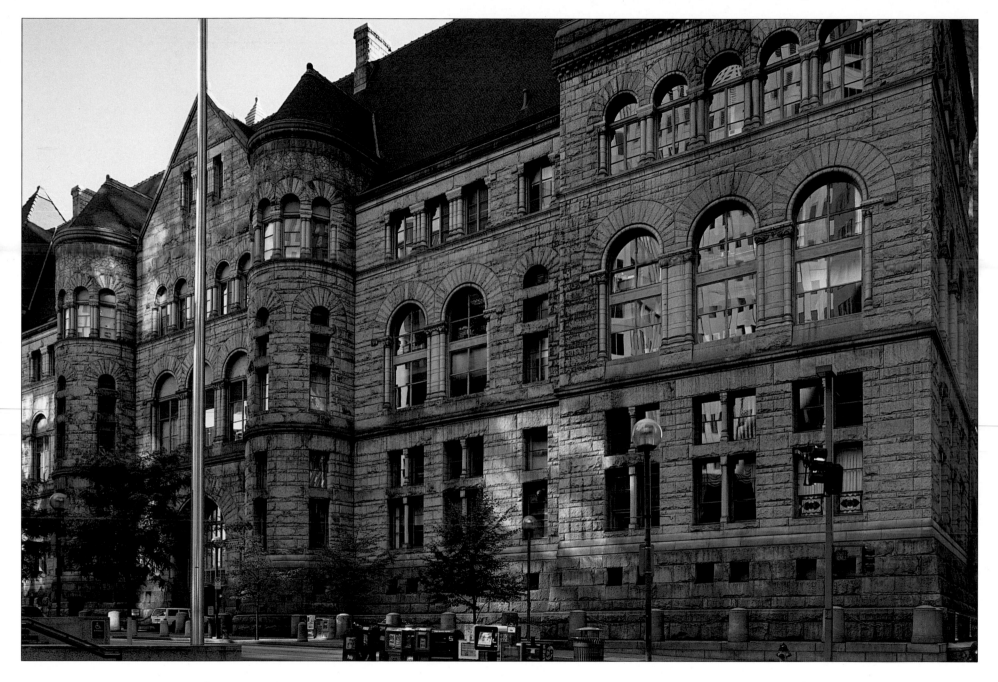

A competition in 1883 for the courthouse replacement garnered a design from Beaux Arts–trained architect Henry Hobson Richardson of Brookline, Massachusetts. He had developed a Romanesque style applicable to a multitude of building types, eventually to influence architecture in Europe and even Australia. It favored the grand and simple gesture, an absence of fuss that went from the elevation to the plan, and it was Richardson's simple, workable plan that actually got him the job. The lowering of the Hump by about fifteen feet has altered the proportions of the fronts, a fact most noticeable at the doorways. This side view is from a plaza in front of One Mellon Center.

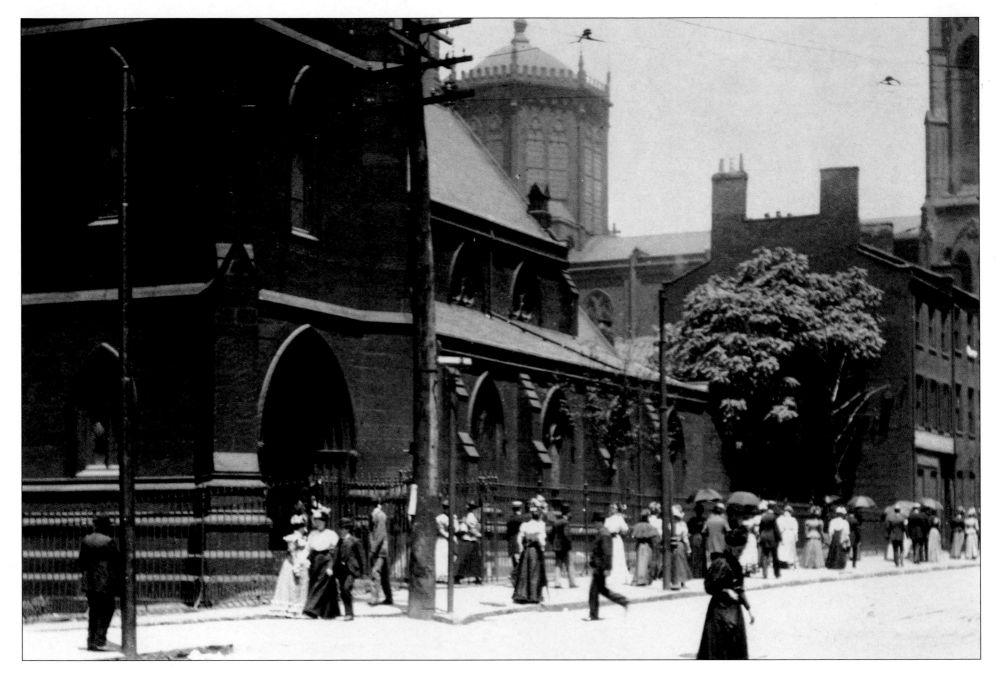

This is Grant Street opposite the courthouse, around 1900. At the corner with Diamond Street to the left is St. Peter's Episcopal Church. What appears to be a cupola on the church actually belongs to St. Paul's Roman Catholic Cathedral, across Fifth Avenue to the right. Everything in this picture was removed to make place for real estate ventures by Henry Clay Frick, a business partner of steel magnate Andrew Carnegie. St. Peter's was moved, stone by stone, to Oakland and reconstructed in 1901. St. Paul's, in Frick's hands by 1903, was demolished the following year for the Union Arcade. The diocese eventually moved to Oakland as well, and a new cathedral was constructed there in 1906.

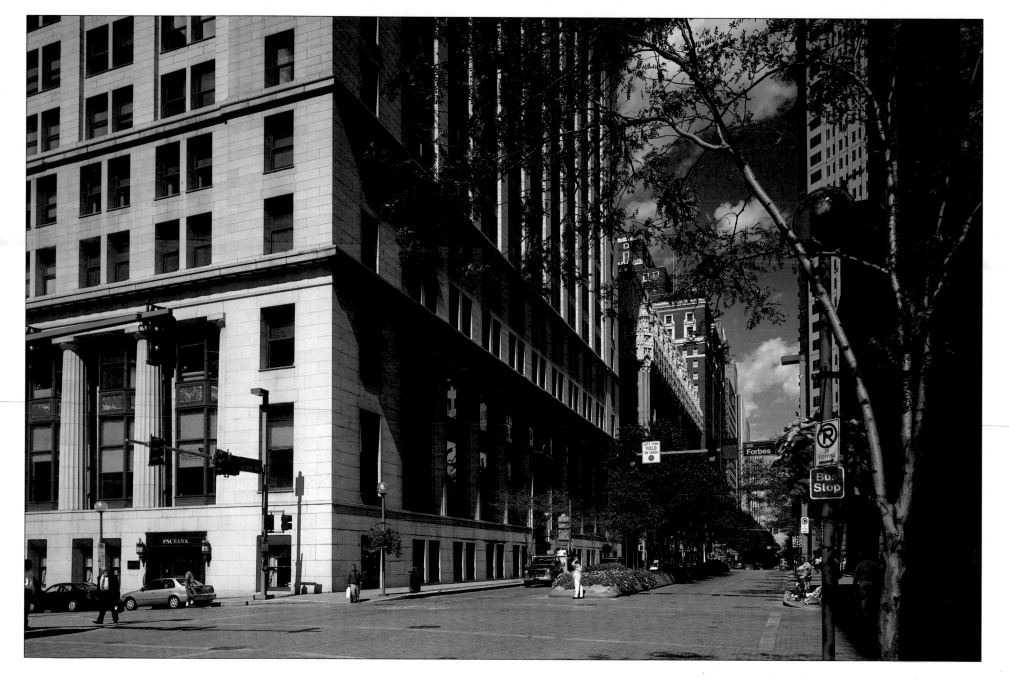

Grant Street is now Pittsburgh's grand civic boulevard and includes three of the city's most stunning historic buildings, all ventures by Henry Clay Frick. The Frick Building, completed in 1902 to designs by D. H. Burnham & Co. of Chicago, gave Frick his headquarters. The white marble interior contains *Fortune on Her Wheel*, an opalescent glass window by John La Farge. Next is the Union Arcade of 1917, with Flemish Flamboyant Gothic terra cotta that culminates in a fantastic roof. Inside is a dramatic ten-story central space beneath a stained-glass dome. The Union Arcade (or Union Trust Building) is now called Two Mellon Center. The redbrick and terra-cotta William Penn Hotel of 1928 includes the Art Deco Urban Room of 1929, designed by New York architect Joseph Urban.

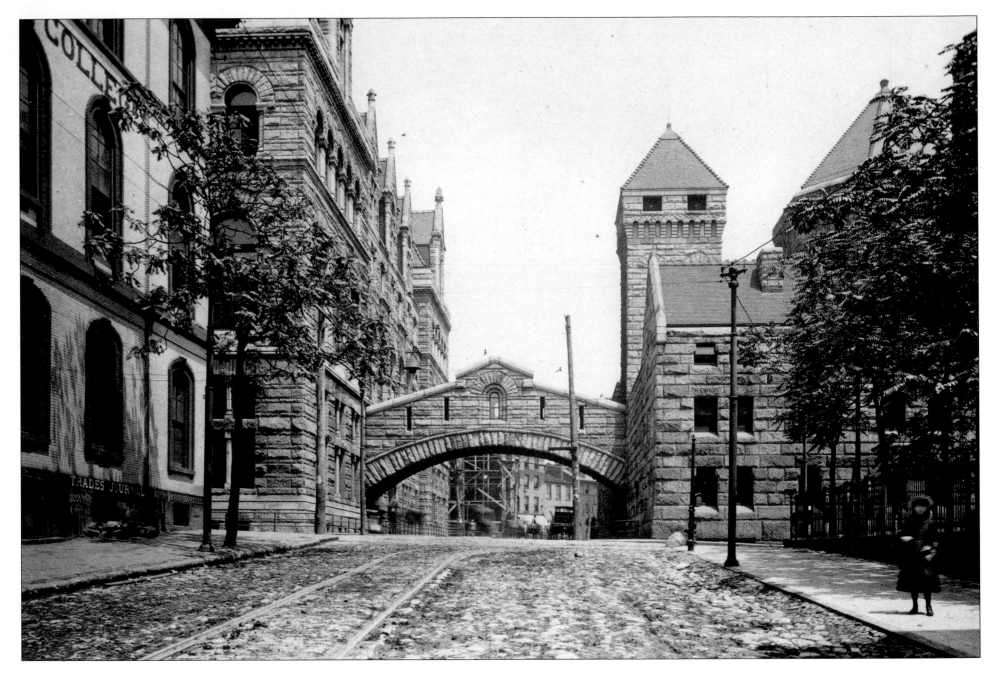

A view from 1893 shows Ross Street between the courthouse and the jail, with the Bridge of Sighs that connects them. This picture shows us the fresh, pale-gray granite but gives no idea of the vivid red-orange of the terra-cotta roof tiles when they were new. The proportions of the courthouse and jail were lower in this picture than they would be twenty years later when the Hump was reduced. Beyond the fence to the right was the county morgue, Romanesque, but not by Richardson. In the background is Wylie Avenue, a street now associated only with the Hill District, which once did reach the Triangle.

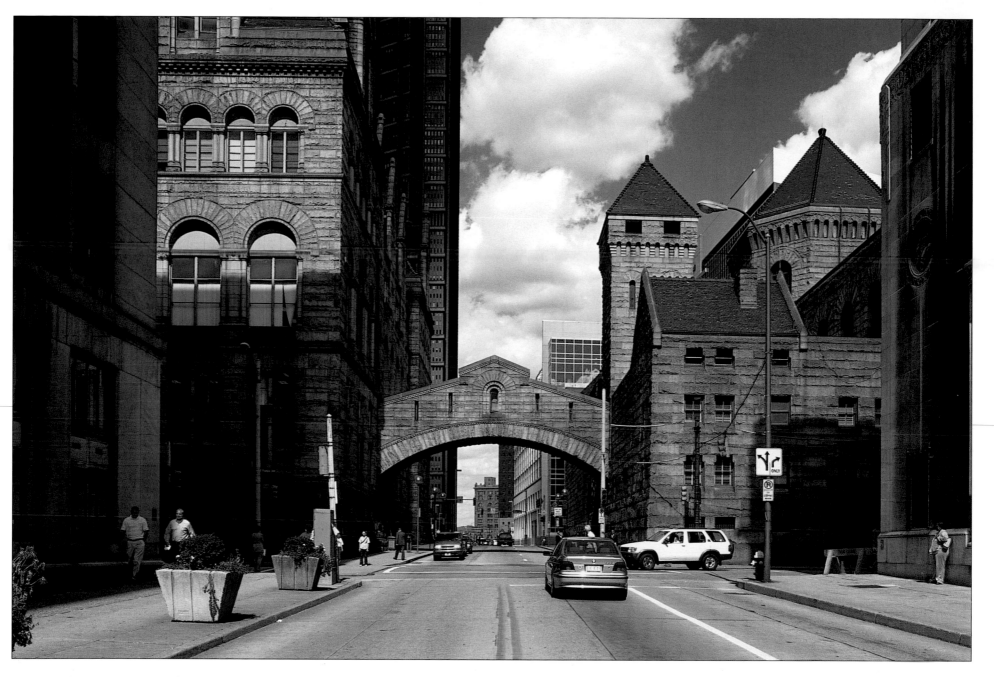

Of the pron
Park Buildir
remodeling.
by a marble
terra-cotta
glimpse of t
Steel Buildi
that Trowbr
fronted buil
remodeled i

Although the courthouse and jail look much the same, the jail is no longer a jail. It was renovated in 2000 for the Family Division of the Allegheny County Court of Common Pleas. The courthouse has received two neighbors since 1893. In the left foreground is the City-County Building of 1917, a work of New York architect Henry Hornbostel. Its smooth gray granite facade and businesslike rectangular shape beautifully contrast with the Richardson buildings. The airy corridor of the City-County Building that goes from Grant to Ross Streets is one of the architectural treats of the city. Across Ross Street is the County Office Building, a work by Stanley Roush that offers a scaled-up, mellowed-down 1920s version of Romanesque. To accommodate this, the morgue was moved downhill on rails.

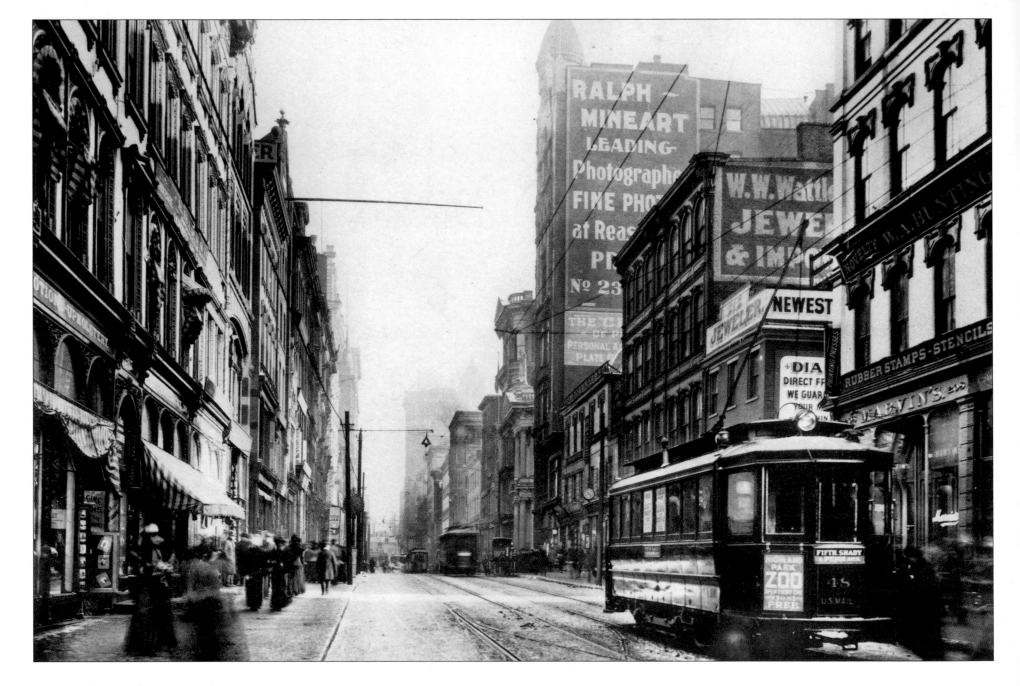

Fifth Avenue looking east from Market Street in 1899, with a typical Victorian mixture of Italianate and indeterminate architectural styles, including a little Gothic, executed mainly in brick and cast iron. This scene would have seemed a little old-fashioned to the 1899 viewer, except for the presence of trolley cars. Before 1896, Fifth Avenue had cable cars that ran between the Triangle and East Liberty, but most of these buildings, in fact, are contemporary with the horsecars that preceded cable cars. In the distance a little of the Hump is visible, awaiting its final reduction.

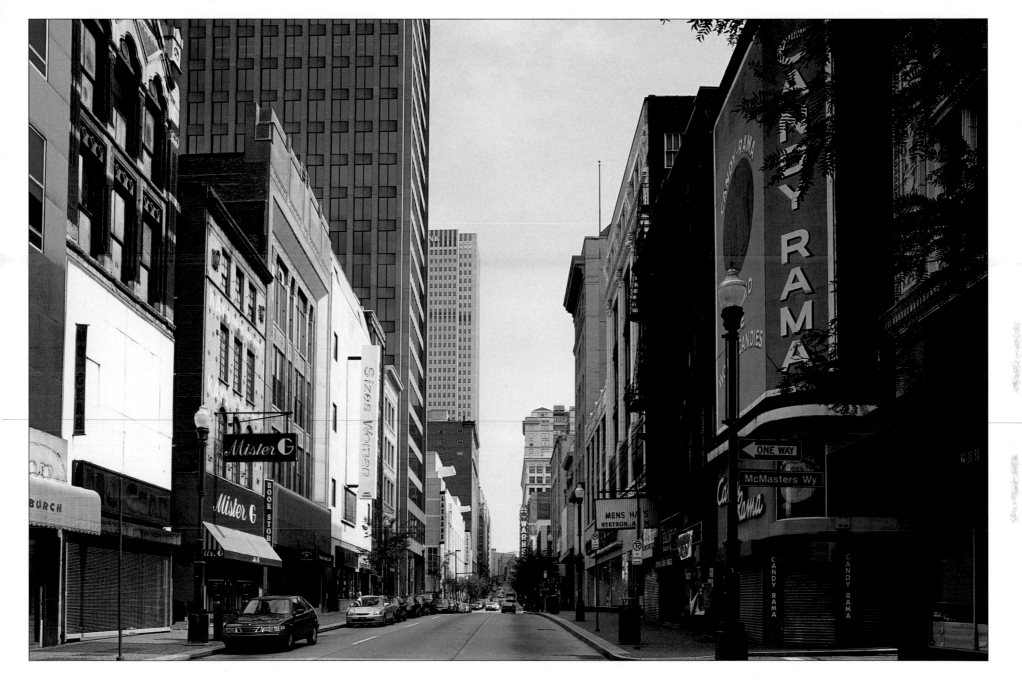

A little of the older architecture has survived: the Floyd Building on the left is one of Pittsburgh's finest examples of the High Victorian Gothic style and the Italianate cast-iron front on the right is one of the oldest commercial structures in the area. But for the most part we see terra-cotta and brick from the 1910s and 1920s, Moderne from the 1930s, and newer architecture still.

There are plenty of remodeled storefronts, of course. One PNC Plaza, whose thirty-story mass is only partially seen in this photo, was designed in 1969 by Welton Becket Associates of Los Angeles. This street scene will change dramatically when plans for the revitalization of the Fifth/Forbes area are implemented.

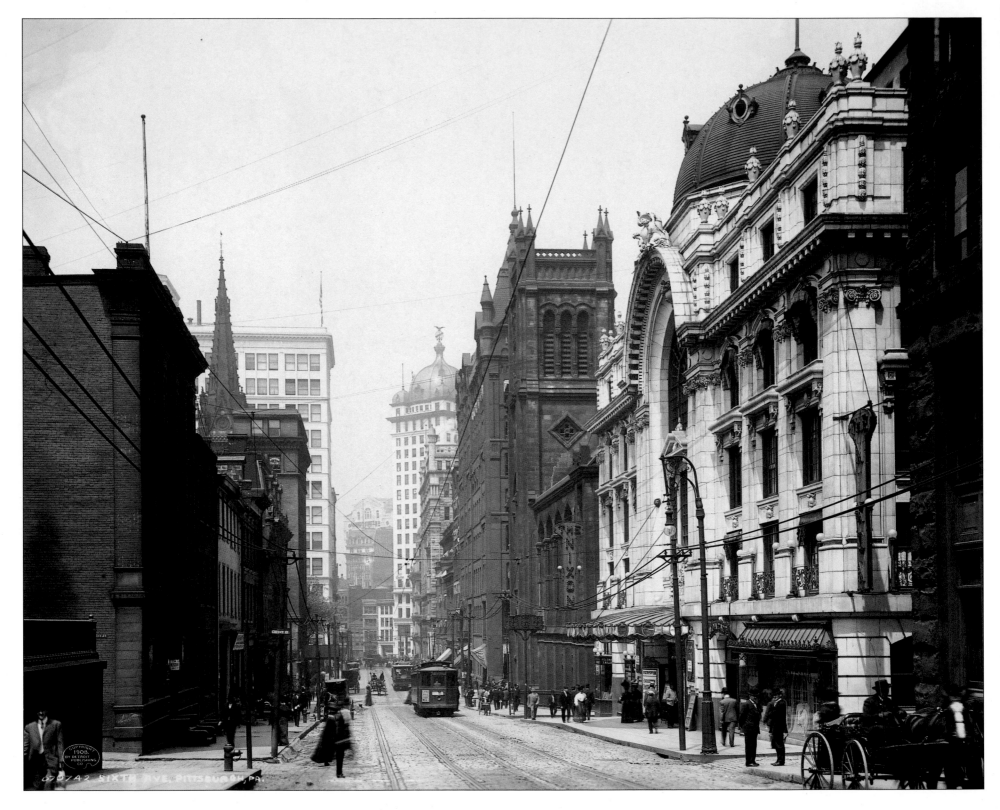

Left: Sixth Avenue facing west from Cherry Way looked like this around 1905. The two most prominent buildings on the right are the Nixon Theatre, built in 1903 and regarded as exemplary, and beyond that the German Evangelical Lutheran Church. Beyond the church is the Lewis Block, a Romantic office building; further back and discernible by its awnings is the brownstone-fronted Duquesne Club, designed in 1887 by Longfellow, Alden & Harlow. The Richardson Romanesque German National Bank of 1890 and the Keenan Building are seen in the distance. Across the street, the Gothic spire of the 1872 Trinity Church contrasts with the business architecture, and D. H. Burnham & Co.'s McCreery's department store rises beyond.

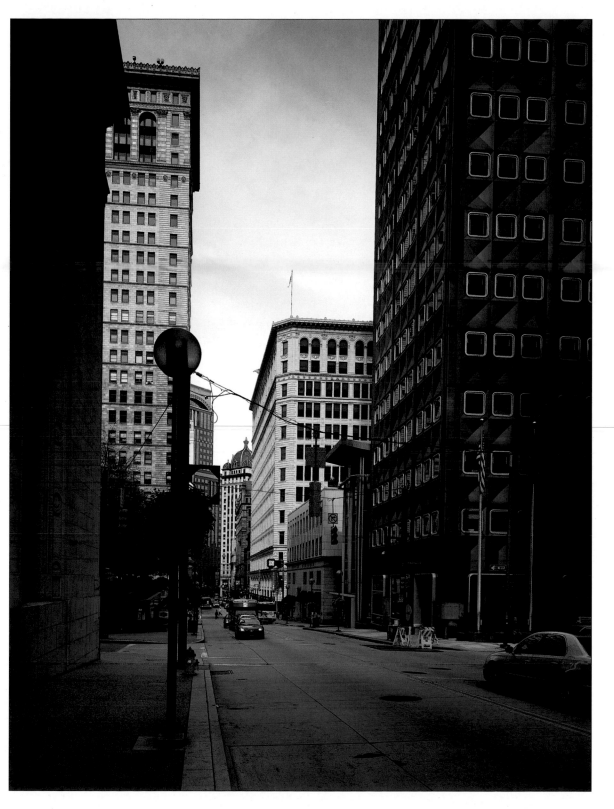

Right: In the place of the Nixon came the Alcoa Building, finished in 1953. Designed by Harrison & Abramovitz, this was a proud work of the Pittsburgh Renaissance, one of the earliest attempts to use aluminum as an architectural material inside and out. In 1998 Alcoa moved to a new headquarters on the North Shore, and this building is now called the Regional Enterprise Tower. Replacing the Lewis Block is the 1913 terra-cotta building for the Kaufmann & Baer department store, later Gimbel's and now headquarters for H. J. Heinz. The Duquesne Club is still there. The Henry W. Oliver Building (to the left), designed in 1908 by D. H. Burnham & Co., obscures the view of Trinity Cathedral and McCreery's (now 300 Sixth Avenue).

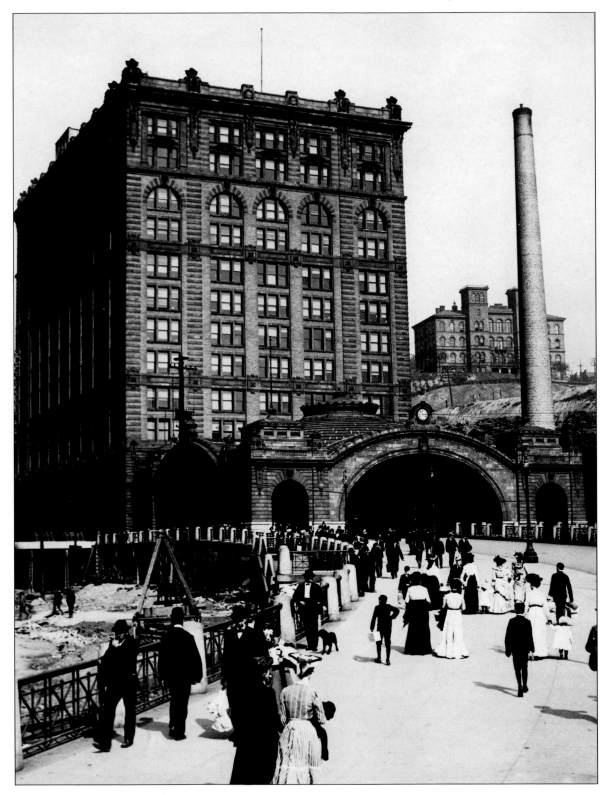

As chartered in 1846, the Pennsylvania Railroad ran only from Philadelphia to Pittsburgh, but it extended itself northward and westward by leasing five other lines, and thus called its Pittsburgh terminal Union Station. A handsome station of 1865 was destroyed in the railroad strike of 1877, and the railroad eventually ended the city's consequent "architectural penance" with this grand new station of 1903, the work of D. H. Burnham & Co. Its ocher terra-cotta and brick showed resignation to its bathing in smoke by passing and idling steam locomotives. The balloon trainshed lasted until 1946. On the hill (in a neighborhood known as the Hill) is the Central High School of 1874.

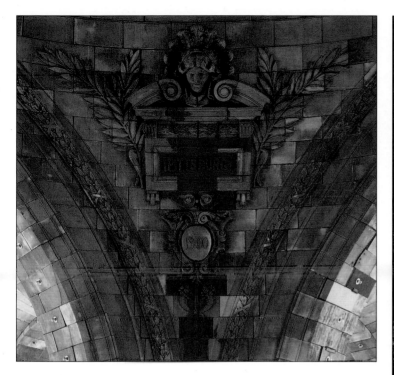

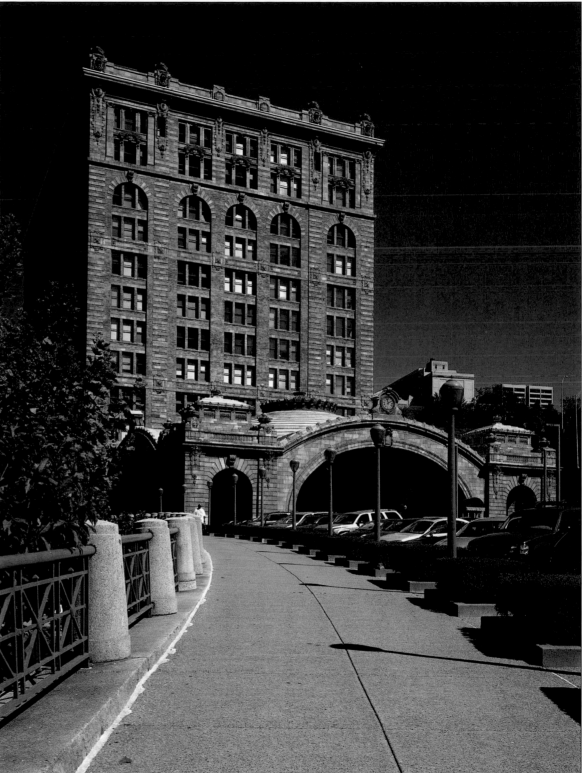

A landmark at the northeastern corner of the Triangle, the carriage shelter of the former Union Station is the city's most flamboyant architectural gesture, with its play of arches and its top-lit dome. The building is now the Pennsylvanian, an apartment house, and offices are located on the main floor. Amtrak runs a passenger service, but is camped out in a minor space behind the station building. A pendentive from the Union Station entrance (*above*) shows the name "Pittsburg." In 1891, the U.S. Board of Geographic Names determined that the name "Pittsburgh" (a name given by a Scottish general, John Forbes) should be changed to "Pittsburg." Many Pittsburghers actually went along with this. It was only in 1911, after organized protest, that the "h" was officially restored.

The vicinities of railroad stations are often cheerless areas. This is Liberty Avenue looking along Eleventh Street toward the Allegheny River in 1901, while the present Union Station was under construction. There are railroad tracks on Liberty Avenue itself, and freight cars stand behind the fence on the right. The extensively wired electric poles suggest the multiple uses of electricity at this time, but the Smoky City is still much in evidence.

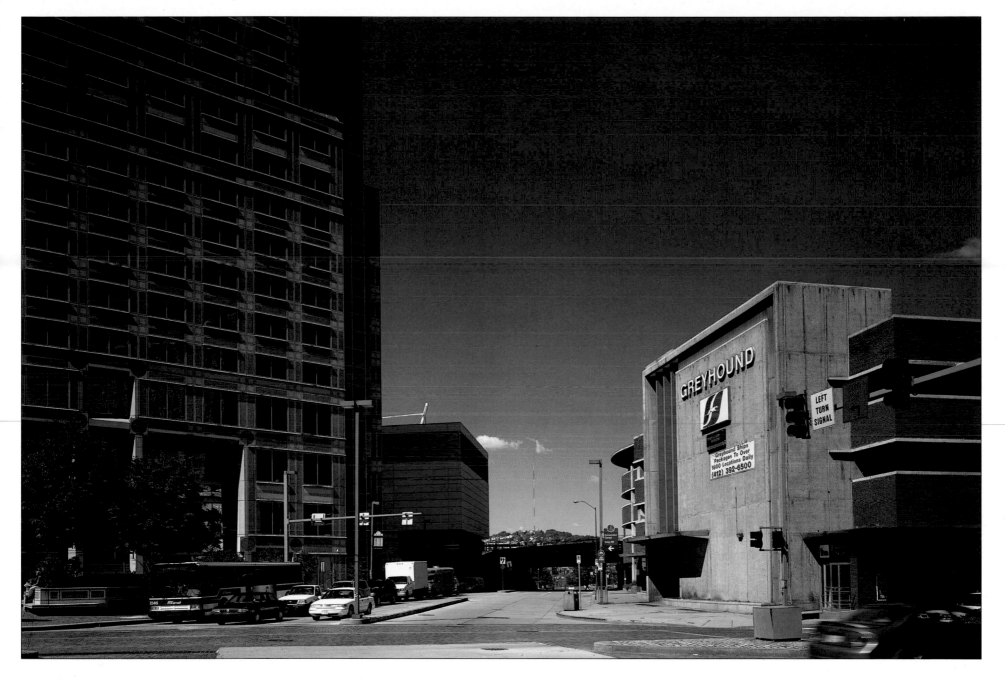

Today the vista has opened up, almost in a scaled-up version of the 1901 scene: Federated Tower (with its Westin Convention Center hotel) is where Eleventh Street once had cheap, ephemeral hotels, and a Greyhound station of the 1950s for passenger transportation. The Pennsylvania Railroad's plate-girder bridge in the distance dates from the 1900s and was built for the new Union Station.

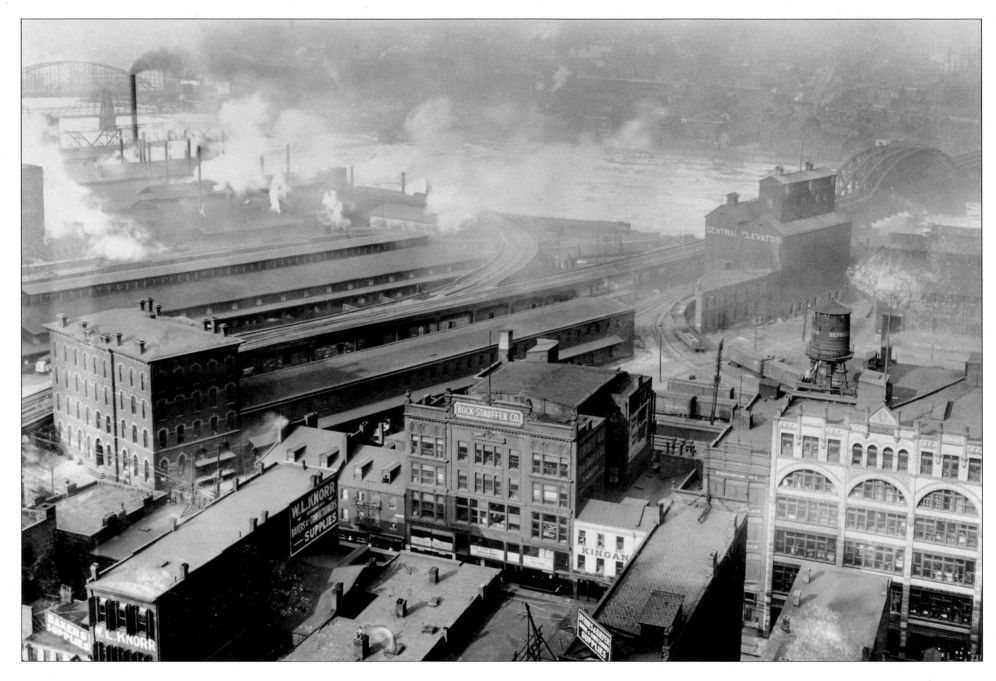

This is what Eleventh Street led to in 1916: a Pennsylvania Railroad freight station, a grain elevator, and an assortment of mercantile architecture on Liberty Avenue in the foreground, with Penn Avenue beyond. In the upper left are the now-gone Sixth, Seventh, and Ninth Street bridges, and to the right is the Pennsylvania Railroad's Fort Wayne Bridge, built to withstand the pounding of driver wheels beneath the masses of steel, cast iron, and water, which were the locomotives of the time. It was a link of the road to Chicago. The view is north from the roof of Union Station.

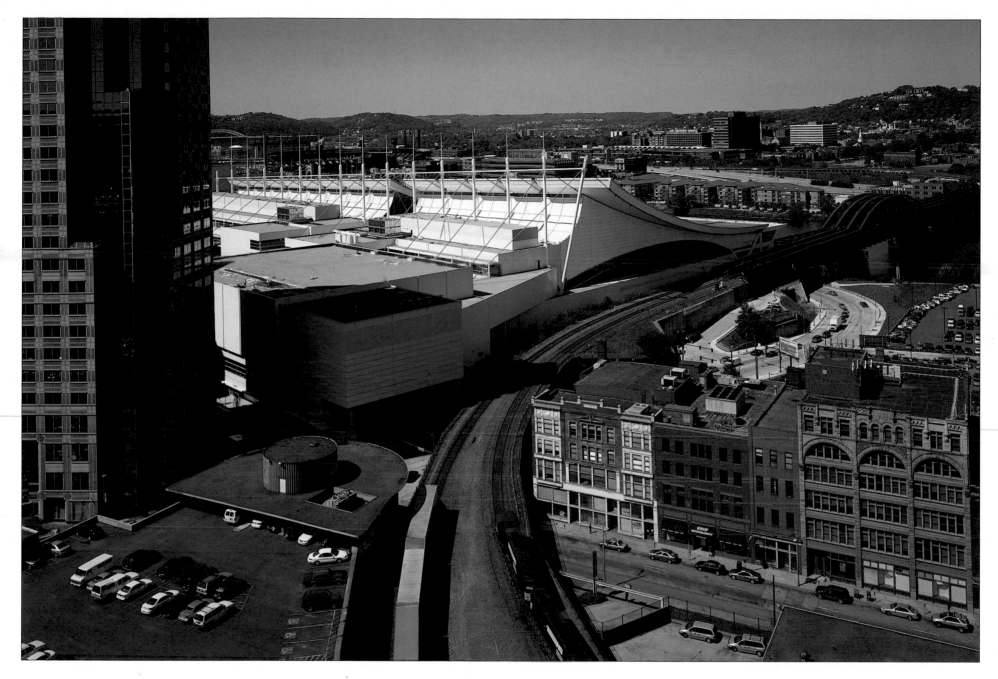

Much is new. To the right of the Federated Tower is the brand-new David L. Lawrence Convention Center, named in honor of the Democratic mayor who joined forces with Republican financier Rickard King Mellon to engineer Pittsburgh's Renaissance. The Convention Center, a work of Rafael Viñoly, has a sail-like main roof that was inspired by the catenaries of the present Allegheny River bridges nearby. It is the first convention center in the world to be designed according to Green building principles, using natural ventilation and lighting and drawing water from a subterranean aquifer. The Fort Wayne Bridge is its old self, and some of the Penn Avenue architecture remains. All the old industry is gone. In the distance is the North Side.

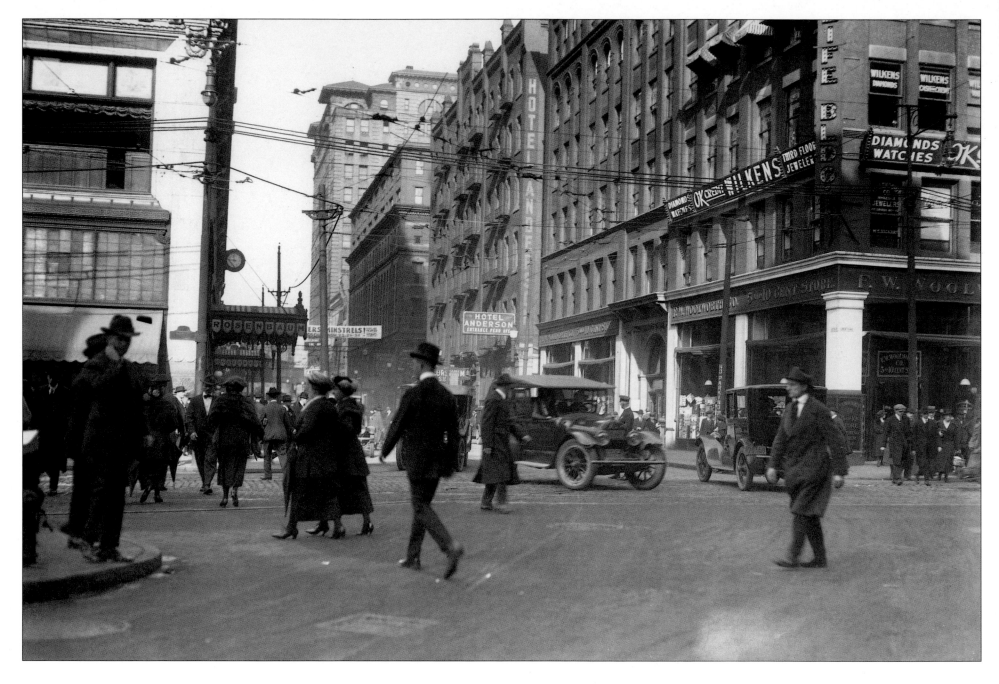

Here is a 1921 view looking across Liberty Avenue and northward up Sixth Street from the end of Market Street. To the left is Rosenbaum's department store, there since 1915, and across Sixth Street is the Pittsburgh Life Building, with a well-remembered Woolworth's that was there for generations. Up the street are three hotels and numerous small business places, and at the end are two nearly similar buildings erected around 1905 by Andrew Carnegie's one-time partner Henry Phipps: the Fulton Building, visible here, and the Bessemer Building, across Sixth Street but just out of sight in this photo.

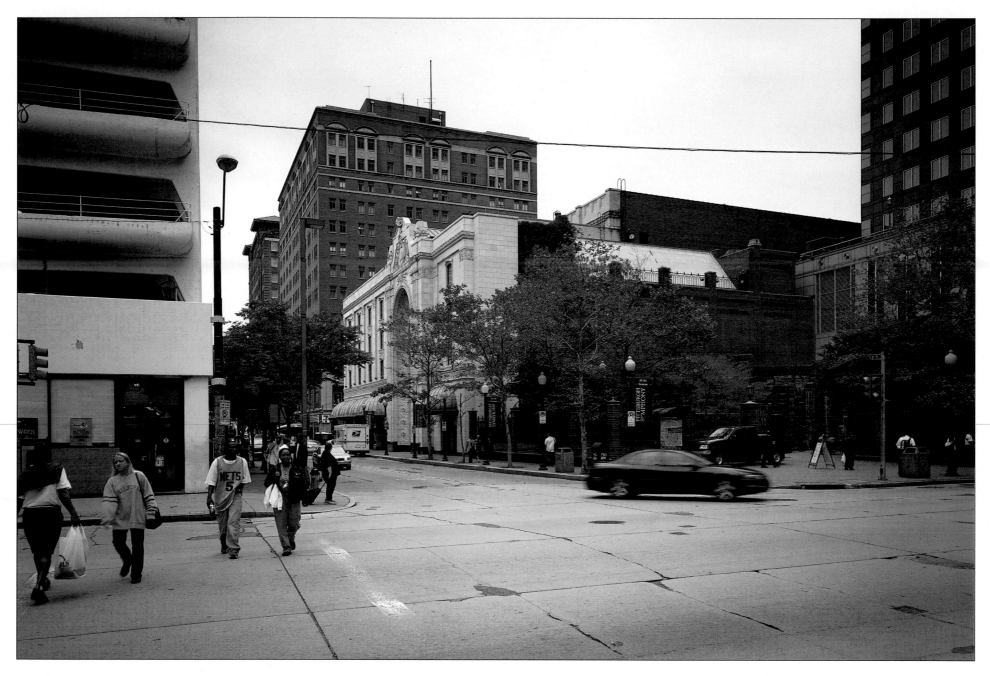

Now the central object is Heinz Hall, beautifully restored on the exterior, remodeled on the interior, and reopened in 1971 as the home of the Pittsburgh Symphony Orchestra. Erected in 1926, it had once been the Loew's Penn Theater, a silent-movie house. Heinz Plaza, a landscaped intermission space primarily for symphony patrons, is where the Pittsburgh Life Building once was. The redbrick 1926 Roosevelt Hotel is now senior housing. Beyond that is the Renaissance Pittsburgh Hotel, formerly the Fulton Building. The hotel opened in 2001 after three years of extensive renovations: 300 pounds of coal dust alone were removed from the rotunda dome, thirty feet in diameter, during the initial cleaning process. A garage from the 1960s stands in place of Rosenbaum's.

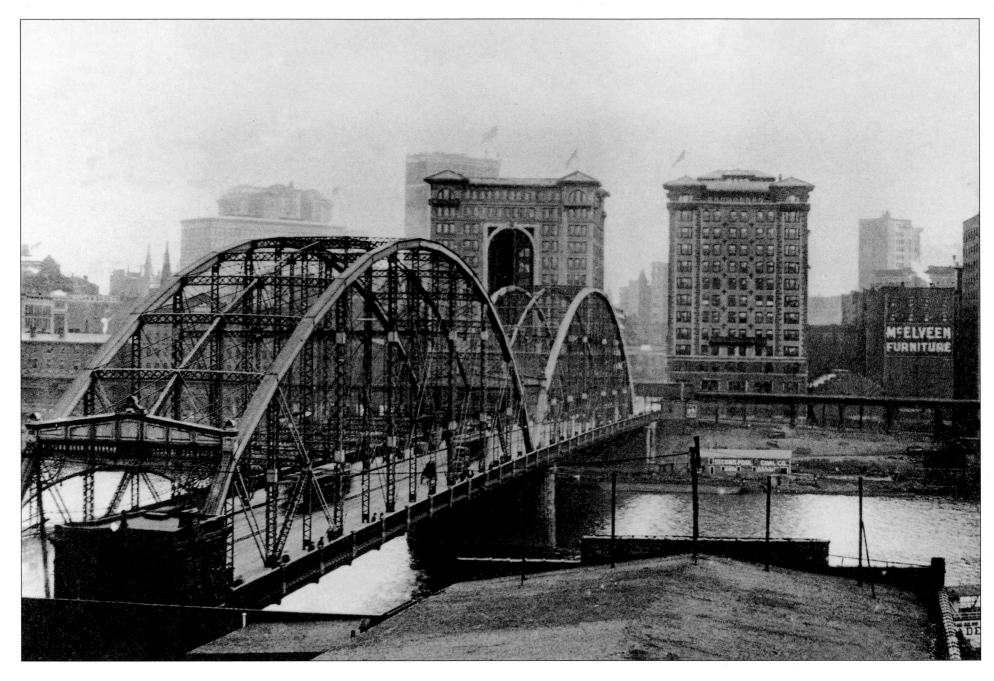

Henry Phipps's architect for his speculative buildings along the Allegheny River was Grosvenor Atterbury, a mildly progressive New Yorker. The Fulton Building to the left and the pendant Bessemer Building were similar in massing but not in detail. The tile hipped roofs give a slightly Latin flavor to both designs but the Fulton Building's detail is inclined toward Classicism and the Bessemer has technological allusions, with detailing of steel strapwork and riveting. The bridge is the third Sixth Street Bridge, built in 1892. Replaced in the 1920s, it was floated down the Ohio to a second existence between Neville Island and Coraopolis.

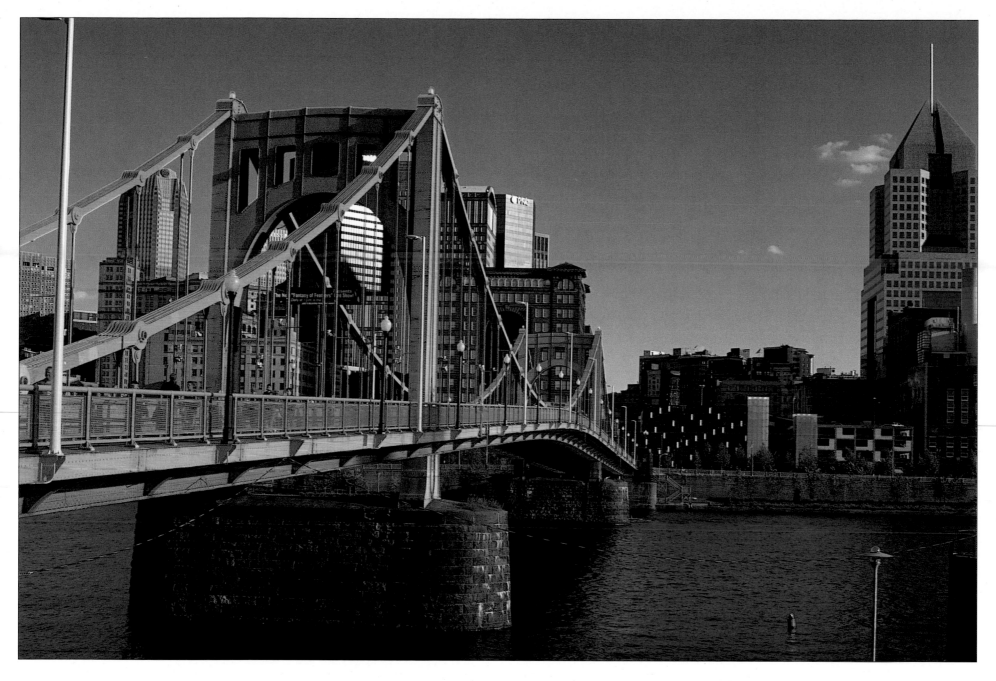

Pressure from the U.S. secretary of war to increase Allegheny River bridge clearances led to the county's determination to rebuild the Sixth, Seventh, and Ninth Street bridges over the Allegheny River. The Pittsburgh Art Commission had some say in the appearance of public structures and, in this instance, chose the suspension bridge as a type to follow. Site conditions forbade conventional suspension bridges, though, and a novel German design was followed in these bridges, "the Three Sisters," whose principal structures are about 880 feet long. The Sixth Street Bridge was renamed the Roberto Clemente Bridge in honor of the Pirates' famous right fielder and is dramatically lit at night. The bridge connects the PNC Park baseball stadium on the North Shore with the Golden Triangle. The most prominent downtown building in this view is Fifth Avenue Place, designed by Stubbins Associates in 1985.

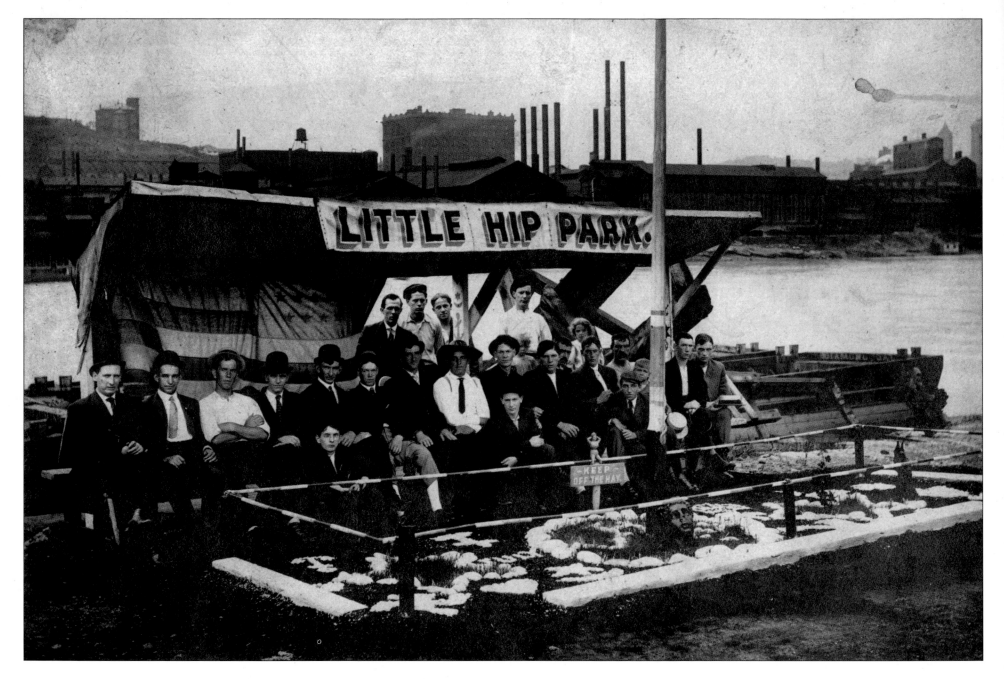

Little Hip Park seems to have been a project of the working-class residents of a North Side neighborhood. Its executants, along with a small girl, are posed here in as formal a manner as they would ever have assumed. Across the Allegheny River is the Triangle, with Union Station and the old Central High School on the skyline and the Fort Pitt Foundry and the Wayne Iron and Steel Works beside the river. The sign reads "Keep Off The Hay."

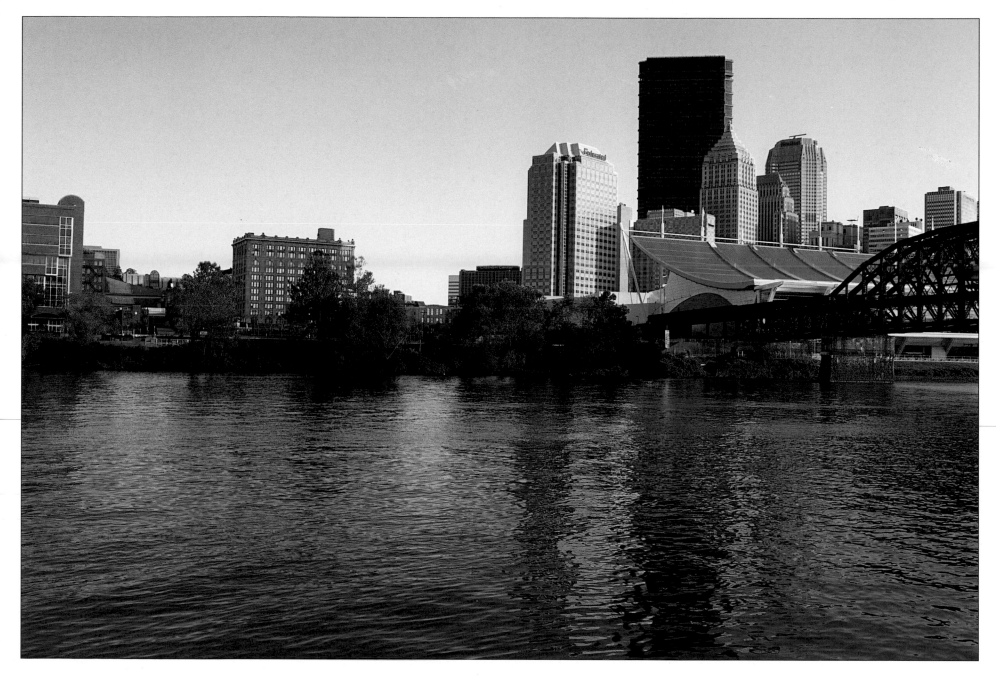

Little Hip Park lasted only a short time, but this view is still accessible from the Three Rivers Heritage Trail along the Allegheny River. Industry has vanished, and tall buildings have appeared. The convention center, just beyond the Fort Wayne Railroad Bridge, catches the eye most readily: the greater part of its area hangs from fifteen masts, and its lightness of appearance is in marked contrast with the geometric solidity of what is beyond. The Gulf Tower stands half-silhouetted against the U.S. Steel Tower.

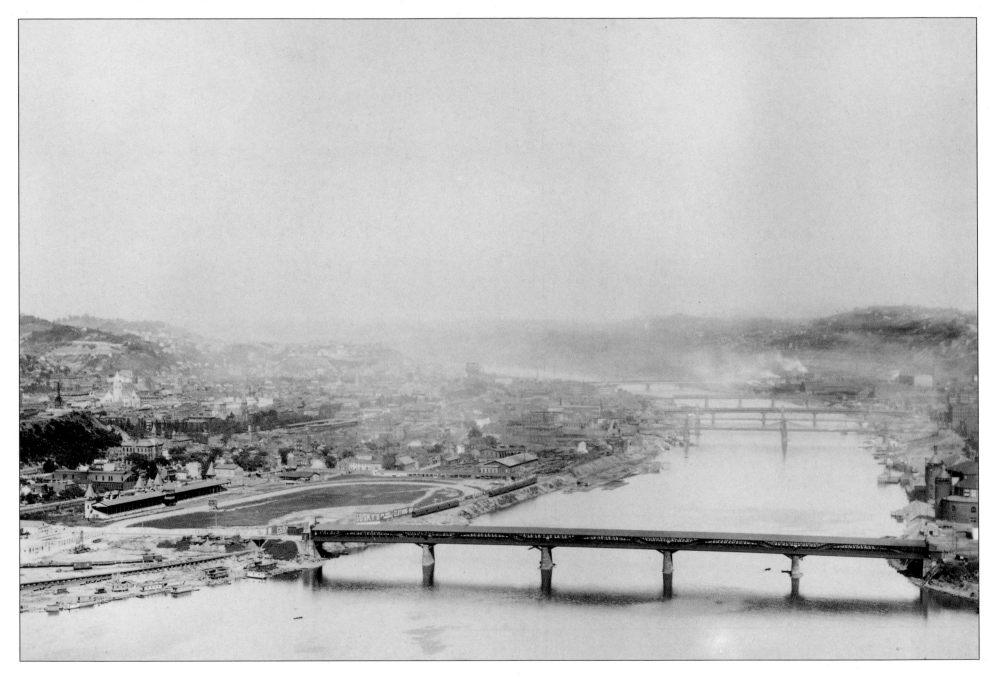

Until December 1907 the Allegheny River separated two distinct incorporated cities: Pittsburgh to the south, Allegheny to the north. In this view of 1890, Allegheny City is to the left. The Union Bridge, a wooden covered bridge of 1874, joins the two at the mouth of the Allegheny River. Its approach passes Exposition Park, long a sports field for both cities.

Up the river we see the Sixth, Seventh, and Ninth Street bridges as well as the Pennsylvania Railroad's Fort Wayne Bridge, all to be replaced. In the center of Allegheny City, bright in its just-set granite, is the Carnegie Library that marks its crossroads.

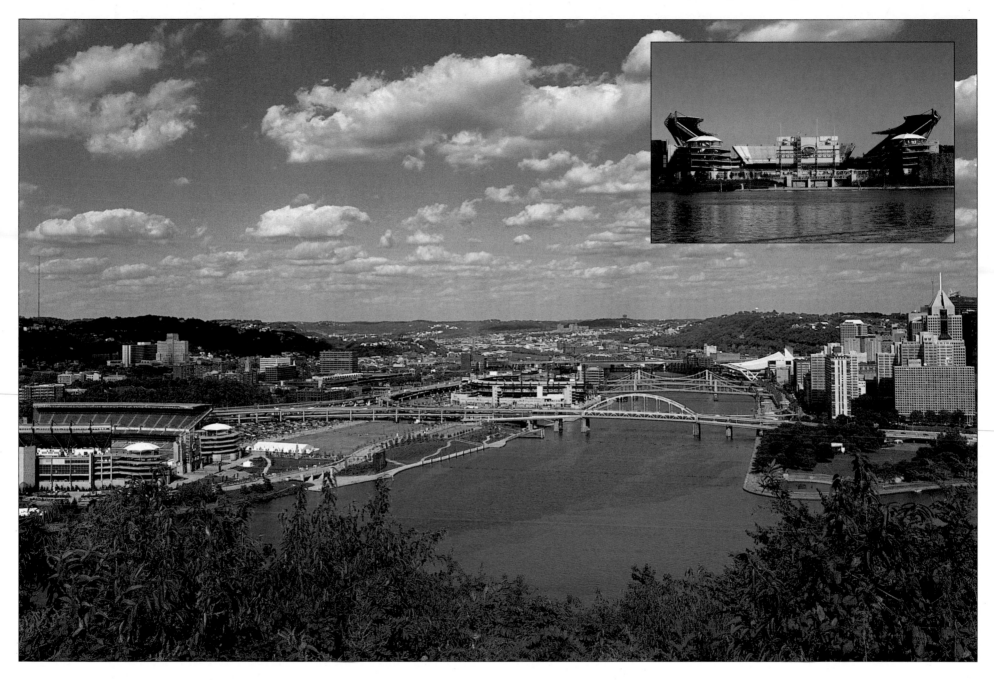

Heinz Field, home of the Pittsburgh Steelers (see inset), is located near the site of Exposition Park and years later of Three Rivers Stadium, built for the Pittsburgh Steelers and Pittsburgh Pirates in 1970 and imploded in 2001. A little further up, just beyond the tied-arch Fort Duquesne Bridge, completed in 1963, is PNC Park, designed to re-create the intimacy of the 1909 Forbes Field in Oakland. Heinz Field and PNC Park were designed by HOK Sports of Kansas City, Missouri. All the bridges are new. The most conspicuous building on the North Side, silhouetted against the hillside, is Allegheny General Hospital.

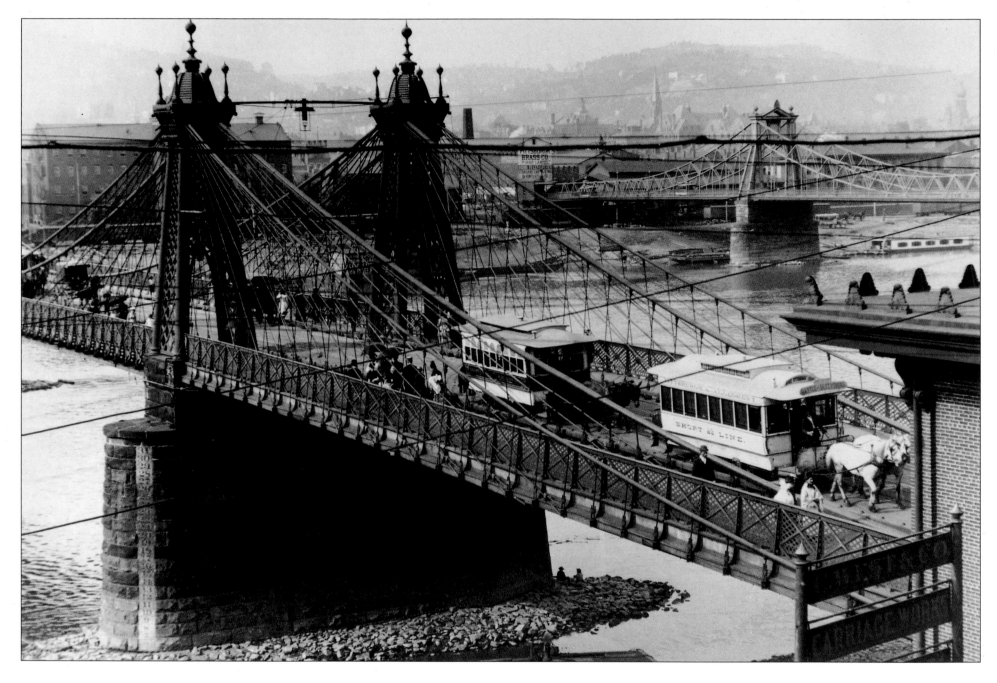

Until 1896 all Pittsburgh river bridges were privately erected and charged tolls. Here are two Allegheny River suspension bridges, photographed around 1890. In the foreground is the second Sixth Street Bridge, built in 1859, which lasted until 1891. Its engineer was John Augustus Roebling, who already had the local aqueduct for the Pennsylvania Canal and the second Smithfield Street Bridge to his credit. Beyond is the Seventh Street Bridge of 1884, designed by Gustav Lindenthal, who had already seen erected the third (and present) Smithfield Street Bridge.

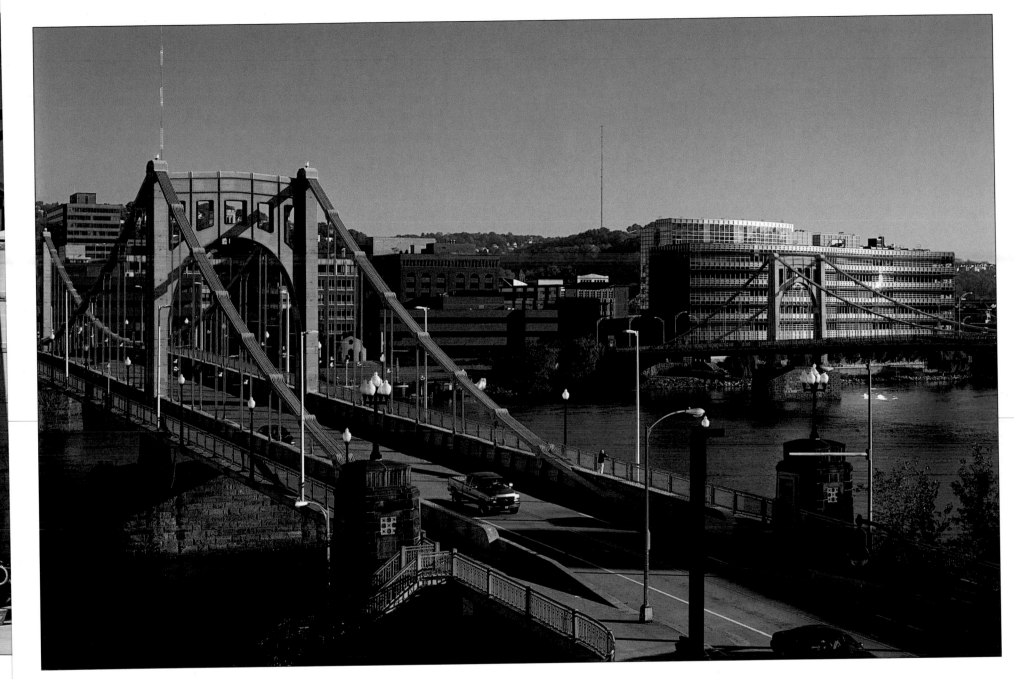

Opened in 20
and the area
Triangle. Ban
Roberto Clem

Despite the Art Commission's call for suspension bridges under adverse site conditions and the odd erection procedures this required—they had to be framed as cantilevers, then transformed into "self-anchored" suspension bridges when the basic structures were completed—the Three Sisters have always been favorites, and one received a beauty prize from the American

Institute of Steel Construction on its completion in 1928. The Roberto Clemente Bridge is in the foreground. Just beyond the Seventh Street Bridge is Alcoa's new headquarters of 1998, a dramatic glass and aluminum structure whose facade suggests the undulations of the Allegheny River.

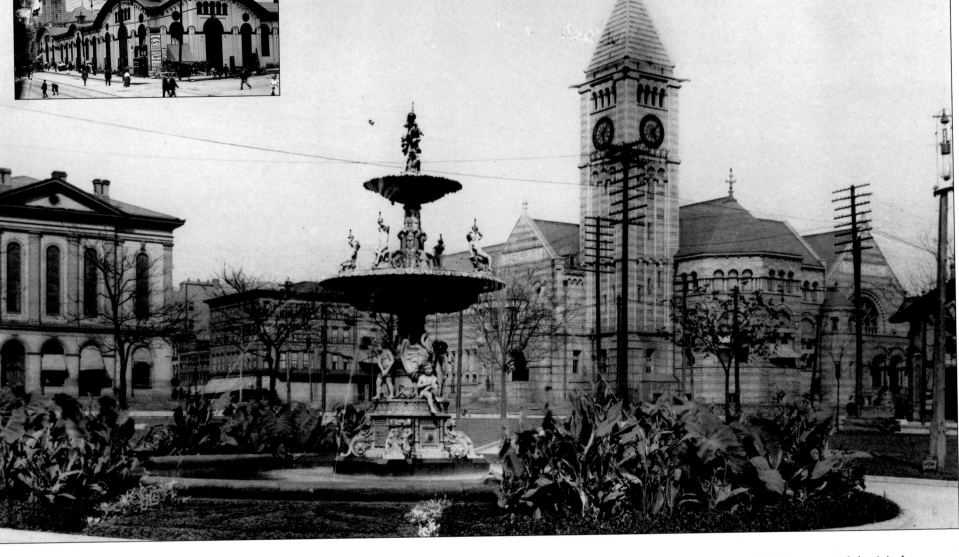

Federal Str
Pittsburgh:
in 1893, wi
of its emine
old town cr

This was the center of Allegheny City in 1899. A corner of the Market House (inset) appears at the far right edge of the picture, but the place of honor goes to the Carnegie Library, the first that Andrew Carnegie commissioned in the United States. To the far left is the city hall of Allegheny. The fountain occupies a fourth quadrant of this public area of Allegheny Town's century-old crossroads.

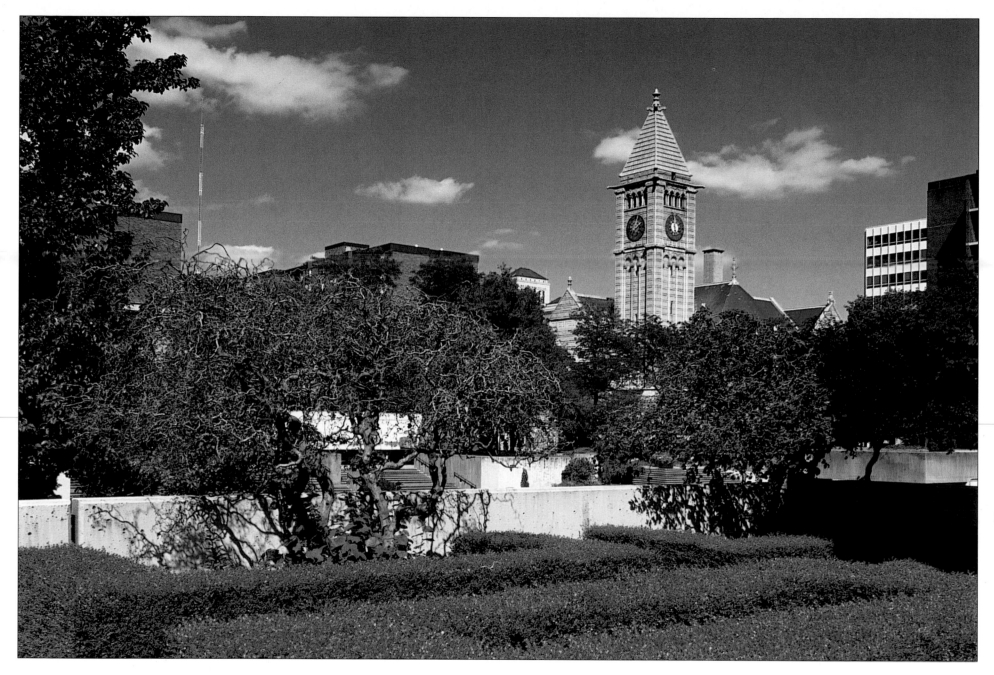

After four decades of urban renewal, the former crossroads looks like this. Neither Federal nor Ohio streets carries wheeled traffic to the center point anymore. Apartments occupy the approximate site of the handsome old Market House. The city hall's site has long been taken by the Buhl Planetarium (hidden from view by trees), a Stripped Classical work of 1939. Now vacant, the planetarium is to be adaptively reused and incorporated in an expansion of the neighboring Pittsburgh Children's Museum. The Victorian fountain went out of fashion—and existence—years ago.

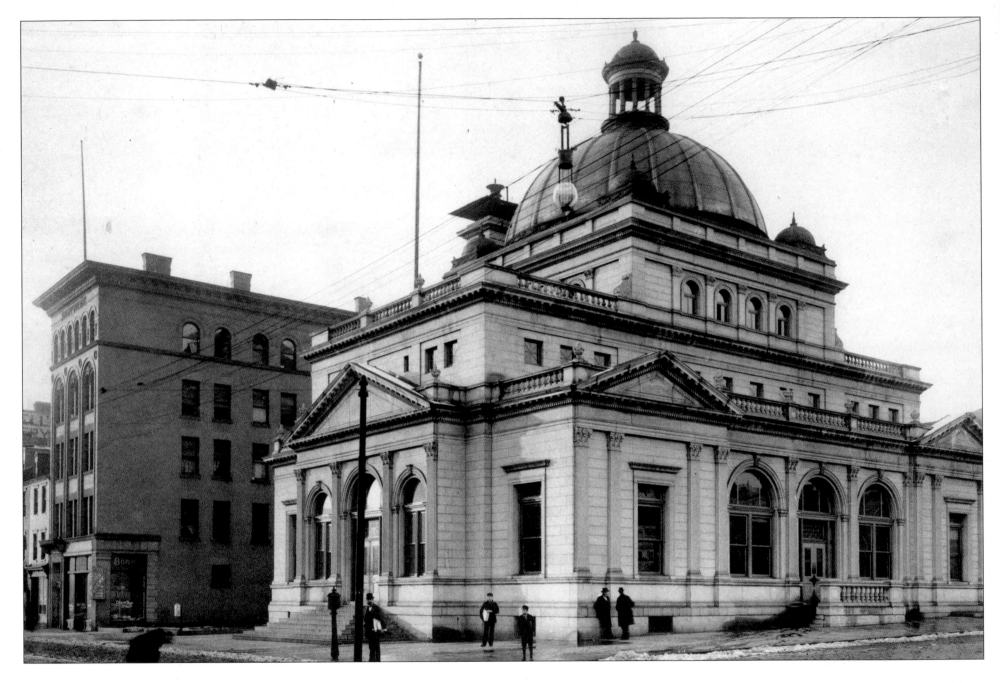

Adjacent to the Allegheny City Hall on Ohio Street was this post office of 1897, the work of the U.S. Treasury architect William Martin Aiken. Its formality of character was kept within the human scale. The central interior beneath the dome was a full-height mail-sorting room, the customers being confined to surrounding corridors. The old post office was slated for demolition as part of the urban renewal plans in the 1960s, but was saved by the Pittsburgh History & Landmarks Foundation, concerned citizens, and neighborhood organizations. In 1971 it became the headquarters and museum for the Pittsburgh History & Landmarks Foundation until its move to Station Square in 1983.

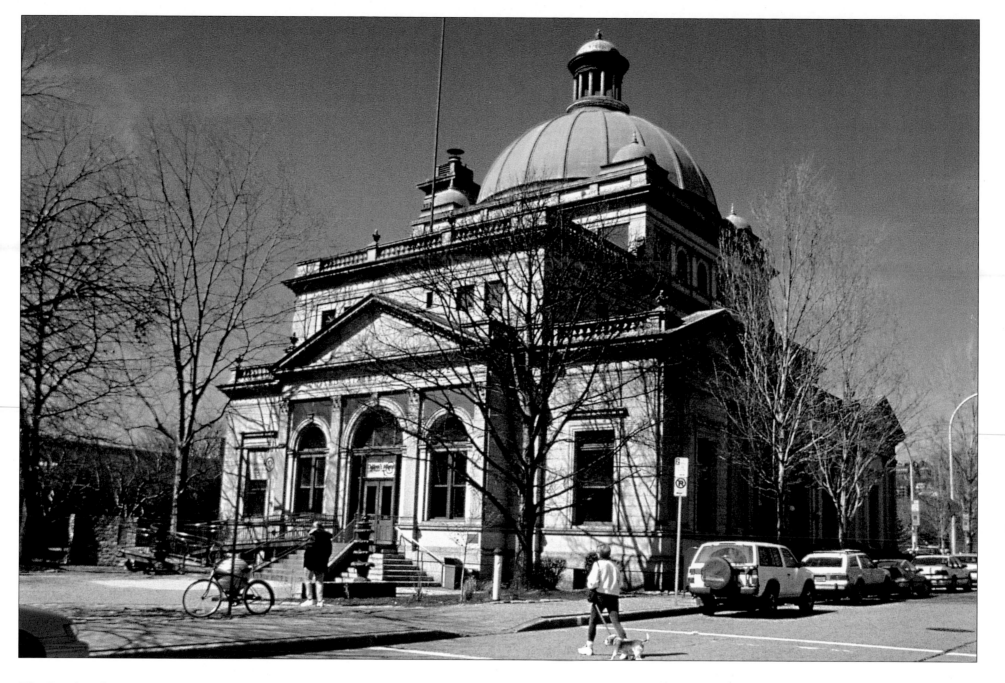

The Pittsburgh History & Landmarks Foundation handed the old post office over to the Pittsburgh Children's Museum as a gift in 1991. (The museum had been housed in the building since 1983.) With annual visitation to the museum now over 110,000, the Pittsburgh Children's Museum is undertaking a major expansion. Koning Eizenberg Architecture of Santa Monica, California, has designed a new building that will link the Children's Museum to the Buhl Planetarium next door. The new complex, to be known as the Pittsburgh Children's Center, will include the expanded museum, the Children's Park, and the Pittsburgh Center for Children, a space for children's organizations to share resources and ideas.

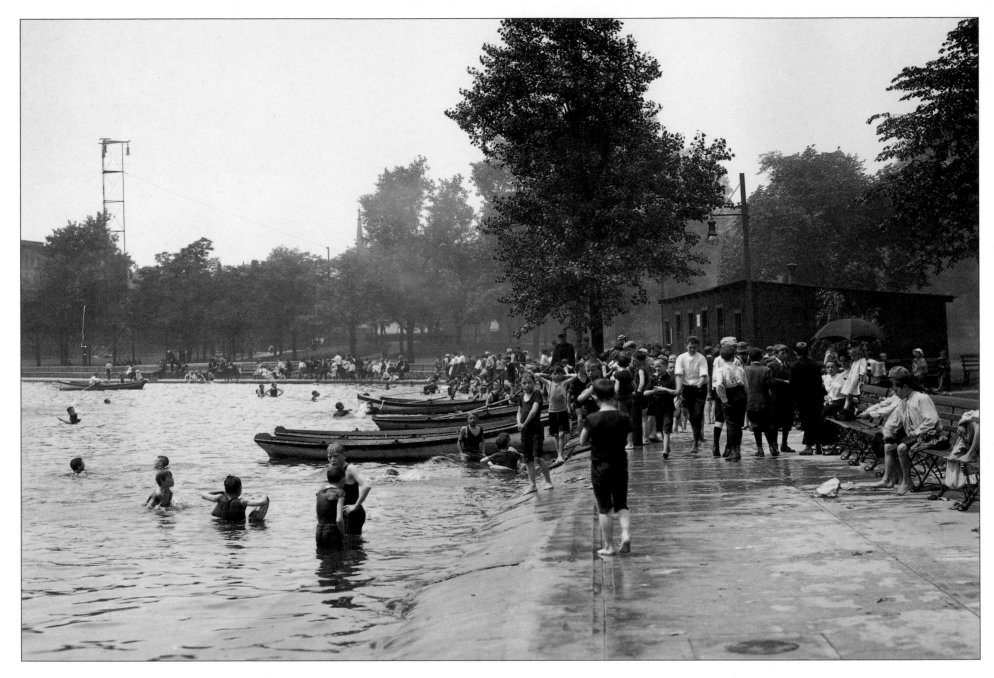

The 1788 plan for Allegheny City called for a town a third of a mile on each side surrounded by grazing commons that were surrounded by "out-lots" for agriculture. In the late 1860s, with the out-lots built up, the city turned the Allegheny Commons into an elaborate mid-Victorian park. The New York firm of Mitchell, Grant & Co. designed the plan for Allegheny Commons, which included lawns, monuments, fountains, tree-lined paths, and ornamental flower beds. West Park, the largest of its areas, eventually received a conservatory, a bandstand, a memorial to the dead of the warship *Maine*, and a romantic pond called Lake Elizabeth, seen here in the mid-1920s.

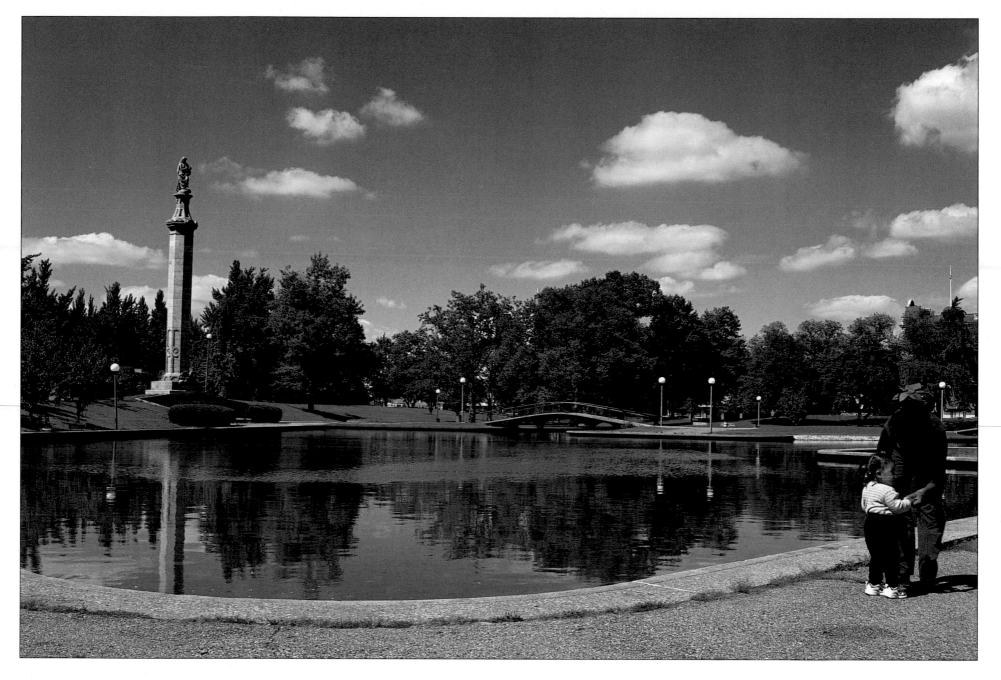

Although no longer a place for swimming, boating, or ice skating, Lake Elizabeth provides solace to many people. The lake was modernized in the 1960s, given a freeform shape and neatly edged. The Soldiers' Monument was designed by Louis Morganroth of Mitchell, Grant & Co. in 1871 with Peter Charles Reniers as sculptor. Originally erected on Monument Hill (further north), the monument was moved to the Allegheny Commons in 1931.

A restoration plan has been prepared for Allegheny Commons by Pressley Associates, Inc. of Cambridge, Massachusetts. If funds can be raised, the boathouse will be rebuilt. The National Aviary is located in the commons, and the historic neighborhoods of Allegheny West, Manchester, Central North Side, the Mexican War Streets, and Deutschtown are within walking distance of the park.

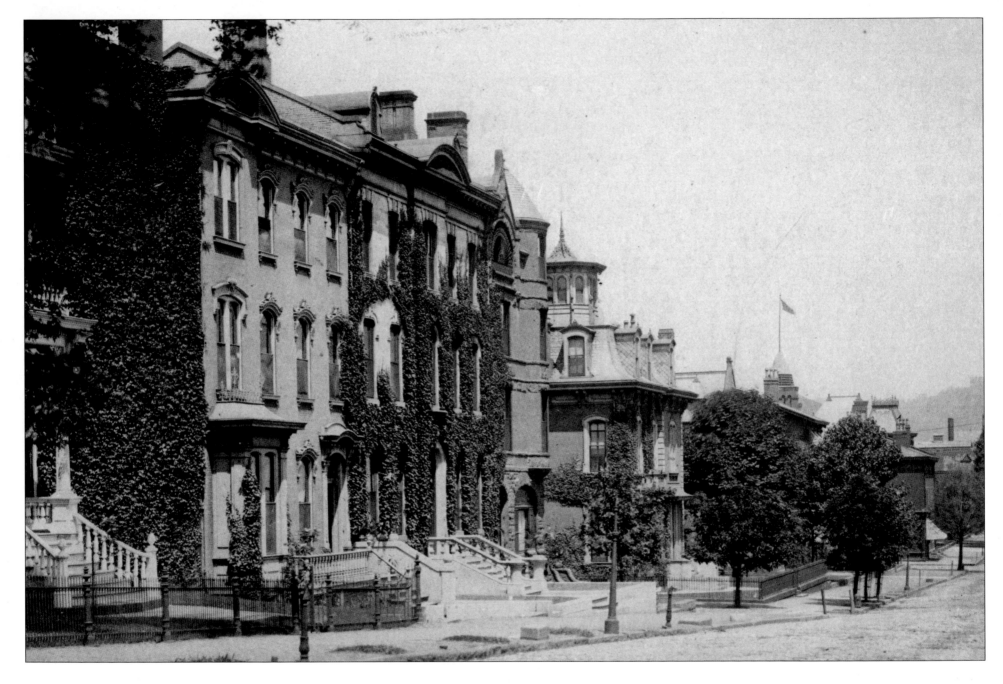

Irwin Avenue, seen here in 1893, was one of the showplaces of Allegheny City, fronting on West Park. It formed the eastern edge of Allegheny West, a neighborhood of solid prosperity, where, for instance, millionaires whose names spoke of iron and steel chose to live: Joneses and Laughlins, Snyders, Byerses, and Olivers. The mansard-roofed house with the cupola, for instance, is that of M. F. Laughlin.

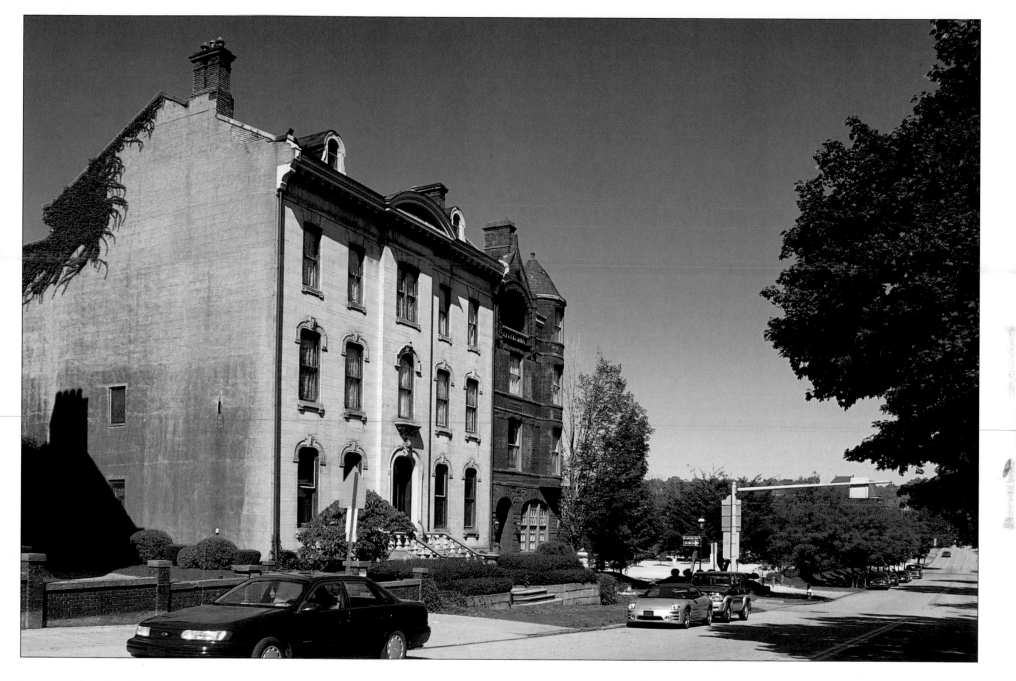

Irwin Avenue has been renamed Brighton Road. Several of its houses were demolished in the late 1950s, however, two have survived: the limestone house of c. 1871 of Letitia Holmes, widow of a pork packer, and the very narrow Romanesque Harry Darlington house of c. 1890. Both houses have been beautifully restored and are located in the Allegheny West City Historic District and National Register Historic District. Thanks to the efforts of many preservationists, Allegheny West has recovered much of its prominence. It has pleasant late-Victorian homes and two outstanding churches: Emmanuel Episcopal, designed by H. H. Richardson in 1886, and Calvary United Methodist, designed in 1895 and famous for its Tiffany windows.

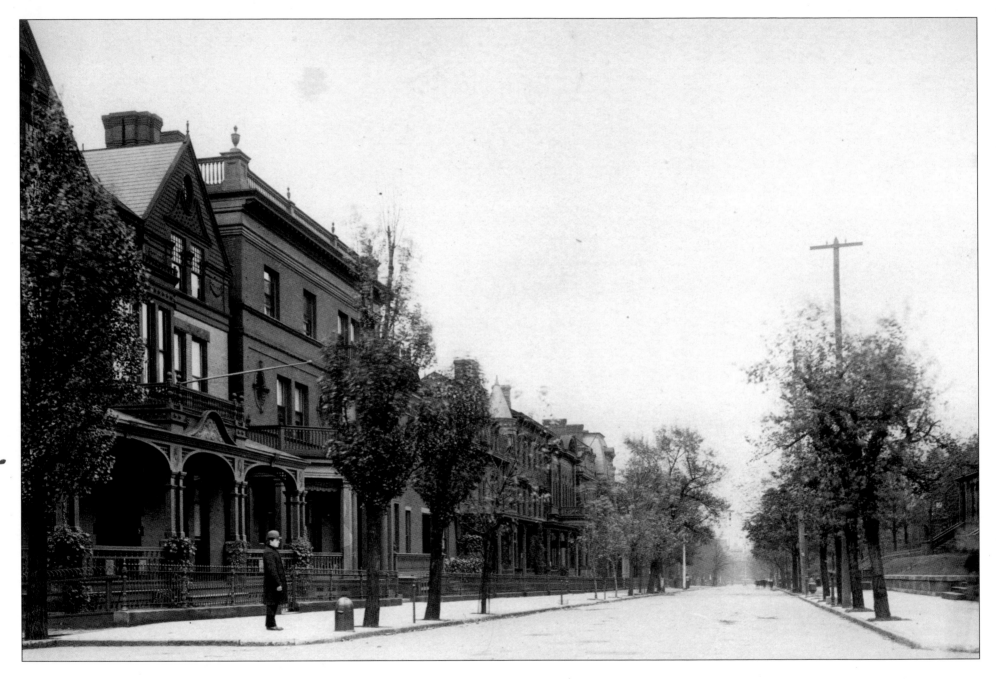

Around the corner on Ridge Avenue the display continued. To the right, in this view of 1899, can be seen the rising ground of Monument Hill, where industrialists such as the Olivers and Scaifes shared rising ground with the Western Theological Seminary, an institution that had been in the neighborhood since 1827. The houses on the left, fairly new, were soon to be replaced by even larger houses and an isolated section of the Western Theological Seminary. In those prezoning days Ridge Avenue millionaires lived not far from the workplaces of the Clark Company, makers of chewing gum; some gas storage tanks of the Equitable Gas Company; the Damascus Bronze Company; and the Pittsburgh Iron Folding Bed Company.

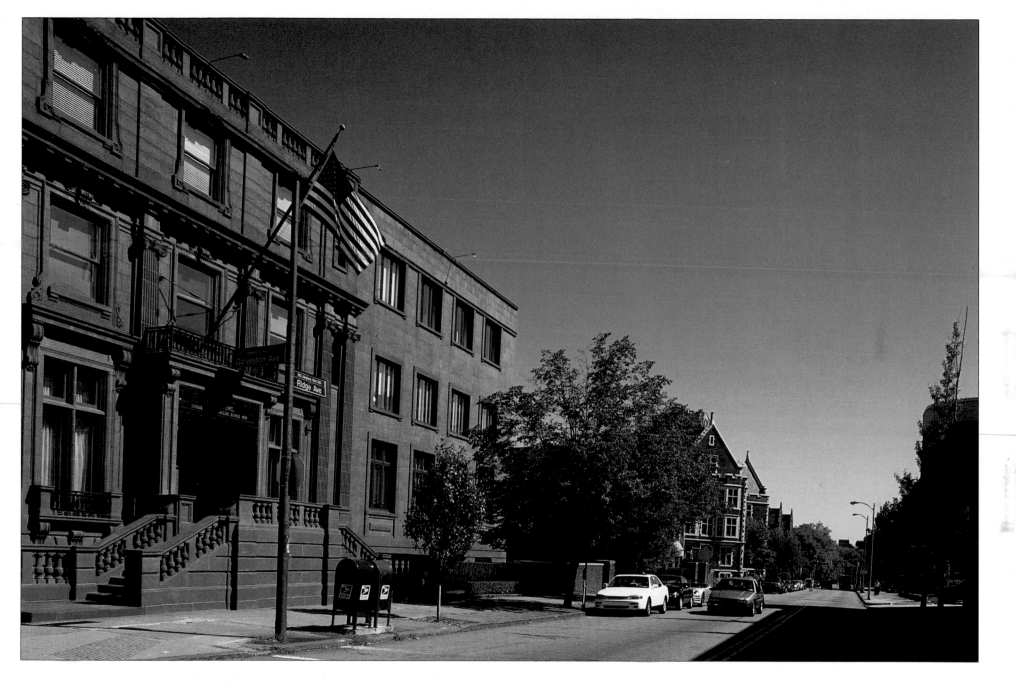

As the twentieth century began, the confidence in Ridge Avenue and its future seemed only to increase. The steelmaker Benjamin Franklin Jones Jr. and the ironmaker William Penn Snyder built within a block of each other. Here, the Snyder house of 1911 dominates the left side of the street. Converted years ago to business, it received the plain annex to the right.

Further down the street is all that remains of the Western Theological Seminary built in white terra cotta and red brick. Beyond that is the great Jones house of 1908, now part of the Community College of Allegheny County. Across the street, beginning in the 1960s, the college was built anew for the most part.

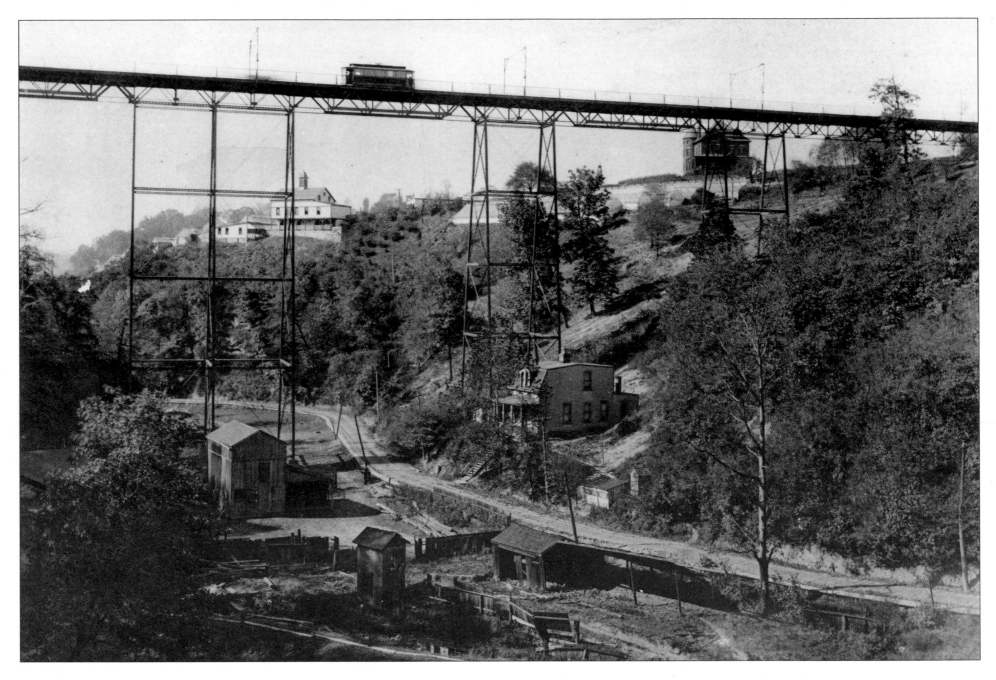

The High Bridge, running between the western edge of Allegheny City and the Ohio River suburb of Bellevue, was already up and carrying trolleys in 1893. This view of 1899 shows what a giddy experience this manner of leaving town could offer. The Ohio River towns, at river level, had benefited from commuter rail traffic as early as 1851, but development on the rising ground depended on the trolley.

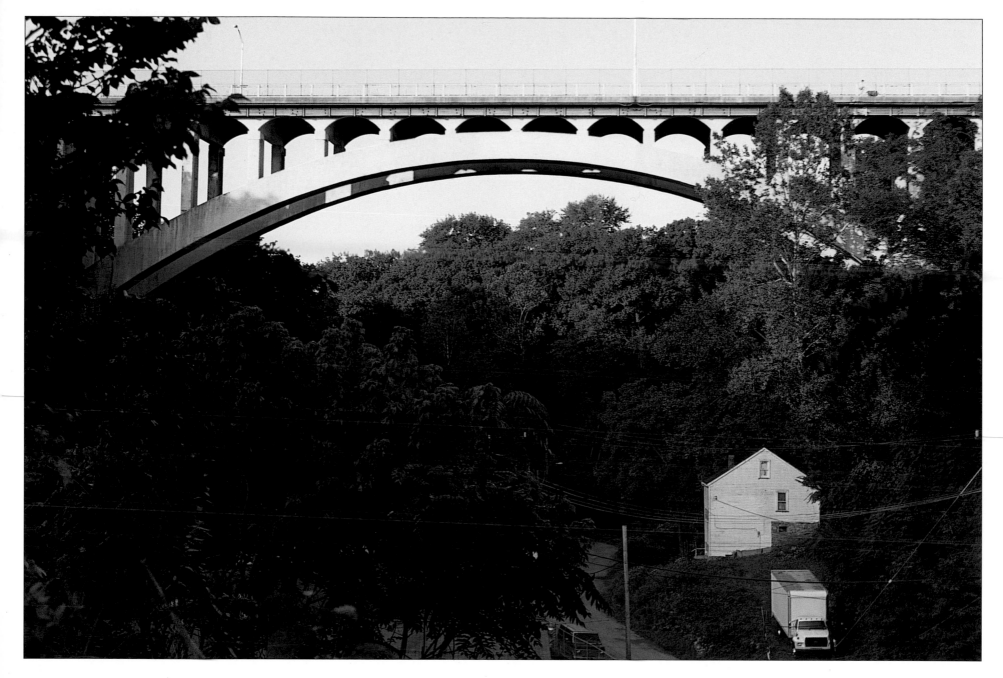

A highway bridge built in the 1920s now carries California Avenue in Pittsburgh to join Lincoln Avenue in Bellevue. At one time it carried the trolleys as well, which went on to a loop in Emsworth, six miles down the Ohio River. The new bridge reflected a change in technology and design attitudes. It was built of reinforced concrete, a glamour material of the early twentieth century, and it showed a new interest in making bridges objects of beauty.

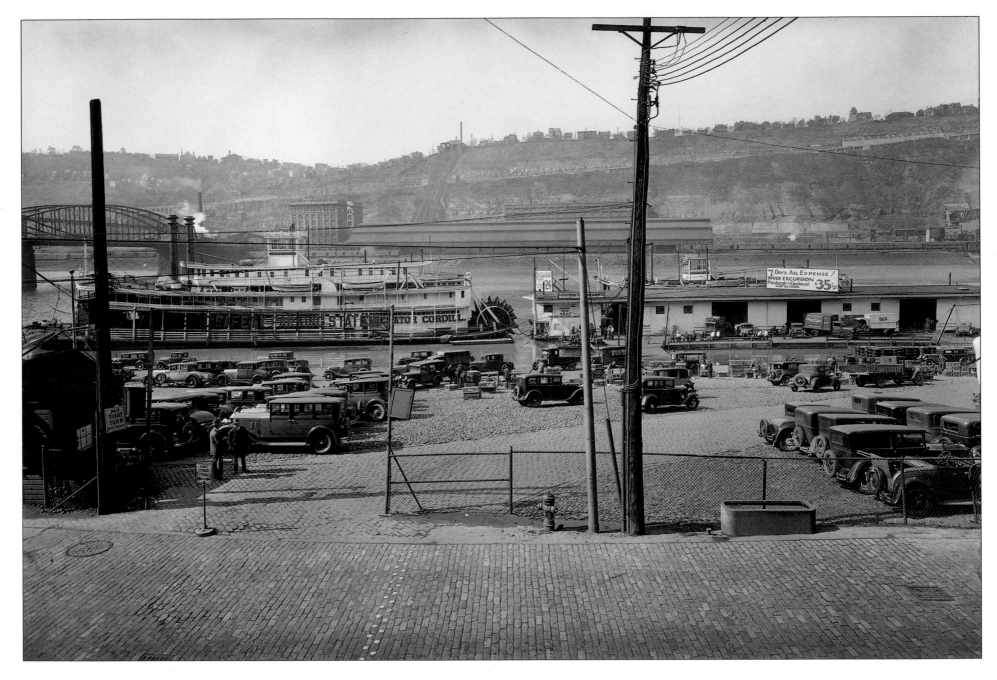

Mount Washington is remembered as the vantage point, 400 feet above the Monongahela River, from which the Virginia major of that name spied out the strategic possibilities of the forks of the Ohio River. Here is a view of Mount Washington in 1932 from the Monongahela Wharf, which is seen as half transshipment place, half parking lot. The passenger boat *Senator Cordill* and the very low excursion fare advertised on the wharfboat give a period flavor to the scene. Across the river close to the water are the station building and trainshed of the Pittsburgh & Lake Erie Railroad. The new Mount Washington Roadway, opened in the late 1920s, rises up the hillside.

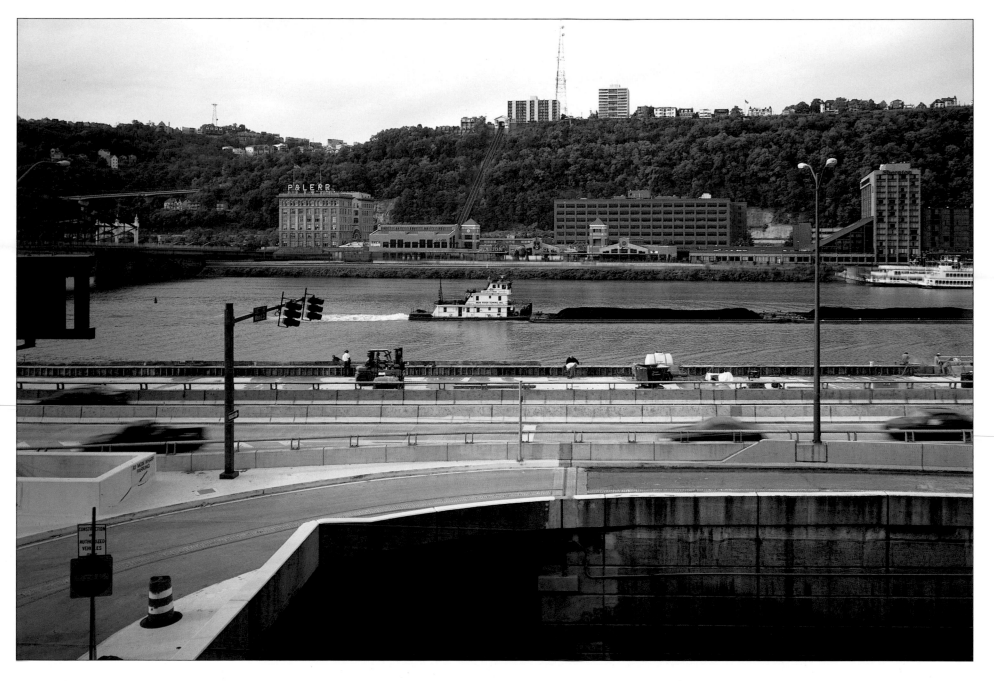

The Pittsburgh & Lake Erie Railroad ceased most passenger operations in the 1960s, and indeed its freight operations at the Pittsburgh station were in a sharp decline by then. A terminal-sized railroad station was thus approaching uselessness, though the main line that passed it remained busy. The Pittsburgh History & Landmarks Foundation proposed adaptation of most of the surviving railroad structures for new commercial purposes, was

given its opportunity, and in 1976 became tenants—and later proprietors—of a fifty-two-acre restaurant, retail, and office site that has prospered under the name of Station Square. Now privately owned, new buildings and public spaces have been added in front of the redbrick Commerce Court, and an expanded dock is to extend beyond the Gateway Clipper Fleet.

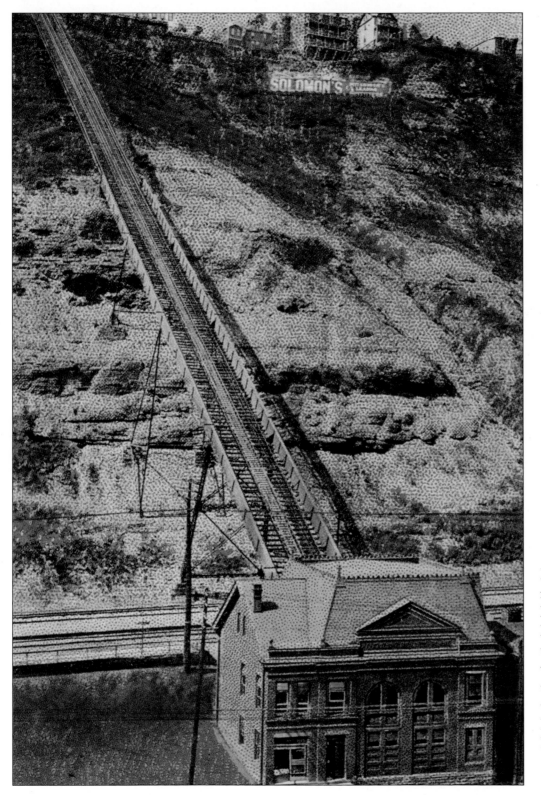

Inclined planes were already in use in the Pittsburgh area in the mid-nineteenth century, but the earliest ones carried coal down from Mount Washington. In 1870 the Monongahela Incline, also on Mount Washington, initiated local passenger service and in 1877 the Duquesne Incline, shown here, began operations a mile to the west. Other inclines soon followed, and at one time there were nearly twenty inclines in and near Pittsburgh, but one by one they yielded to the automobile and now only two are left: the Monongahela and the Duquesne. Both began steam-powered but converted to electricity long ago.

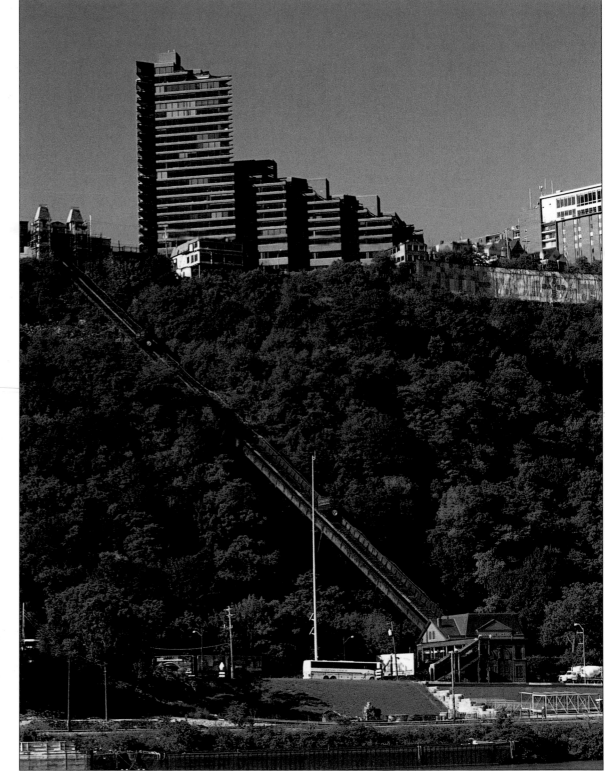

Today the Duquesne Incline looks very much as it did a hundred years ago, though the upper station has been remodeled. All else has changed. Apartments, remodeled houses, and restaurants have altered the Mount Washington skyline in places, though some older buildings remain. The Trimont condominium building now dominates the scene. The hillside vegetation has benefited from the smoke clearance and has flourished. The Indian Trail, a crazy staggering succession of steps and boardwalks that once made the 400-foot climb, has long disappeared and so have most of the unlovely patches of industry and housing once everywhere along the shore.

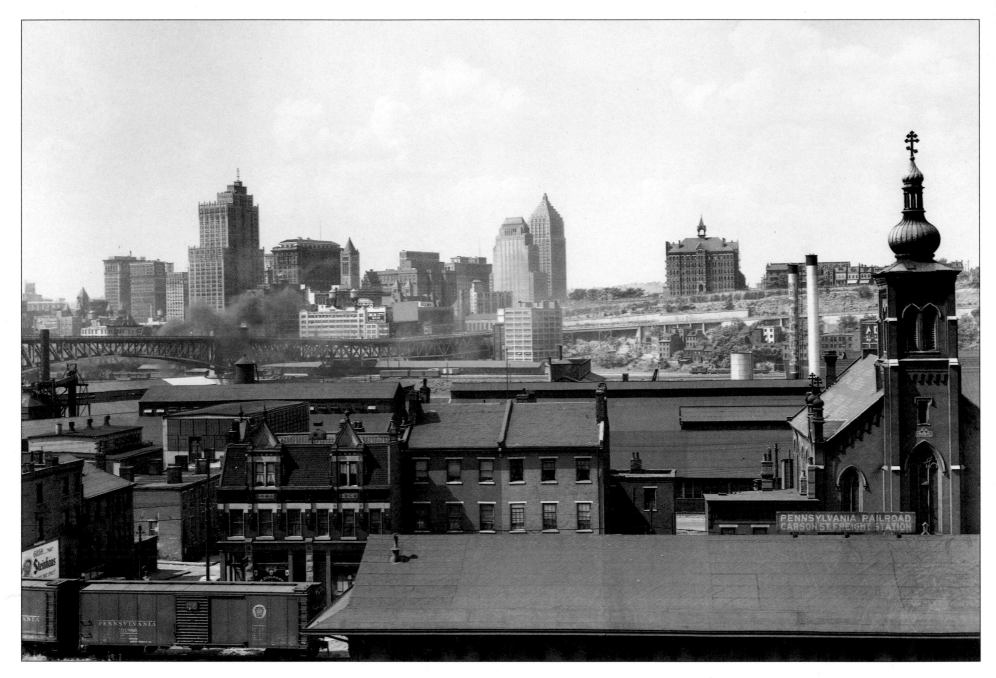

The view looking north toward South Sixth and East Carson streets, with St. John's Greek Catholic Church prominent on the right. The smokestacks mark the A. M. Byers Company, makers of wrought-iron pipe. In the center, across the Monongahela River, is Duquesne University's Administration Building, sitting on top of the Bluff, whose bare side offers a geological history of Pittsburgh. At this time, in July 1938, the Gulf Building was still the tallest in town. The tall building left of center is the Grant Building, with its many pinnacles and neon beacon that flashes P-I-T-T-S-B-U-R-G-H in Morse code. To its right, the Frick Building and the courthouse tower are just visible in the smoggy air.

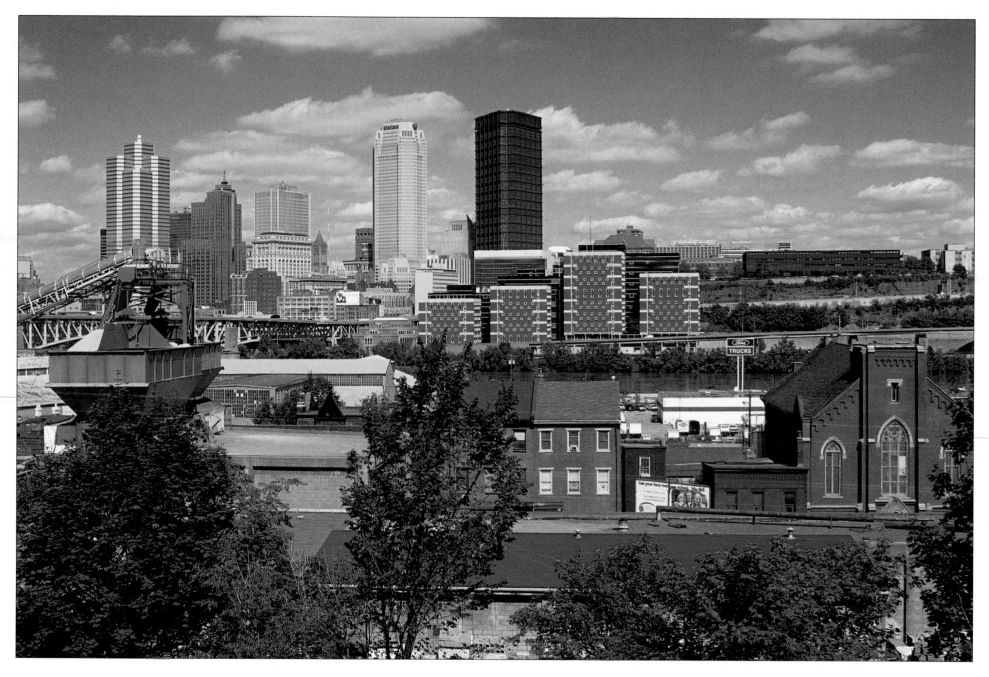

Some fifty years later the downtown skyline is quite different, though the courthouse tower remains visible among the many taller constructions around it. The red-and-white building complex along the river is the new Allegheny County Jail, more spacious than that which H. H. Richardson designed and extremely conspicuous. To the right is Duquesne University, with the low horizontal box of Mellon Hall, designed by Mies van der Rohe in 1962. On the South Side, St. John's Church has lost its steeple, and its vividly colored neighbor down the street is a building supplies plant.

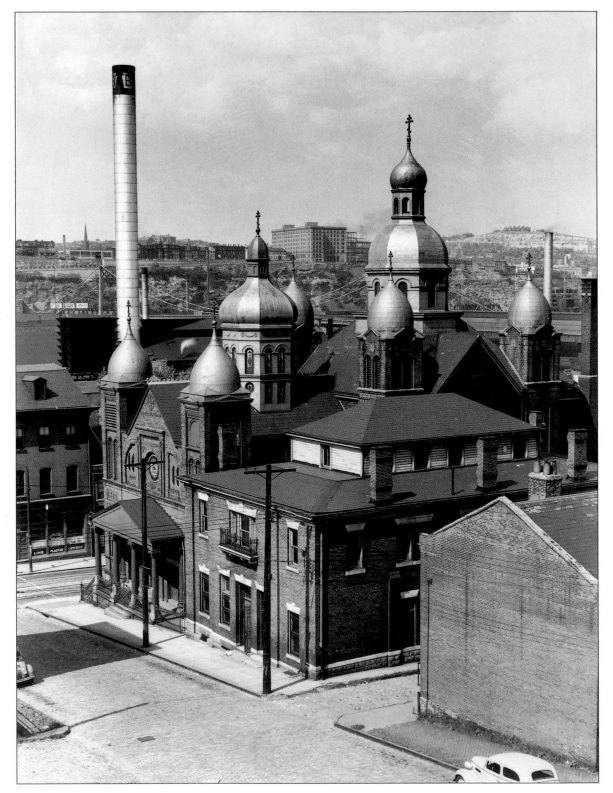

A half-block up Carson Street at South Seventh is St. John the Baptist Ukrainian Catholic Church, built in 1897 but expanded in 1917. The Eastern European presence in Pittsburgh and the industrial areas of the county is manifest in such domes. Founded in 1891, St. John the Baptist Ukrainian Catholic Church is the mother church of all Eastern Rite Catholic churches in Western Pennsylvania. At this time in 1938 its neighbors are partly domestic, but partly industrial too: a small freight yard across Seventh Street and the A. M. Byers Company across Carson. Across the Monongahela River, beyond the domes, is Mercy Hospital, founded in 1847.

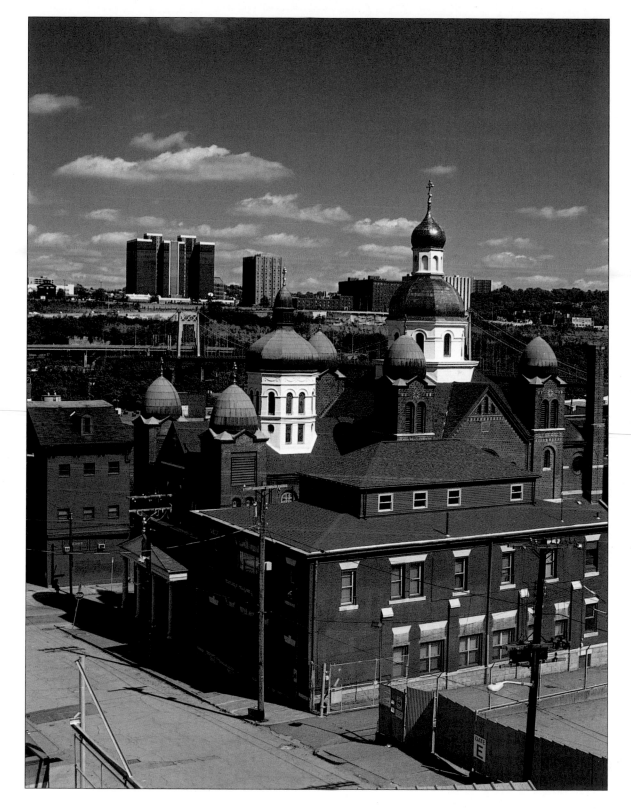

St. John's, with its eight Eastern-looking domes, is used in pictures sometimes to symbolize the polyethnic character of the South Side, or of Pittsburgh as a whole. The area's first settlers were of English, Scottish, Irish, and German descent, but the expansion of industry in the latter half of the nineteenth century drew upon people from all of Europe, especially Slavs and Magyars, to man the plants. The parishioners of St. John's still make pierogi in the church basement and sell them to Pittsburgh businesses, taverns, and families. The Tenth Street Bridge of 1931, the city's only conventional suspension bridge, is visible in both photographs.

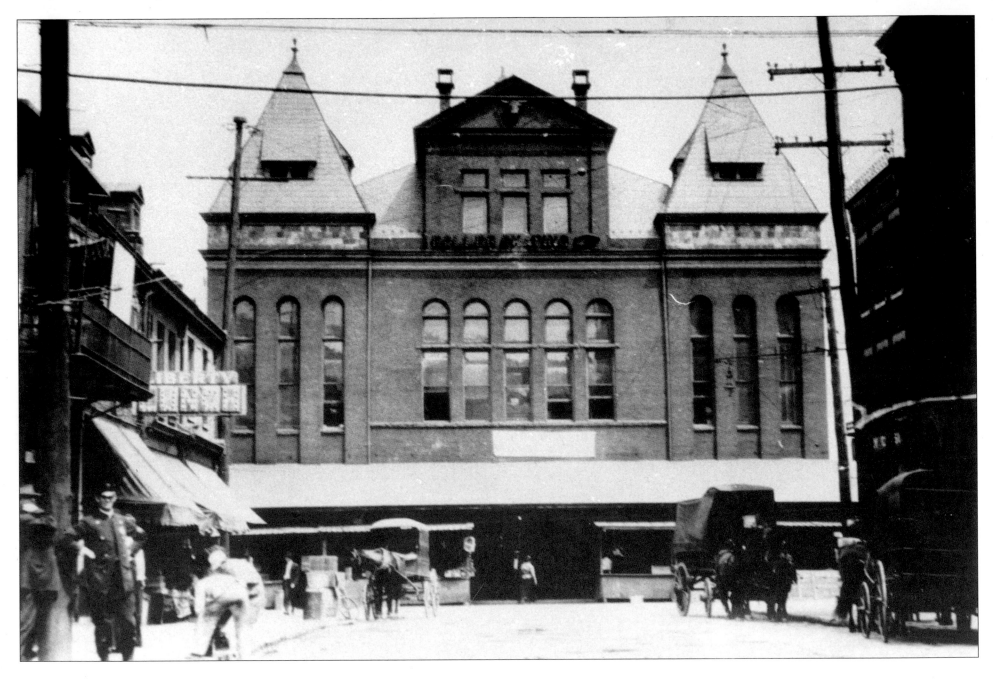

In 1811, Nathaniel Bedford laid out a little town called Birmingham, which extended between what are now South Sixth and South Seventeenth streets. (His relatives in the Ormsby family extended the development further east: first to South Twenty-seventh Street as East Birmingham, then even further eastward as Ormsby.) On South Twelfth Street, Bedford put a marketplace, Bedford Square. In 1891 the market house shown here was constructed in this square—a more or less Romanesque work by the modestly talented Charles Bickel.

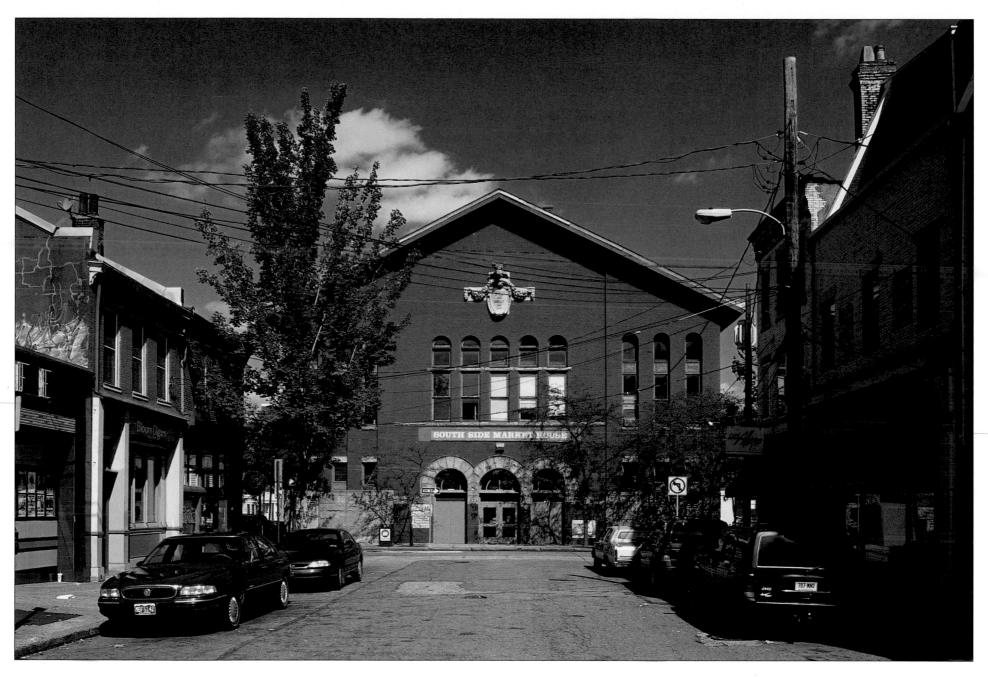

In 1915 the market house was simplified and classicized after a fire, with a handsome cartouche as a central decorative feature. The architect was probably Stanley Roush, who had treated the Corliss Street Tunnel portal in a similar way two years before. The market house is now a community center.

Some of the commerce in and near this little square gives an idea of its mixed character today: blue-collar in much of its commerce and housing, even though the industry has left.

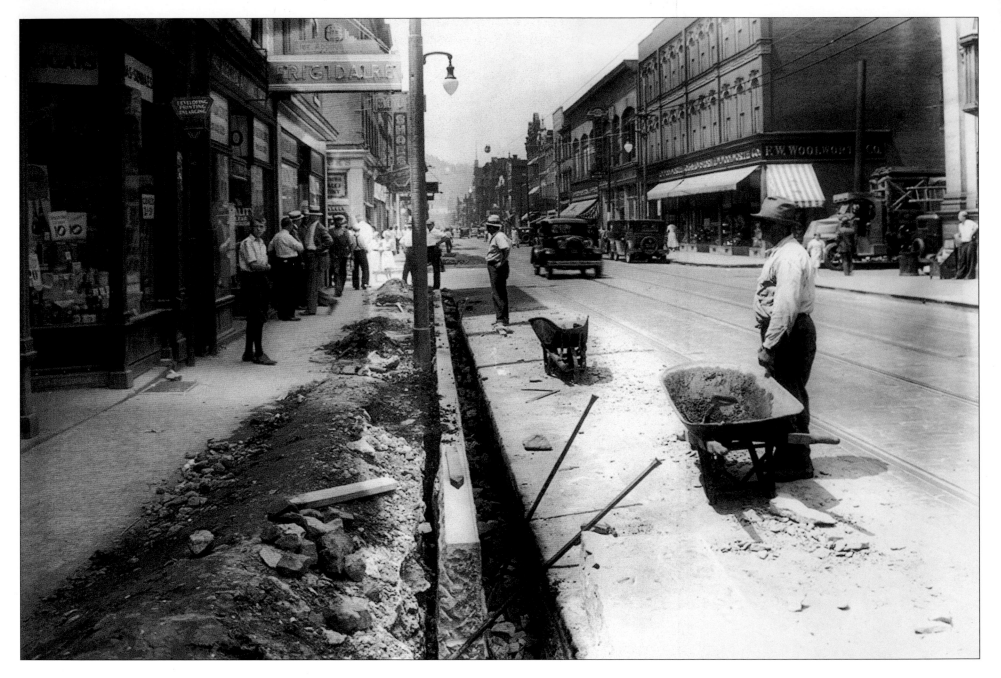

The sidewalk in Carson Street, pictured in 1935. Carson was the main thoroughfare of the South Side Flats, and not much interrupts the Victorian brick and iron facades, though the pale granite front of the German Savings and Deposit Bank at the far right edge is an exception. This photograph was taken by the city photographer to show the progress of a public-works project: hence the men posed by their wheelbarrows and the ditch next to the curb.

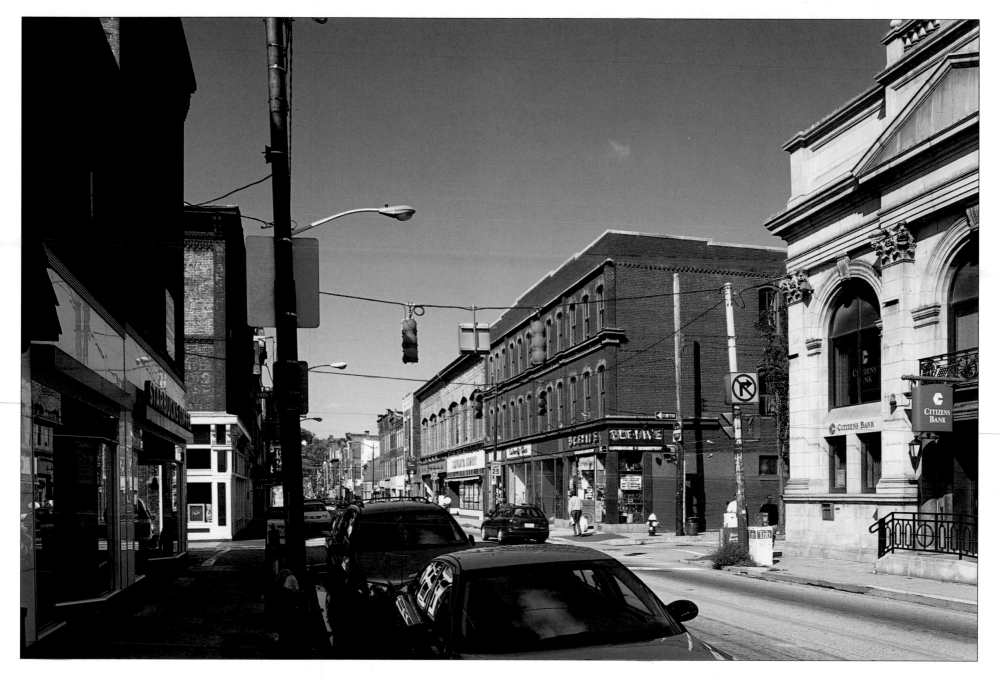

The present-day view is surprisingly similar. This is primarily due to the successful efforts of neighborhood organizations that value historic preservation strategies, an award-winning Main Street program, and the area's designation as a City Historic District. The side streets lead past little houses and churches, northward to riverside industrial land mainly deserted or now built up with houses of a quasi-traditional sort beside the still-busy railroad, or southward past more little houses and churches to an inland railroad line, with the South Side Slopes above.

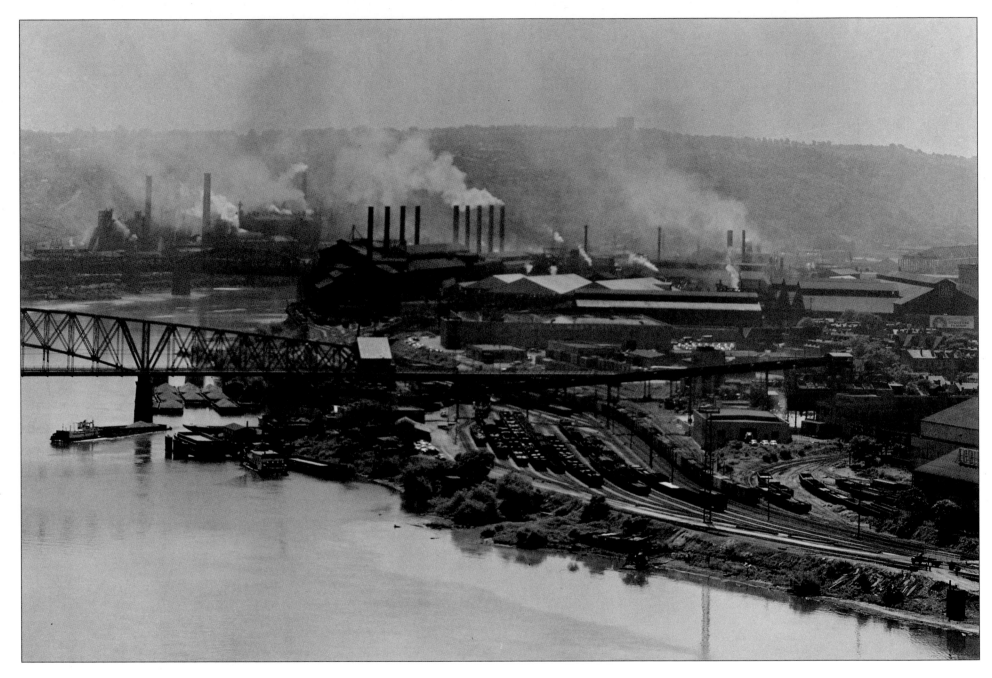

The Jones & Laughlin Pittsburgh Works (J&L) was a persistent visual presence in the city between the years 1850 and 2000. The Eliza Furnaces, built in 1859, were among the first in the immediate Pittsburgh area to succeed in smelting iron, and the South Side Plant across the Monongahela River began converting this into wrought iron at the beginning, and after 1886 into steel: by the Bessemer, open-hearth, and electric processes as the years went on. Here the South Side Plant appears on the right of the picture, with the Eliza Furnaces across the river to the rear. Two stern-wheel towboats under the Brady Street Bridge of 1896 indicate that this is an early twentieth-century photograph.

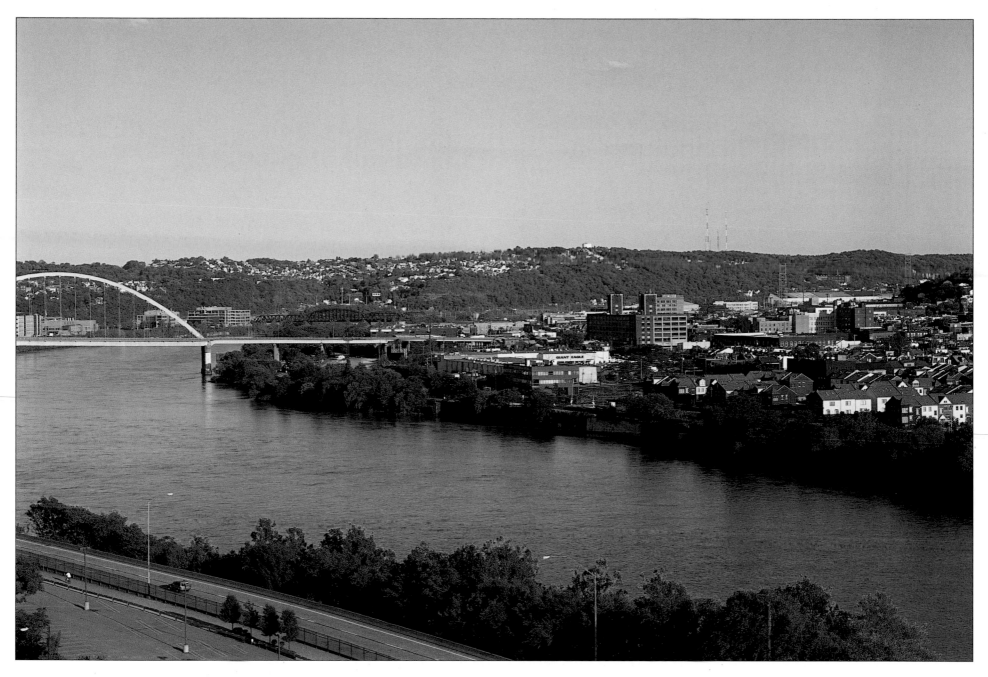

The same view has been totally altered except for the contours of the land and the course of the river. The Birmingham Bridge of 1978 has replaced the Brady Street Bridge. J&L's Pittsburgh Works substantially closed down in 1987 save for the Hazelwood Coke Plant. The steel mill was demolished in the early 1990s, the site was cleaned under the Pennsylvania Land Recycling Program, and new construction began in 1998. South Side Works, a mixed-use, 123-acre riverfront development, is emerging: notable buildings include the headquarters for the International Brotherhood of Electrical Workers, the McGowan Center for Artificial Organ Development, the UPMC Sports Performance Center, and an indoor practice field for the Pittsburgh Steelers and University of Pittsburgh Panthers. New housing is in the right foreground.

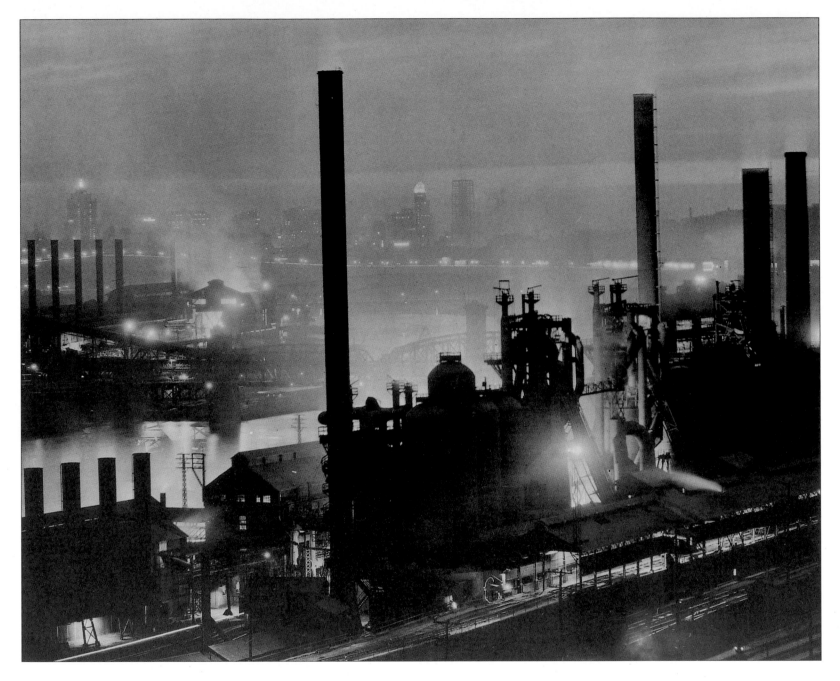

This striking view of J&L, looking down on the Eliza Furnaces from Greenfield, dates from 1931: note the Gulf Building being framed up downtown. Silhouetted against the Monongahela River is the Hot Metal Bridge. In 1928, the six Eliza Furnaces were sending across 4,300 tons of hot metal a day, confident that the Bessemer converters and open-hearth furnaces of the South Side Plant stood ready to receive it. Ladle cars crossed over the Hot Metal Bridge, and its single track was lined with heavy steel, for a spill of molten iron into the river would have had dramatic results. Rolling mills and other shops for processing the steel lay on both sides of the river.

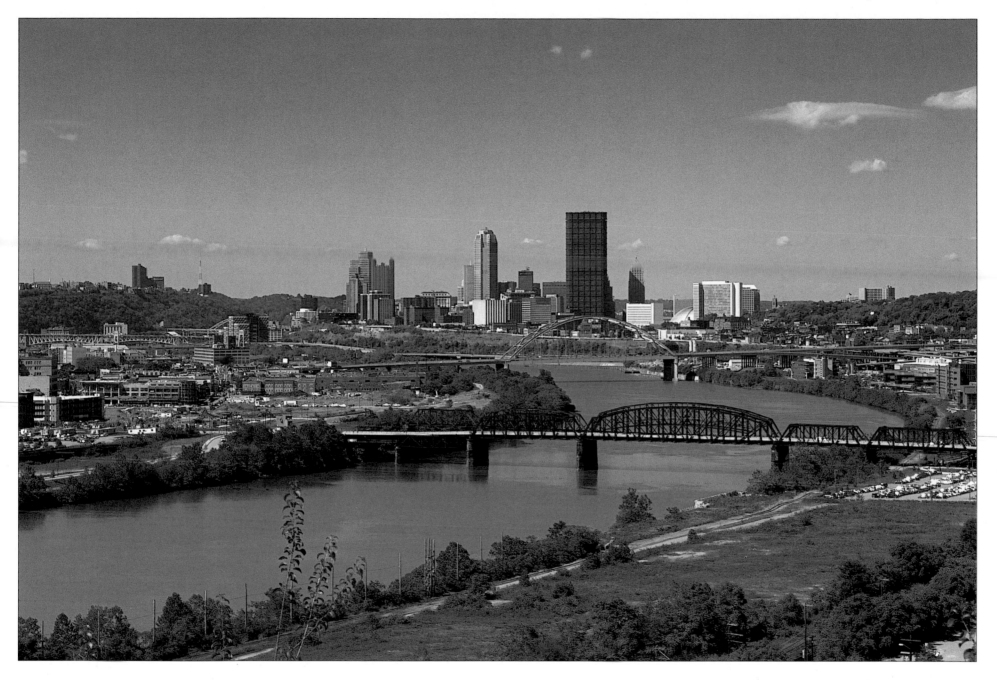

The Eliza Furnaces were blown out in 1979. Talk of their historic preservation led to nothing, and they were toppled in 1983. Like the South Side Plant property, this site is being redeveloped. The Pittsburgh Technology Center is a display of large-scale modern architecture as conceived at the turn of the twenty-first century. Major structures include the University of Pittsburgh's Center for Biotechnology and Bioengineering, the Carnegie Mellon University Research Institute, and Union Switch and Signal. The Hot Metal Bridge is to be renovated for pedestrians and cyclists, and an adjacent bridge has been renovated for automobiles. In the distance is downtown Pittsburgh, and the Gulf Building is now almost dwarfed by the U.S. Steel Tower.

This view of around 1900 shows some of J&L's 1,200 beehive coke ovens upriver from the Eliza Furnaces toward Hazelwood. Coke-making was hot, heavy work that used batteries of little brick ovens whose stored-up heat would ignite fresh charges of coal, letting them smolder in a very restricted air supply until purged of undesirable chemicals. Once the ovens were opened, sulfur dioxide and other volatiles would escape into the air. The coke, on fire from contact with open air, would be quenched and hauled away for blast-furnace fuel. Between 1919 and 1926, J&L phased out its beehive ovens, replacing them with by-product ovens that reclaimed the volatiles and converted them into more or less useful commodities.

Now the Hazelwood Coke Plant is gone entirely. At the beginning of the twenty-first century one could still see the 800-foot plumes of steam that rose from its quench towers, making coke for shipping elsewhere in the latter days. But no longer. In 2002, the 178-acre site was purchased by a nonprofit partnership of Pittsburgh foundations and a regional development authority. The foundations have joined together in this unusual effort to set a national standard for brownfield development. The mixed-use project will take advantage of the riverfront land by creating parkland and recreational trails.

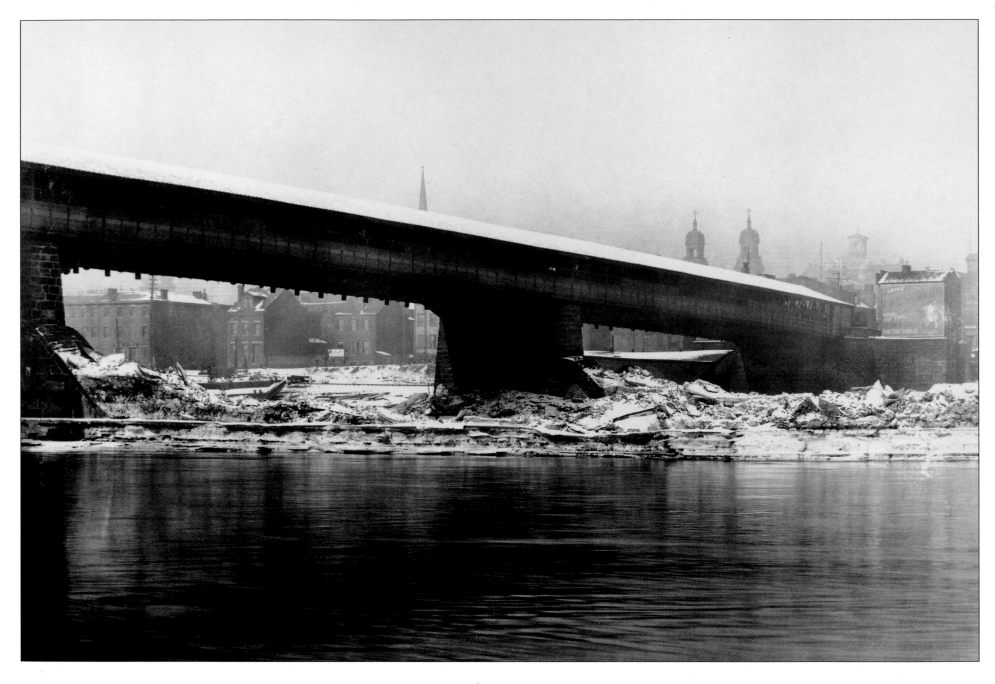

A view of the land between the Allegheny and Monongahela Rivers, the widening area of many neighborhoods east of the Triangle. In the foreground is the former Sixteenth Street Bridge that connected Chestnut Street in the Deutschtown part of the North Side with the Strip, across the Allegheny River. First built in 1837, it burned and was rebuilt in 1851. Then it was partly washed away and rebuilt in 1865 but burned for good in 1918. The Strip district—a long, narrow area of river plain below Herron Hill—is in the distance. It was an intensely active, extremely smoky industrial quarter, with a promiscuous blend of furnaces, industrial sheds, railroad buildings, houses, and churches; the towers of St. Patrick's are visible here.

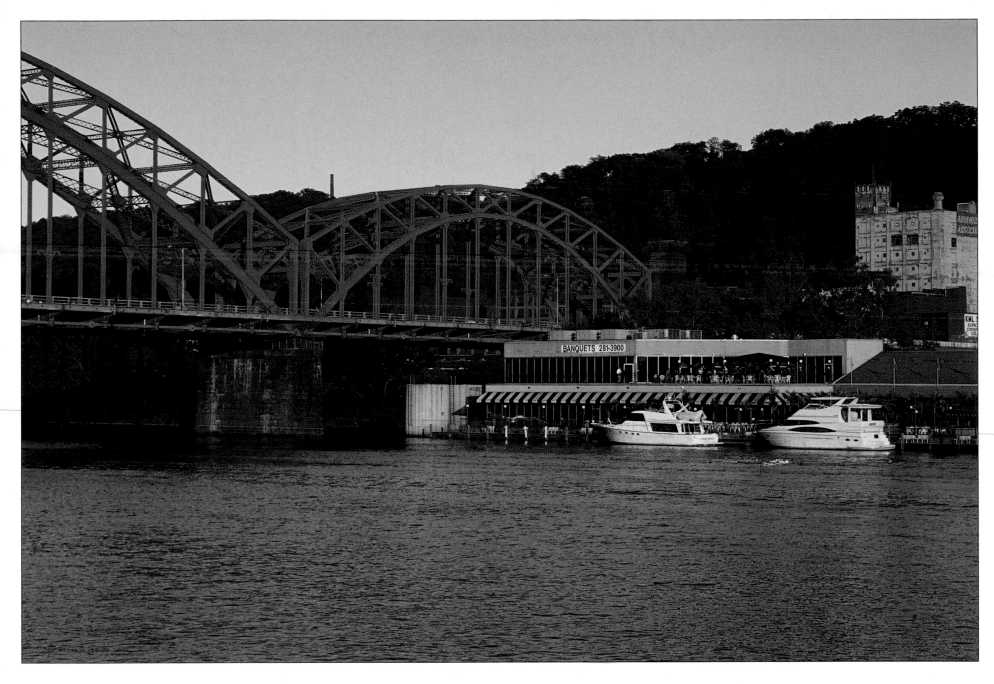

In 1923 a new Sixteenth Street Bridge was constructed and was intended this time as a work of architecture. Its three heavily trussed spans bridged a void of little more than 800 feet, but created a grand effect, made all the grander by symbolic stone abutments designed by Warren & Wetmore, architects of Grand Central Station in New York, topped by armillary spheres and leaping sea horses in bronze by Leo Lentelli. Repainted in 2003, the bridge leads to the Strip district—now famous for its pleasingly haphazard mix of warehouses and wholesalers, produce markets, stores, restaurants, and nightclubs. Two nonprofit organizations occupy renovated buildings in the Strip: the Historical Society of Western Pennsylvania and its Senator John Heinz Pittsburgh Regional History Center, and the Society for Contemporary Craft.

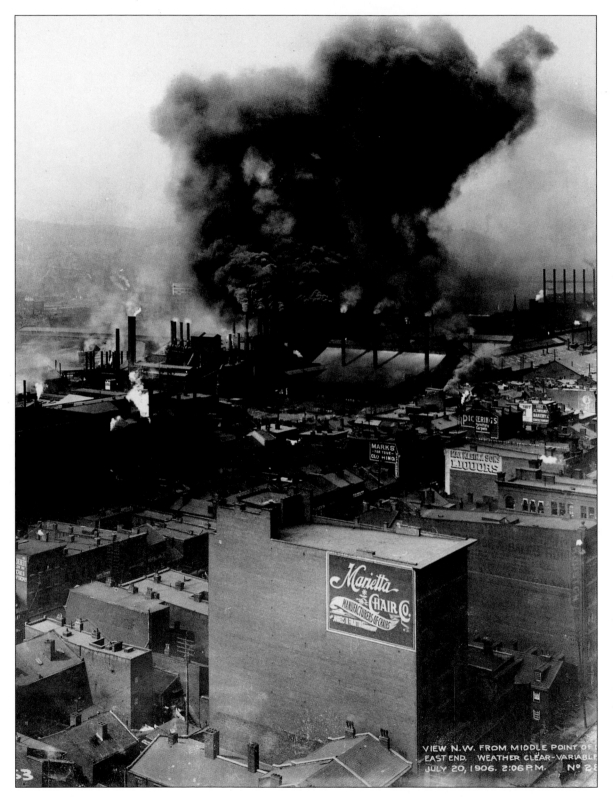

VIEW N.W. FROM MIDDLE POINT OF
EAST END. WEATHER CLEAR-VARIABLE
JULY 20, 1906. 2:06 P.M. N° 2

A classic image of the Smoky City is this 1906 view, looking north from the roof of Union Station over the Strip district to the Shoenberger Works of the American Steel and Wire Company. The Bessemer Department and Open Hearth Mill, both steelmaking facilities, seem to be putting up most of the smoke. Pittsburgh was not to get an effective smoke ordinance until 1947. The Sixteenth Street Bridge is just beyond the plant, hardly visible through the murk.

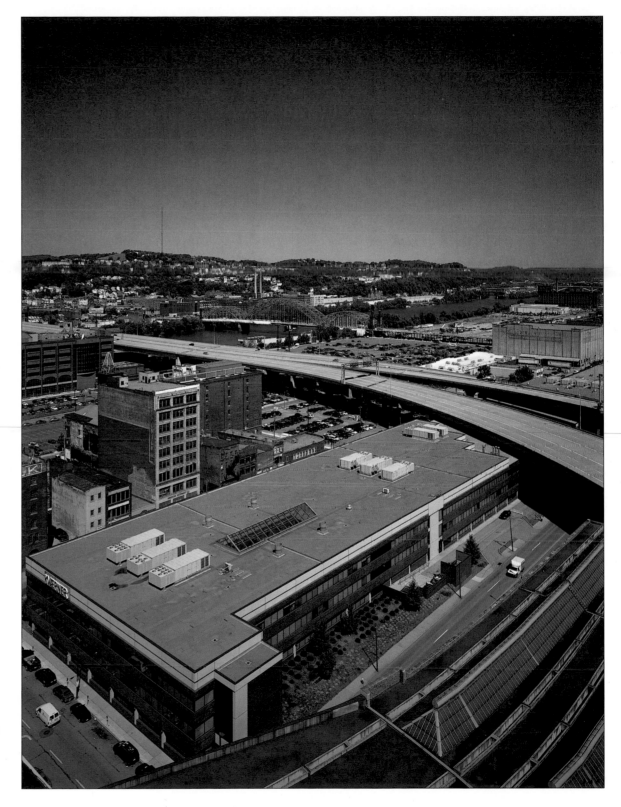

A new bridge, the Veterans' Bridge of 1987, crosses the middle distance, just to the right of the new Seagate Technology Building. The three steel arches of the present Sixteenth Street Bridge cross the Allegheny River beyond. The twin stacks that rise behind it belong to the sprawling H. J. Heinz Company Plant, which has been there since the 1890s. The Shoenberger Works and all the little Strip houses have disappeared, yielding to the car. Kvaerner Metals is located in the renovated warehouse in the foreground.

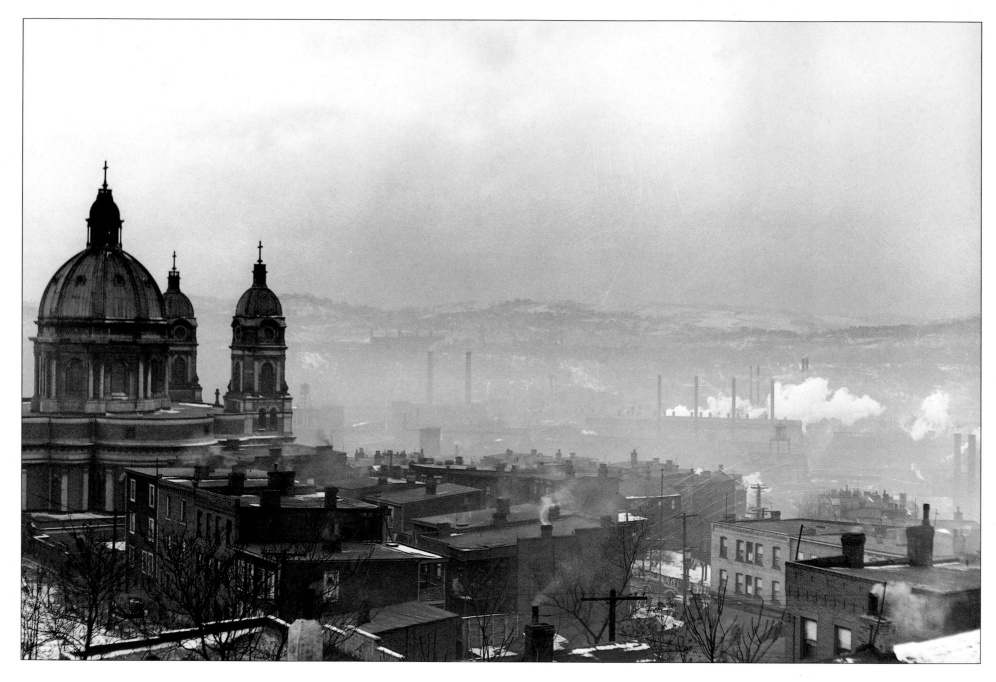

Polish Hill, first settled around 1885, occupies a curious place between the Strip down by the Allegheny River and the Hill, the neighborhood that rises eastward from the Triangle. An early sign of the permanence of this workers' neighborhood is the Church of the Immaculate Heart of Mary, shown here in 1941, three decades after its construction in 1906. The chimneys are probably on Herr's Island, which was occupied early in the century by the Pittsburgh Melting Company, the Allegheny Garbage Company, and a stockyard and slaughterhouse.

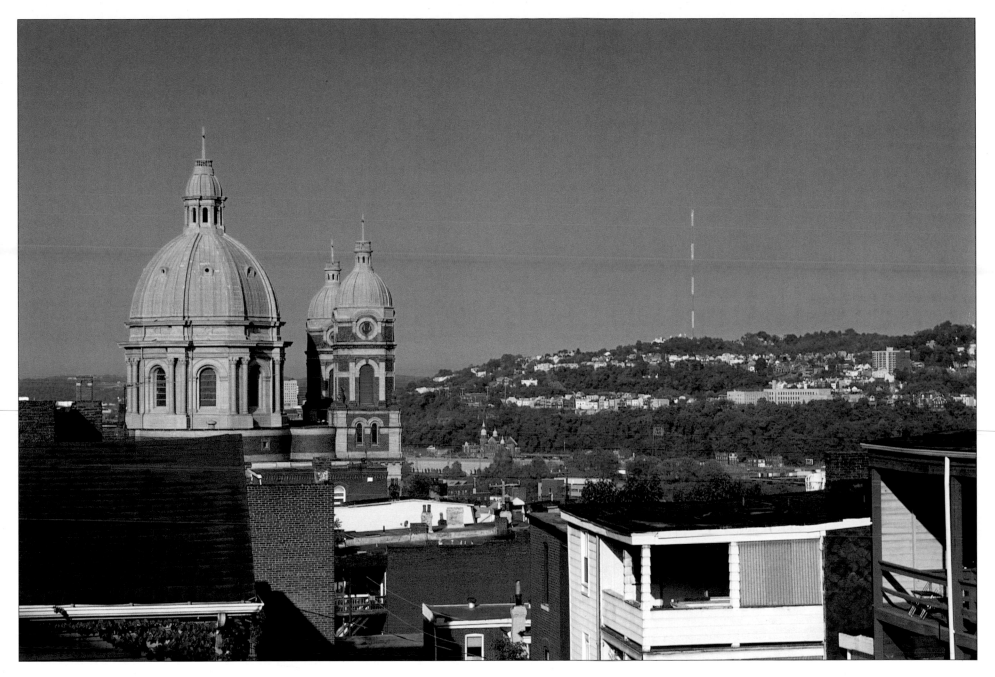

Polish Hill is a neighborhood without many changes, and it is really the background that has altered. Herr's Island these days is Washington's Landing (George Washington crossed the Allegheny River near here on December 29, 1753, and as a matter of fact fell in) and is without its former chimneys, bellows, and smells. Across the river can be seen the domes of St. Nicholas Church of 1901, built for the oldest Croatian Catholic parish in the Western Hemisphere and the center of a lively historic community known as Mala Jaska. Above the church domes, halfway to the horizon, is the predominantly German neighborhood of Troy Hill.

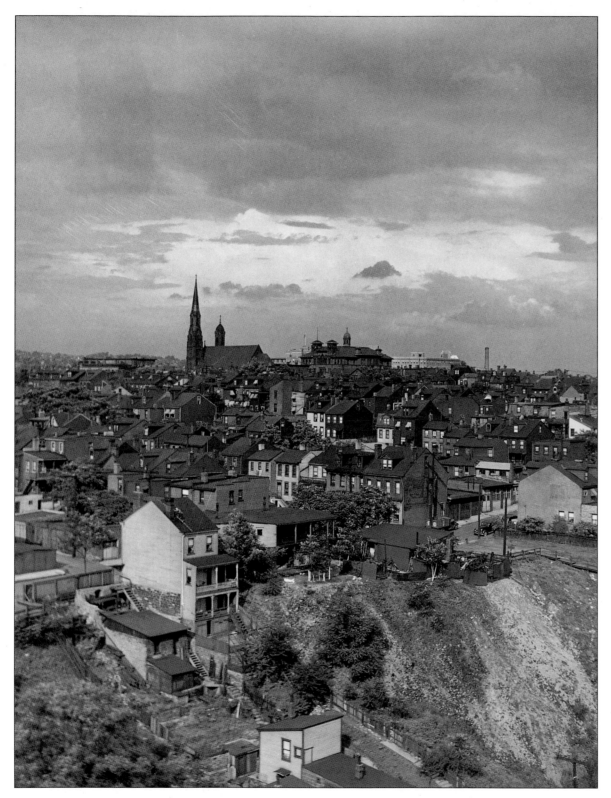

A view from the Bloomfield Bridge to the neighborhood of Bloomfield and particularly toward St. Joseph's Church on Liberty Avenue, with its school. This is a neighborhood of little frame houses on little lots, lacking the bourgeois amplitude of Friendship or East Liberty, both to the east. It gains distinction, though, from some institutions on Penn Avenue at its northwest corner: Allegheny and St. Mary's Cemeteries.

Bloomfield, Pittsburgh's own "Little Italy," has much of its old basic texture, though white aluminum and asphalt siding have replaced the old painted wooden siding in its various shades. St. Joseph's Church has lost its spire and its school. On the horizon is the Garfield Elevated Tank, with a million and a half gallons of municipal water. Over to the far right is a building of West Penn Hospital, one of the two hospitals at the edge of Bloomfield.

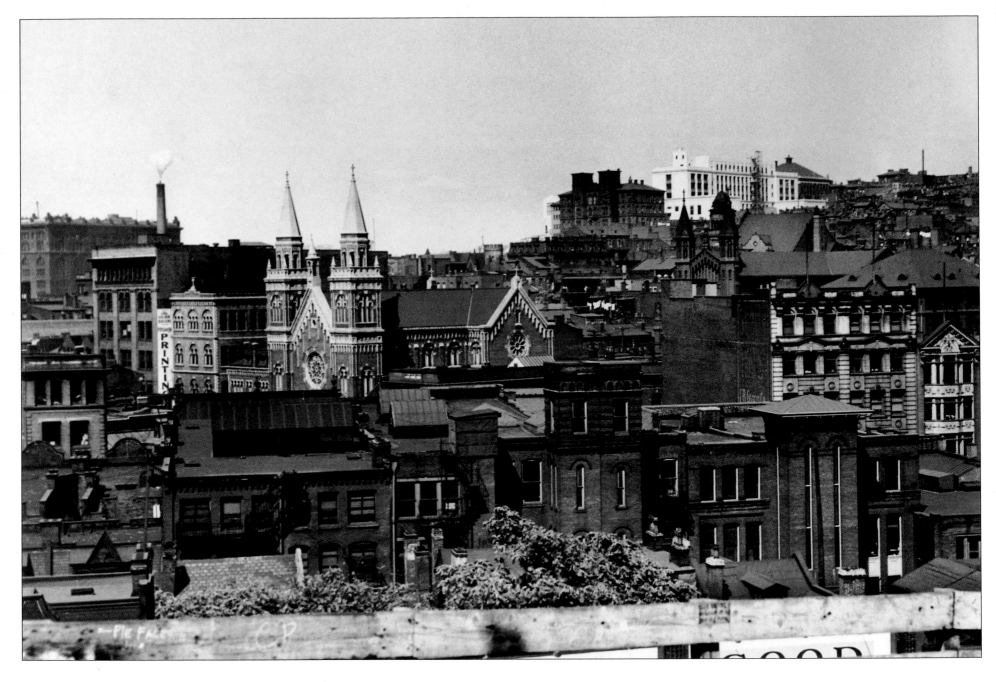

The land that rises from the Triangle inland from both the Allegheny and Monongahela Rivers is known as the Hill: a sprawling area that has housed little colonies of ethnic groups. Its prominence has tempted civic leaders to visions of a cultural acropolis. Here is the Lower Hill around 1930. Union Station appears on the skyline to the back left, and on the skyline to the right are the old Central High School in its last days and the new Connelley Trade School. St. Peter's Roman Catholic Church, built in 1918, dominates the scene, and the twin towers of the Church of the Epiphany, built in 1902, are higher on the Hill to the right.

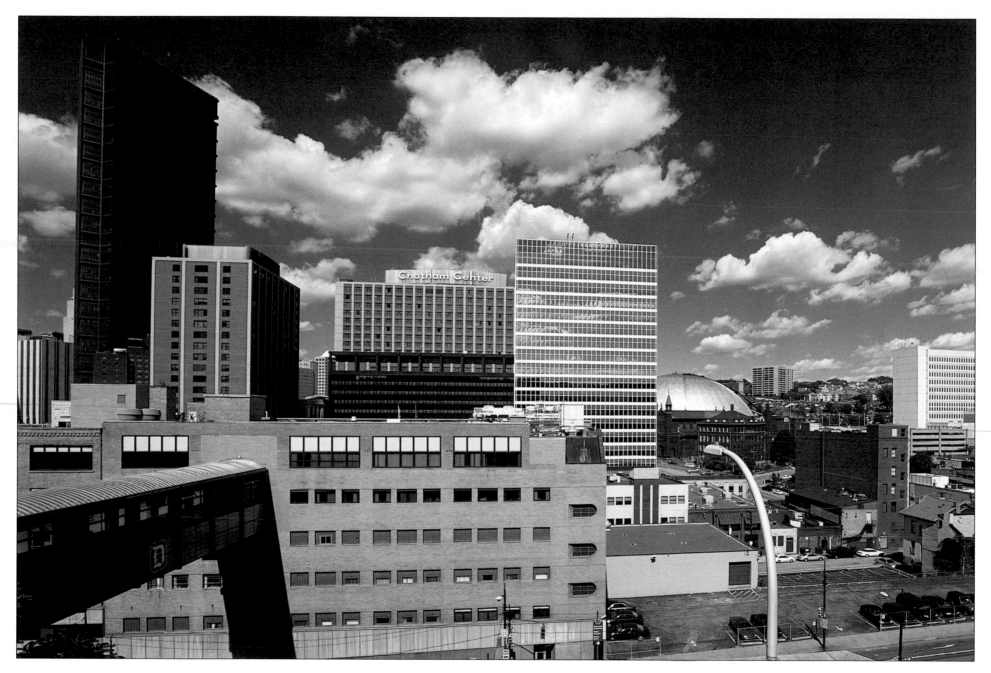

Clearances of the Lower Hill for urban renewal began in 1956, but the red Italian Romanesque Church of the Epiphany is still distinguishable at the center of the picture beneath the swelling metallic dome of the Mellon Arena. Opened in 1961, the Civic Arena, as it was called for years, had been intended for light opera "beneath the stars" but actually has been used as the home of the Penguins, Pittsburgh's professional hockey team. To its left are buildings of Chatham Center, a residential/office development. This photograph was taken from the Bluff, an eminence over the Monongahela River and the location of Duquesne University, which overlooks the uptown area of the Triangle.

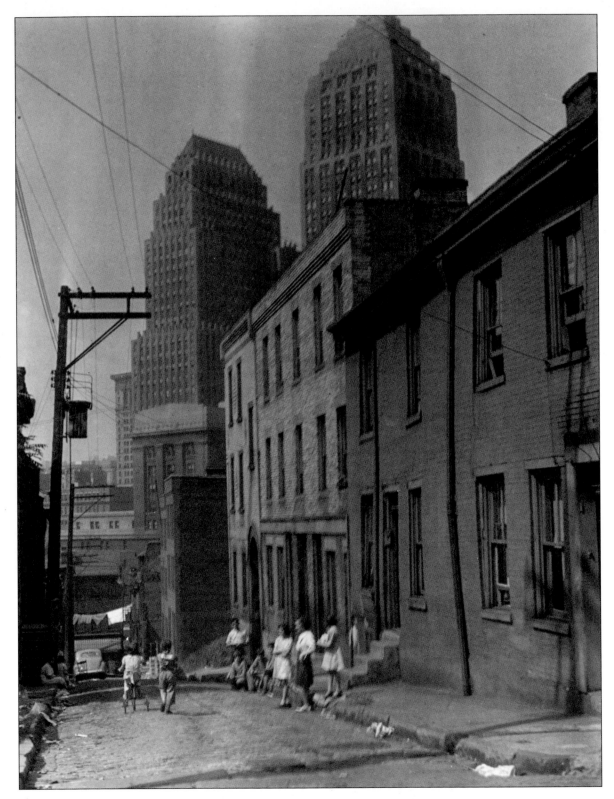

Bustrick Way was situated as if to point up the contrast between the glamorous new architecture of Grant Street and the humble streets of the Lower Hill. A 1930s theater set could hardly do better, especially on some evening when the architectural lighting of the Koppers Building, to the left, played over its tall, hipped roof: proud, aloof, bourgeois architecture and the humble abodes of the people. The Hill became a place of many cultures and many levels of prosperity. In the twentieth century, the Jewish populations moved away, and the Hill became home primarily to Pittsburgh's African American community.

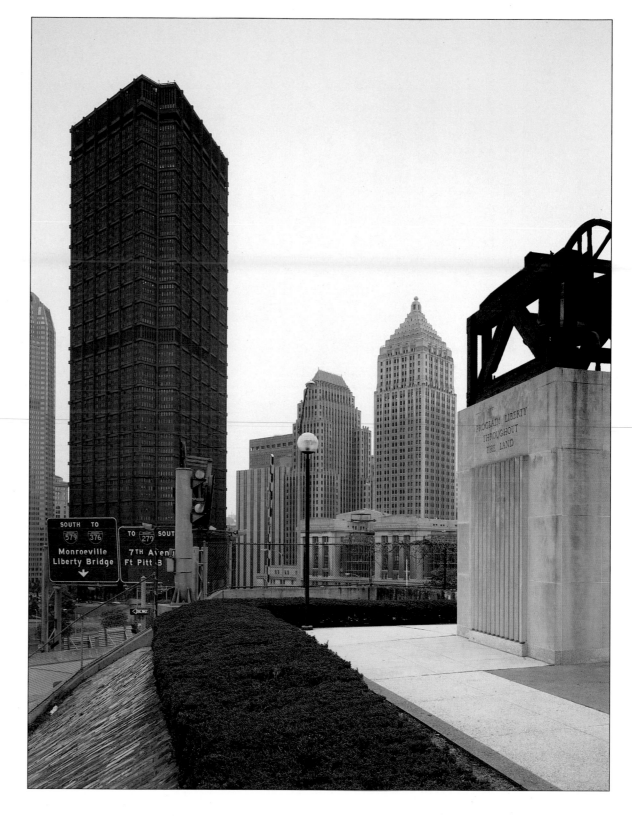

Beginning in 1956 the Lower Hill was almost totally cleared of its homes and stores and most of its religious buildings: a measure whose justice is still in dispute and that did not lead to the acropolis of centralized culture housed in modern architecture that the civic leaders had anticipated. Bustrick Way was obliterated and even its precise location is now inaccessible. This view is from further back, on Flag Plaza in front of the Boy Scout headquarters.

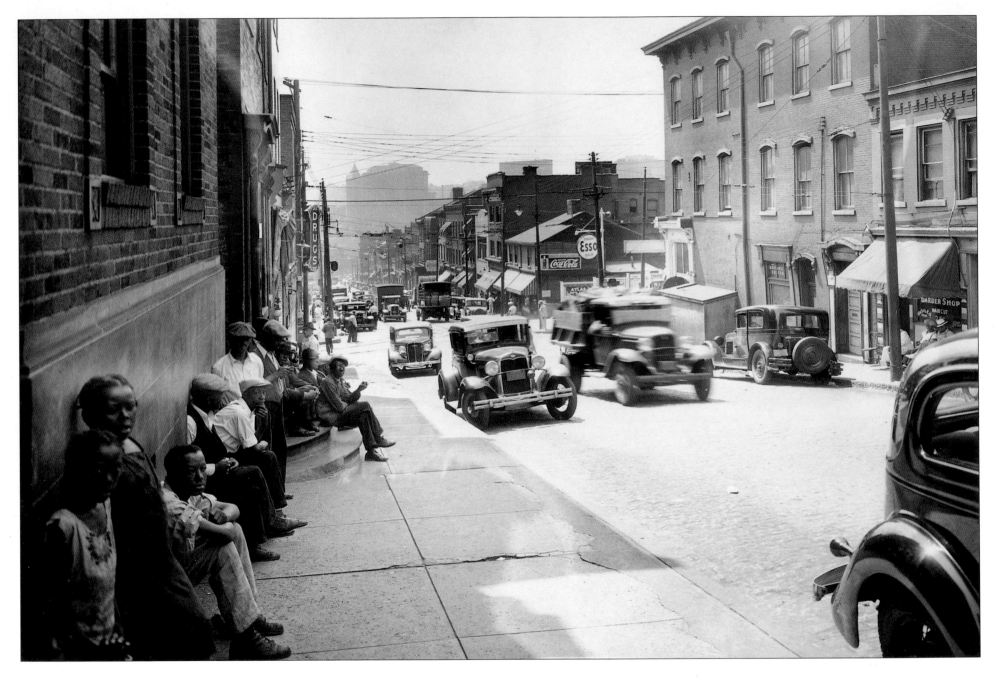

Wylie Avenue is one of the main streets of the Hill, and this view southwest from the 1500 block shows it in 1935. The Hill was the city's major African American neighborhood in the 1930s, but housed only 41 percent of the city's African American residents. The streets filled with cars suggest a modest prosperity, and a nostalgic video, *Wylie Avenue Days*, produced by QED Communications, Inc., in 1991, suggests that life before urban renewal was acceptable for most, despite reports of blighted conditions on the Hill. The 1936 Pittsburgh Crawfords, a baseball team that emerged from integrated neighborhood clubs in the Hill, boasted five eventual Hall of Famers—Satchel Paige, Josh Gibson, "Cool Papa" Bell, Oscar Charleston, and Judy Johnson.

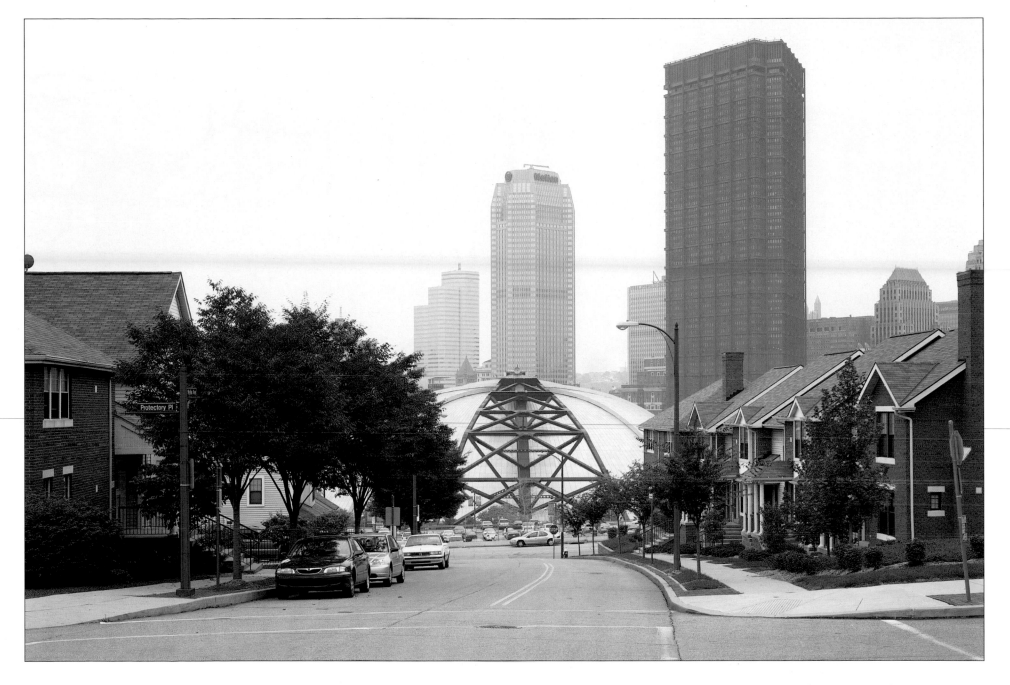

The modern residential architecture of Crawford Square now faces Wylie Avenue, and the street's axis bears down on a dramatic object: the great arm from which the Mellon Arena dome is hung. The idea of a theater for light opera "under the stars" led to this scheme of a dome of several gores, most of them movable so that the dome could open like a fan to reveal the Pittsburgh skyline. In practice, it became prohibitively costly to open the dome with any regularity. The tip of the courthouse tower is visible beyond Mellon Arena, and the skyscrapers of the Golden Triangle are visible beyond that.

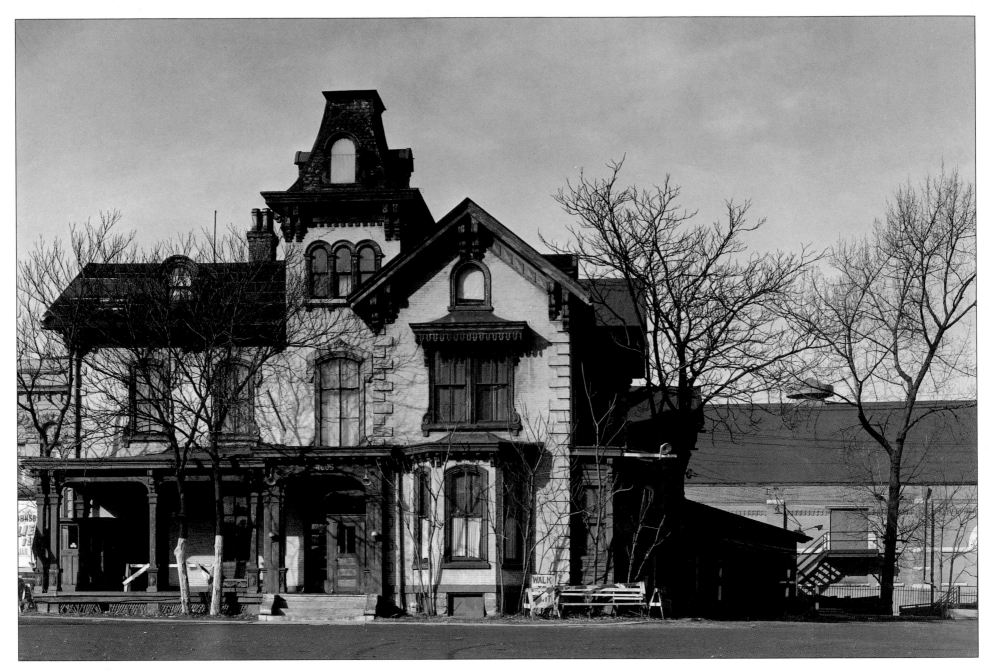

Isaac Hobbs was a Philadelphia architect who around 1870 found the Pittsburgh area a good source of commissions. His best-known and still-surviving work is the Dollar Bank downtown, a vigorous Classical work in brownstone, but most Pittsburghers came to him for houses such as the Carrier-Schmertz house, which once stood at Fifth Avenue and Craig Street. Behind the house is the old streetcar barn on Craig Street that had been converted around 1900 into the Duquesne Gardens, a popular sports arena.

Duquesne Gardens came down in 1956, and the Carrier-Schmertz house as well, for the University Square Apartments. There had long been a trend toward apartment-house construction in this eastern part of Oakland, since not long after 1900. When apartment houses came to Pittsburgh around 1900, Pittsburghers were not to be parted from their porches, and so as homes were stacked up in apartment houses, so were their porches.

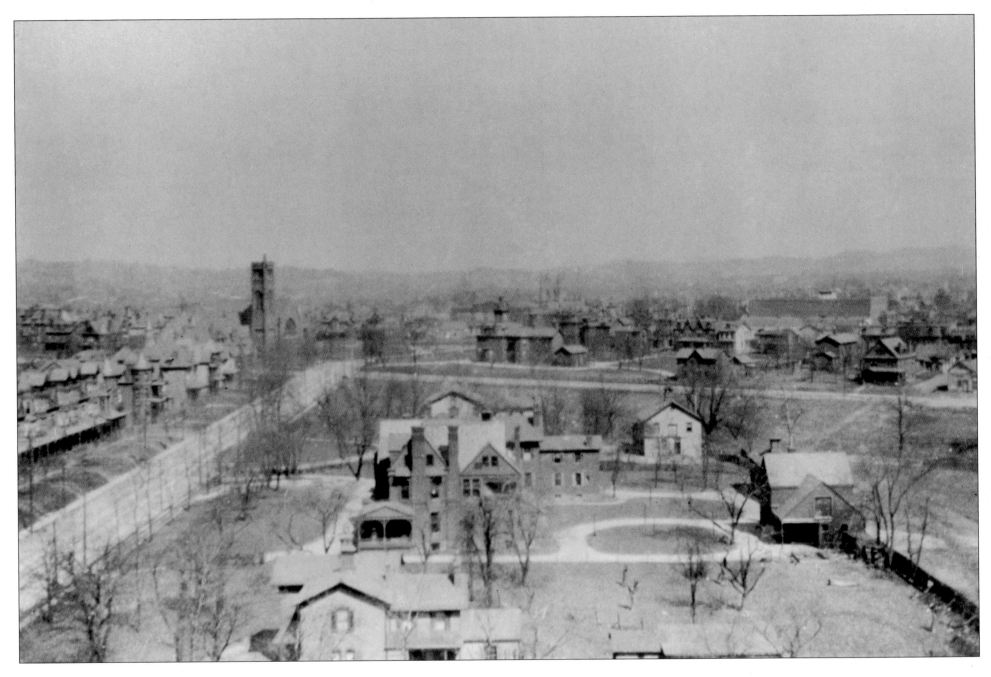

Here is Frick Acres in the eastern part of Oakland, still Victorian and almost rural, with Casey's Row on the left. At the angle of Fifth Avenue is the Bellefield Presbyterian Church of 1889. The vantage point for this shot, however, contains a portent of things to come. It is from the roof of the new Hotel Schenley, completed in 1898 by Franklin Nicola on property purchased from Mary Schenley. Many of the changes to come in this semirural Victorian neighborhood will be on what was recently Schenley land. Incidentally, just out of sight to the right is the new Carnegie Institute at the entrance to the 300-acre Schenley Park.

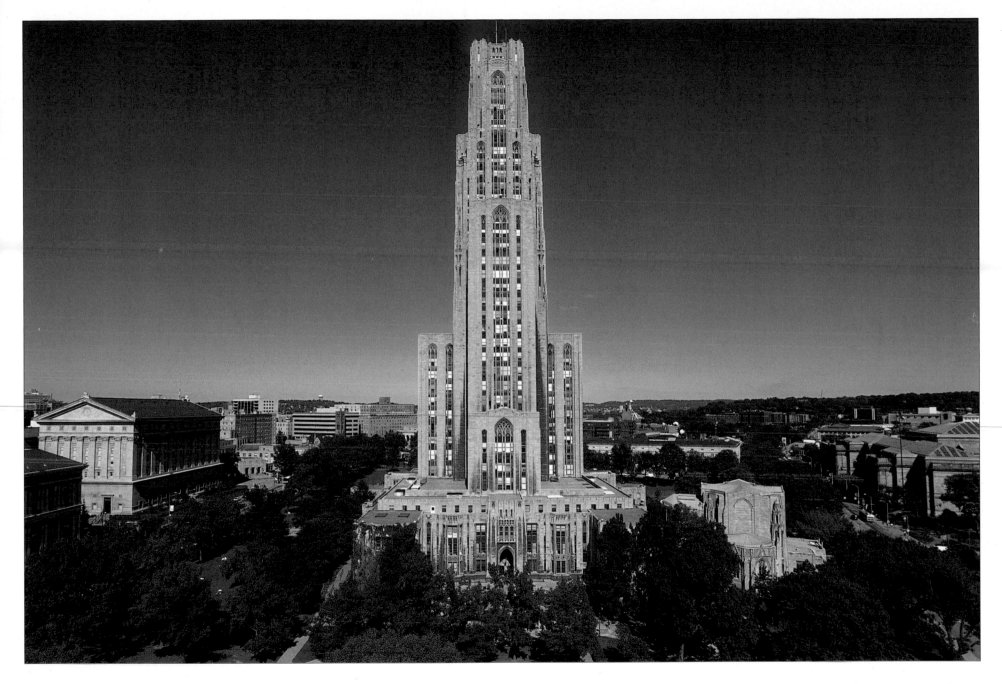

When John Gabbert Bowman became chancellor of the University of Pittsburgh in 1921, he found a grand master plan aborted almost from the start, a spectacular debt, and no credit to be had. But he was one of history's great persuaders, and by 1926 he was breaking ground for a university skyscraper on this site, which had been donated. He got Philadelphia architect Charles Z. Klauder to create an exceptional building, purportedly inspired by Magic Fire Music from *Die Walküre*. The 535-foot tower was finished in 1938. On the first few floors, the Cathedral of Learning contains twenty-six classrooms in different national styles, with seven more Nationality Rooms in planning.

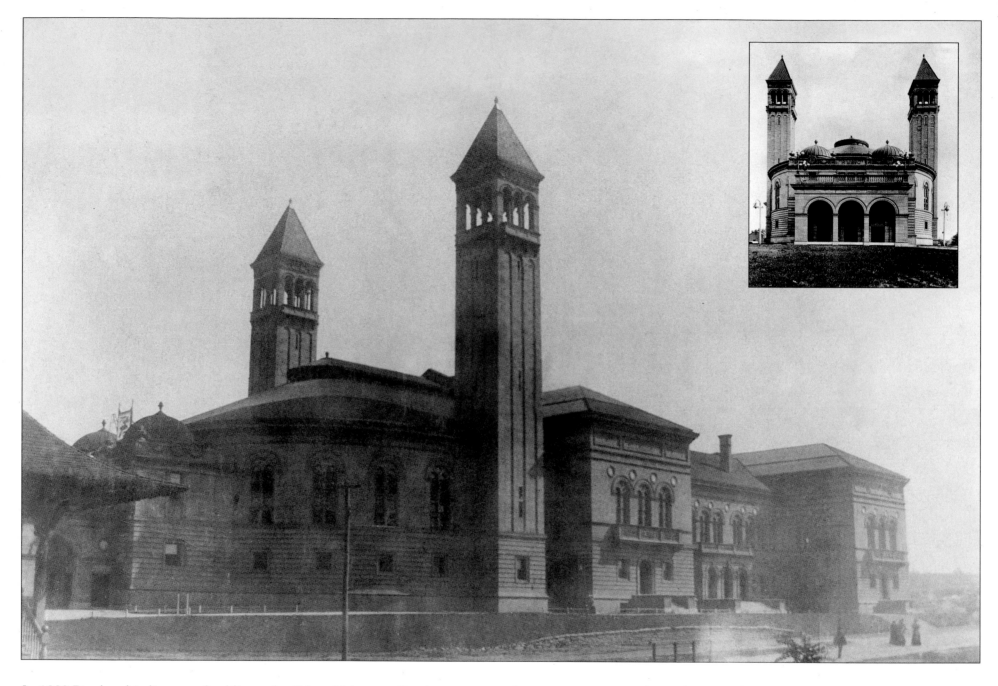

In 1889 Pittsburgh's director of public works, Edward Manning Bigelow, roused a friend from his sleep—so the story goes—and had him race a developer's agent to Mary Schenley's home in London to beg for 300 acres of wild land to be made into Pittsburgh's first real park. The lady agreed, and Andrew Carnegie renewed an earlier offer of a cultural institution at the main entrance to the park. An architectural competition held in 1891 resulted in the first part of the Carnegie Institute, an omnibus building by Longfellow, Alden & Harlow that included a public library, art museum, museum of natural history, and music hall. This opened in 1895, along with the park—Pittsburgh's first attempt at the City Beautiful.

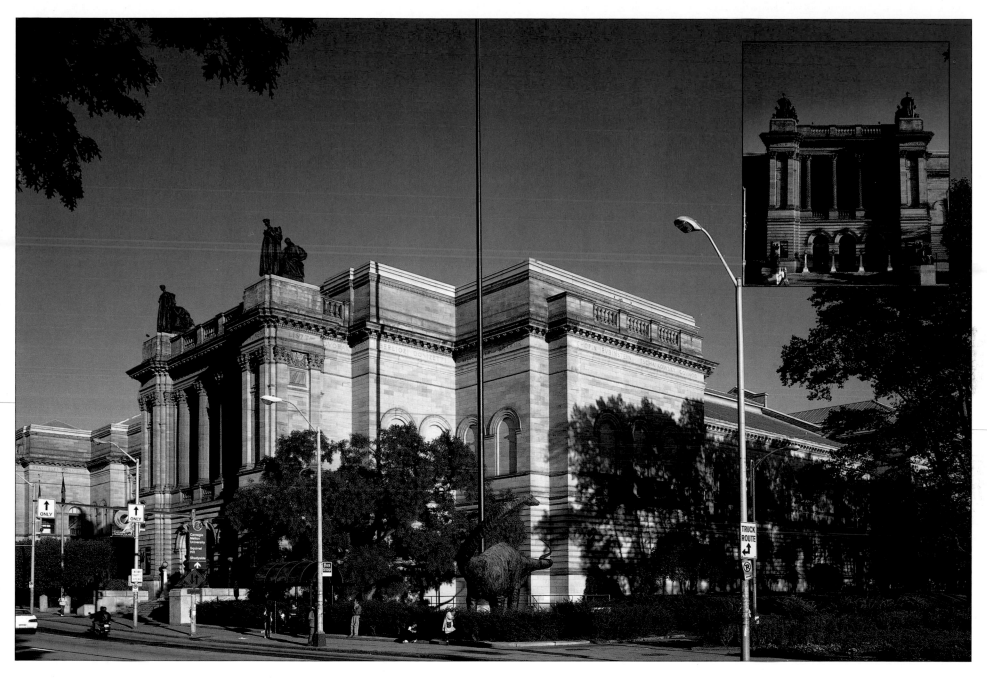

But there was demand for even more space, and between 1903 and 1907 the size of the Carnegie Institute was tripled, with most of the work along Forbes Street. The architects were Alden & Harlow, successors of the original office. The music hall was hidden in a new block designed with a pomp unknown in the earlier building, and an identical element was put before a new and much-enlarged art museum. Bronze statuary by James Massey Rhind and murals by John White Alexander added to this new splendor, and Andrew Carnegie gave the music hall a marble-lined foyer allegedly calculated to cost more than any European throne room. For many years the Carnegie Institute was free to the public.

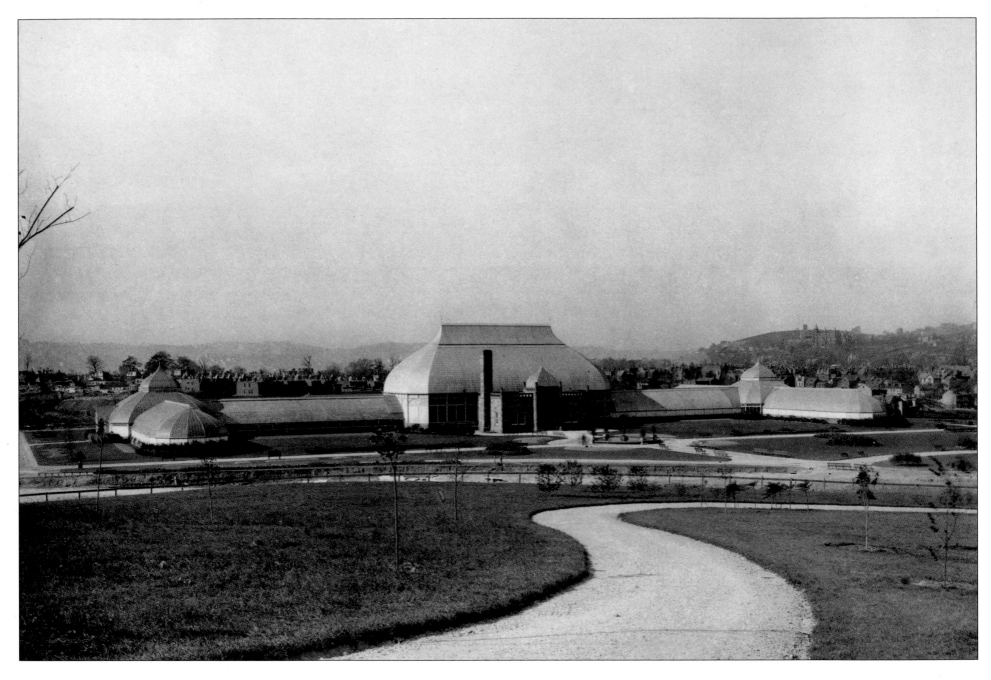

Henry Phipps, a boyhood friend and later a partner of Andrew Carnegie, in the early 1890s offered a conservatory to Schenley Park. Lord & Burnham, a Tarrytown, New York, firm of conservatory designers and builders, was chosen for this handsome new facility. The result was a glass palace with a stone forebuilding that was mostly Romanesque, with a little Renaissance detailing. The view here is from Flagstaff Hill, a long, gently rising meadow in Schenley Park.

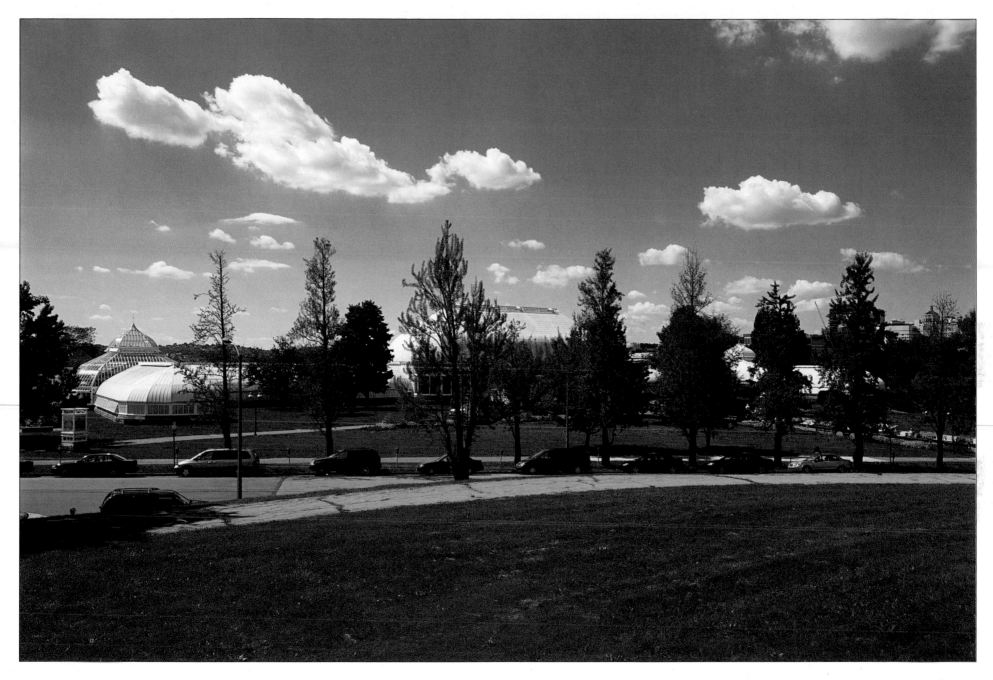

On September 8, 2003, Phipps Conservatory broke ground for a major expansion, the largest in its history since its founding in 1893. The old forebuilding was out of fashion by the 1960s and was too small, so a drab replacement was built, which was refronted in a quasi-Victorian manner, and is now in turn in the process of replacement by a new welcome center, much of which will be underground. The new entrance area will include a café and gift shop with a new glass dome for the indoor lobby. Most of the new construction will be at the back of Phipps Conservatory on two flat terraces, beyond which the ground slopes dramatically down to Panther Hollow.

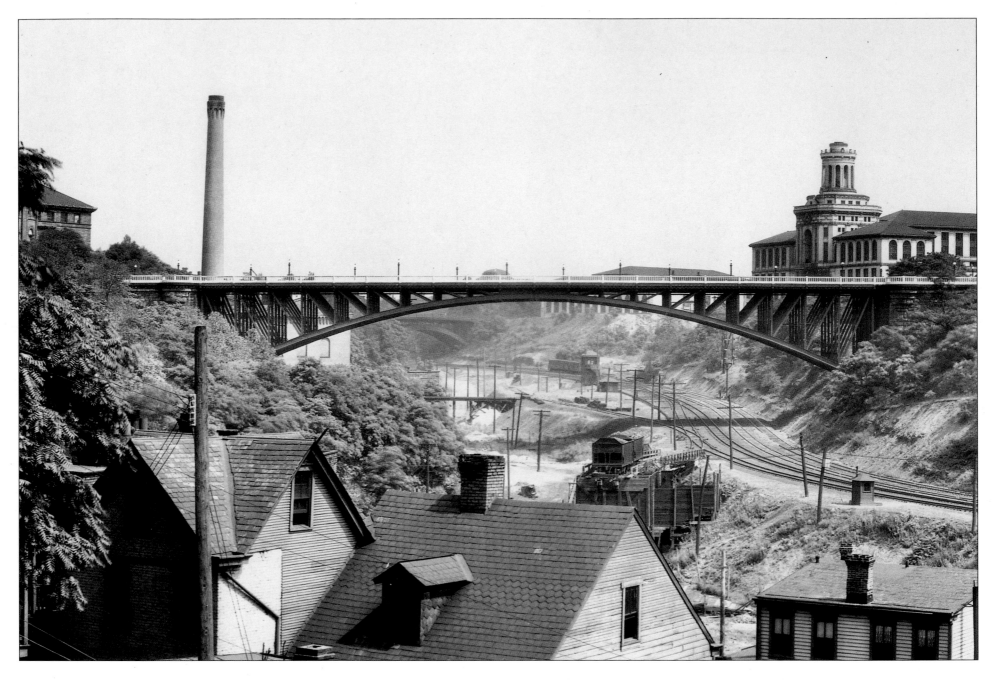

This view from June 1914 sums up some of the city's contradictory character. To the left is the Carnegie Institute and to the right is Machinery Hall of the Carnegie Institute of Technology, bright—so far—in its new white brick and terra cotta. Between them is Junction Hollow, a ravine with a railroad line and a boiler plant sharing space with workers' houses, a few industrial structures, and many wild plants. Spanning the Hollow is the handsome Schenley Bridge.

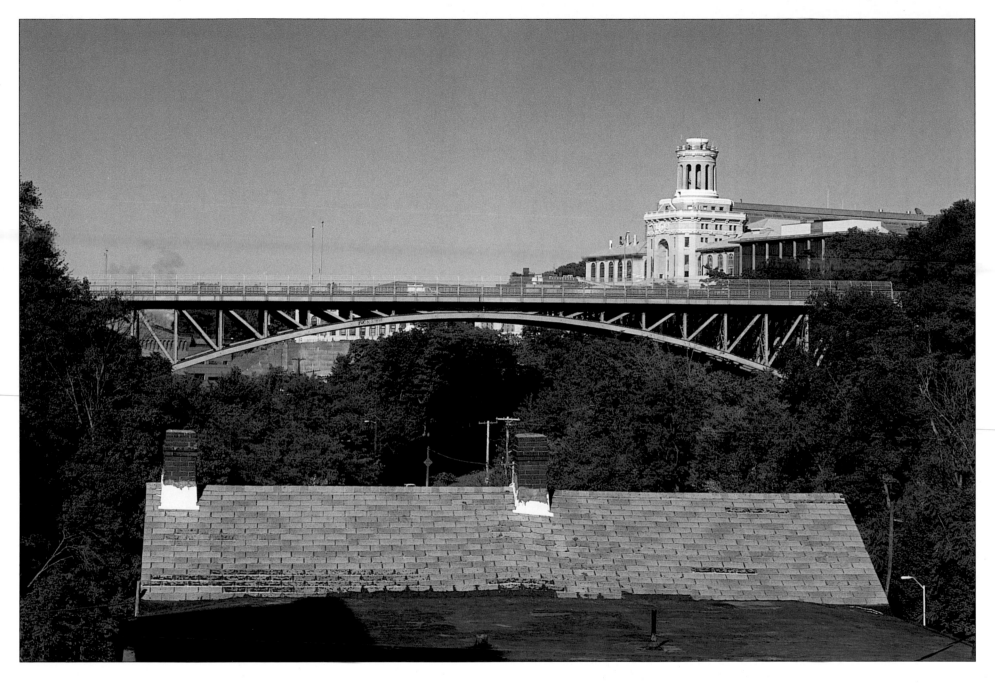

To the tidy minds of some during the Pittsburgh Renaissance, Junction Hollow was merely wasted space, and a plan was made to fill it flush with offices, classrooms, and laboratories, with an arterial road in the railroad's place. This never came to be, but the Hollow still appears to some merely as space to be filled as proves expedient. A building of the 1990s partly conceals the front of Machinery (now Hamerschlag) Hall of what is now Carnegie Mellon University, and more is on the way. The Schenley Bridge now has federally required chain-link fencing along its walk.

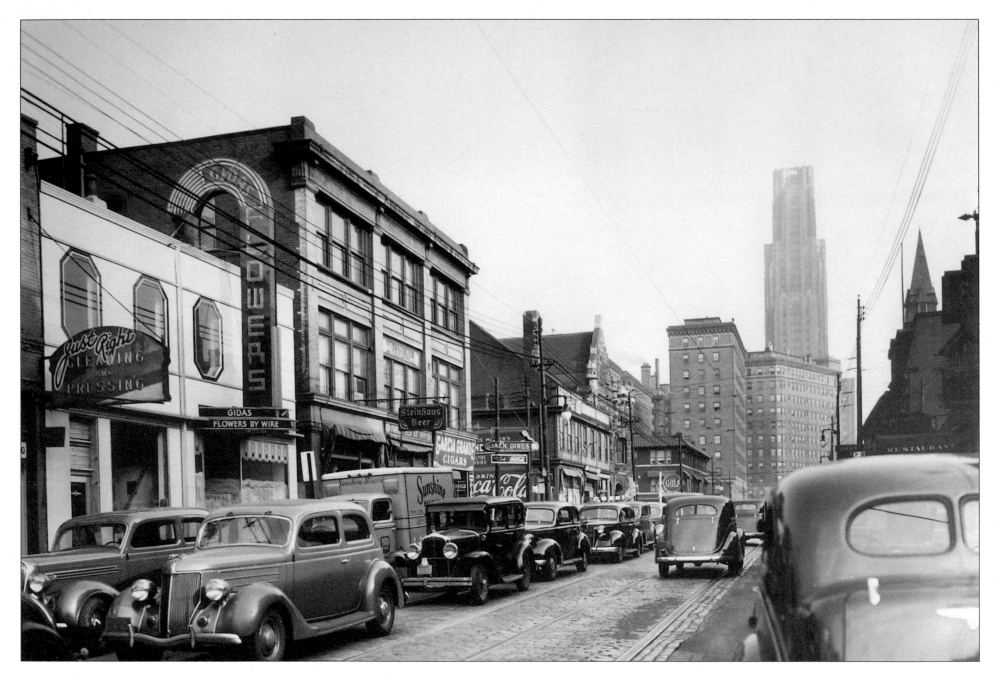

There is more to Oakland than the civic center. This 1937 view down Forbes Street gives an idea of how abrupt the transition could be between the neighborhood's parts. In the foreground is homey commonplace architecture of the time and in the distance the stepped gable of a police station. Then the elegant Schenley Apartments at a bend of the street and, above and beyond these, the University of Pittsburgh's Cathedral of Learning, the pivot around which the civic center turns.

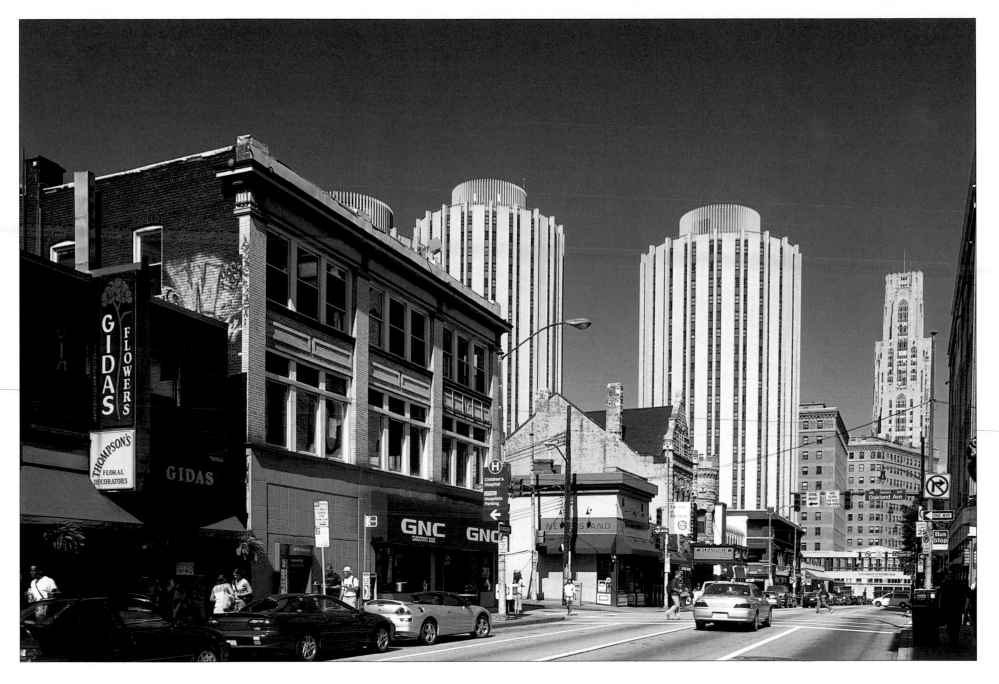

In general, Forbes Street, now Forbes Avenue, looks no different than one could expect after so many decades, but three University of Pittsburgh dormitories on the skyline are startling additions from the 1960s: the Litchfield Towers officially, but also called Ajax, Babo, and Comet. The Schenley Apartments are now university dormitories. The university has a very large presence in this part of Oakland, and moving-in day at the start of a new academic year is an event to be missed for those in a hurry.

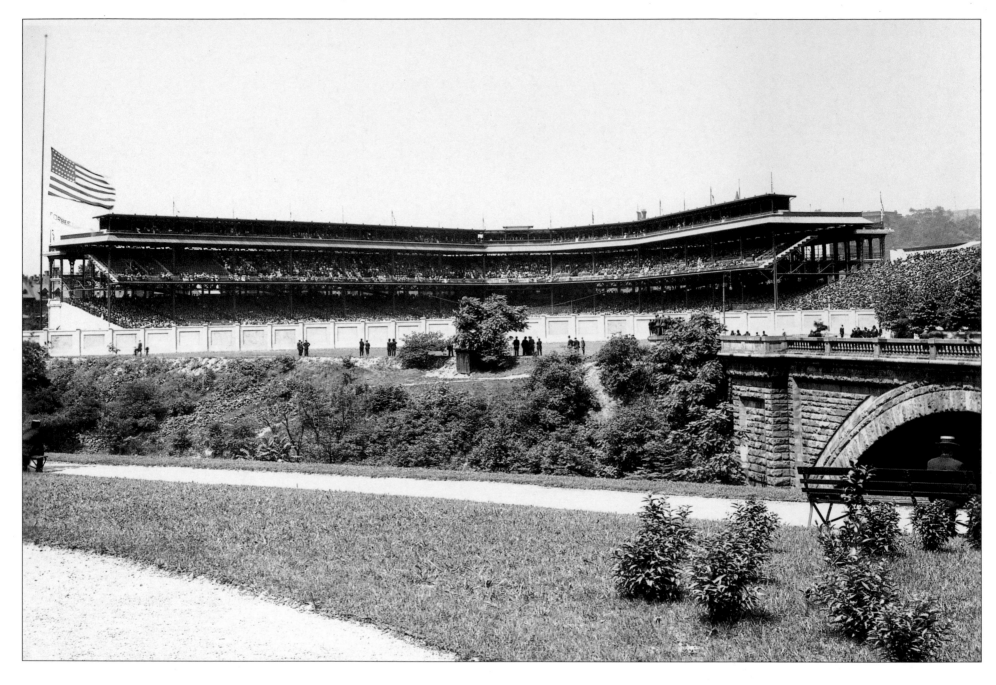

Forbes Field was Pittsburgh's beloved baseball park from 1909 to 1970. It was the successor to Exposition Park on the North Side, and while it lasted, it was an unexpected component of the civic center. Its neighbors, among others, were the Hotel Schenley—handy for visiting teams, the Carnegie Institute, Syria Mosque, the Shriners' auditorium where the Pittsburgh Symphony long had its home, the University of Pittsburgh, the Carnegie Institute of Technology, the Masonic Temple, and the Historical Society of Western Pennsylvania. All these institutions, varied in their purposes, were a few minutes' walk away from each other. To the right is the Bellefield Bridge over St. Pierre Ravine.

A pair of buildings for the University of Pittsburgh now occupies the land. They face onto Schenley Plaza, which was designed in 1915 as a gracious entrance to Schenley Park. To create it, the little St. Pierre Ravine that ran into Junction Hollow was filled up, and the Bellefield Bridge was buried and now serves as the foundation for a large and elaborate fountain, a memorial to Mary Schenley. The flagpole and a small section of wall are all that remain from Forbes Field.

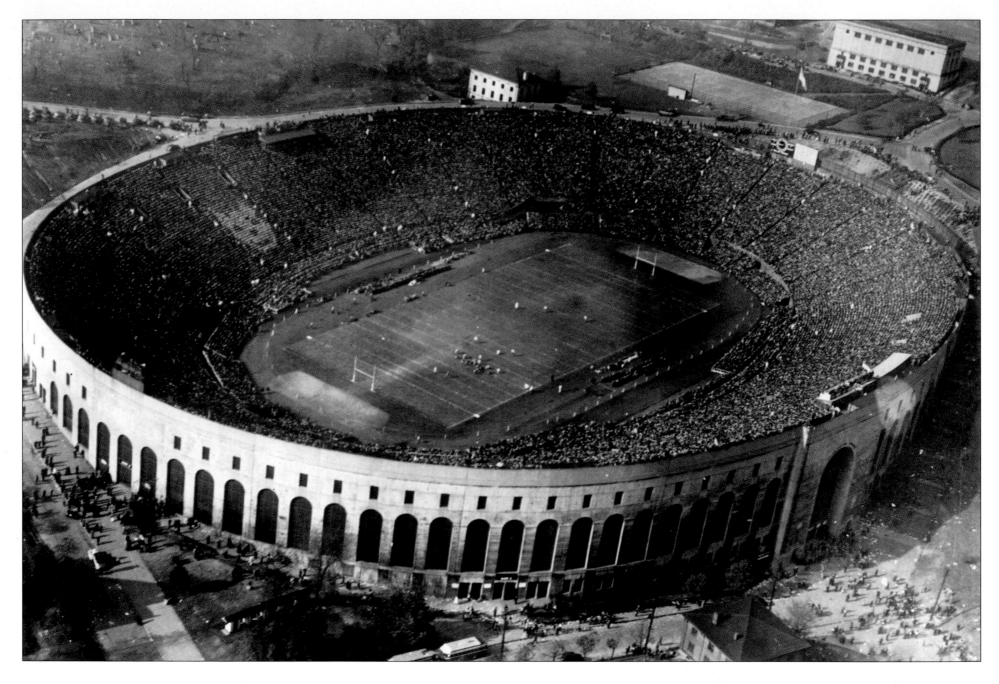

In 1908 the Western University of Pennsylvania decided to move from its crowded buildings in Allegheny City to a new hillside campus in Oakland. It held a competition for a grandiose master plan that institutions favored in those days, and the result was a win by Henry Hornbostel, the New York architect who was already realizing his master plan of 1904 for the Carnegie Institute of Technology about a mile away. In any case little got built, but the University of Pittsburgh—it changed name as well as location—did build a grand poured-concrete stadium against the hill. Pitt Stadium, simple in its exterior treatment, could hold 65,000 in spectator capacity.

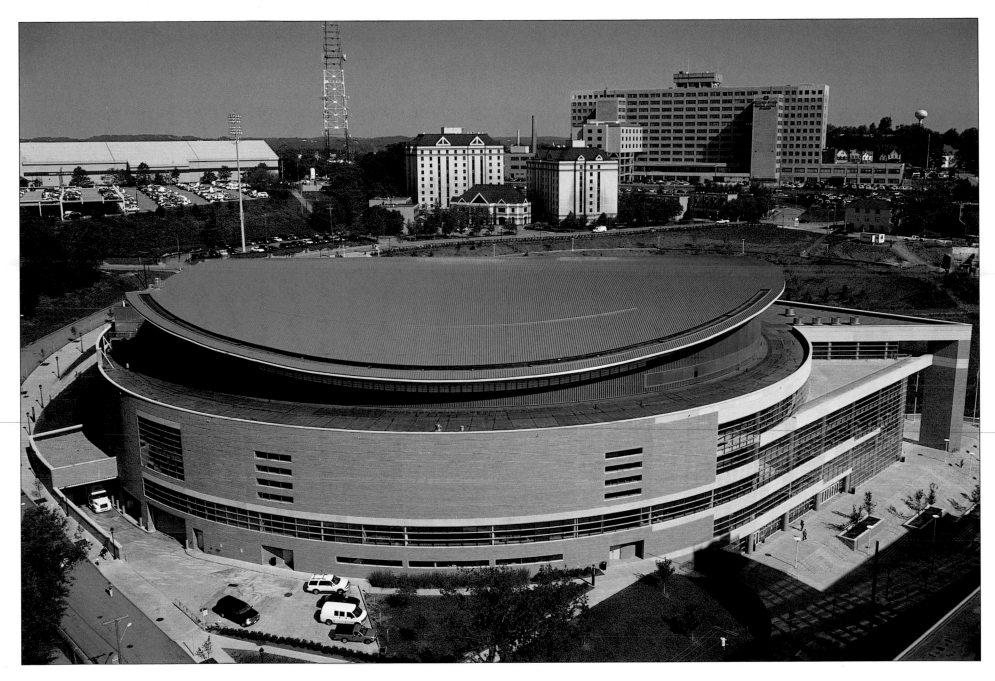

The Petersen Events Center, completed in 2002, has taken the place of Pitt Stadium. It has a spectator capacity of 12,500, and its arena is used for basketball, wrestling, and concerts. Around the same time Petersen was begun, one of Henry Hornbostel's buildings came down: the little of his medical school that actually got built, on a drive that wound down past the stadium. Its terra-cotta bas-relief of *Aesculapius*, which had looked down over the hillside campus since 1908, was dismantled and put in storage. The red-roofed buildings beyond the center are dormitories for University of Pittsburgh students. Beyond that is a veterans' hospital from the 1950s. The university's football team now plays at Heinz Field.

Further out on Baum Boulevard at South St. Clair Street one could see a sight like this around 1925. Baum Boulevard (or Atlantic Avenue or Atherton Avenue at various times) had started out as a solidly bourgeois street close to the Pennsylvania Railroad's commuter stations, but had been massively invaded by the automobile business as early as 1905. Pittsburghers believe this to be the world's first drive-in filling station.

A plaque (inset) marks the site of the world's first drive-in filling station. Now the celebratory gas station is gone, and while some of the architecture made for the car still exists, some of it has been adapted for other uses. The automobile dealership has been renovated as the Spinning Plate Artist Lofts, including loft, studio, and gallery space. There is a little surviving of the corner's architectural treatment (painted purple and minus any context), but otherwise the corner lot seems to serve only for parking these days.

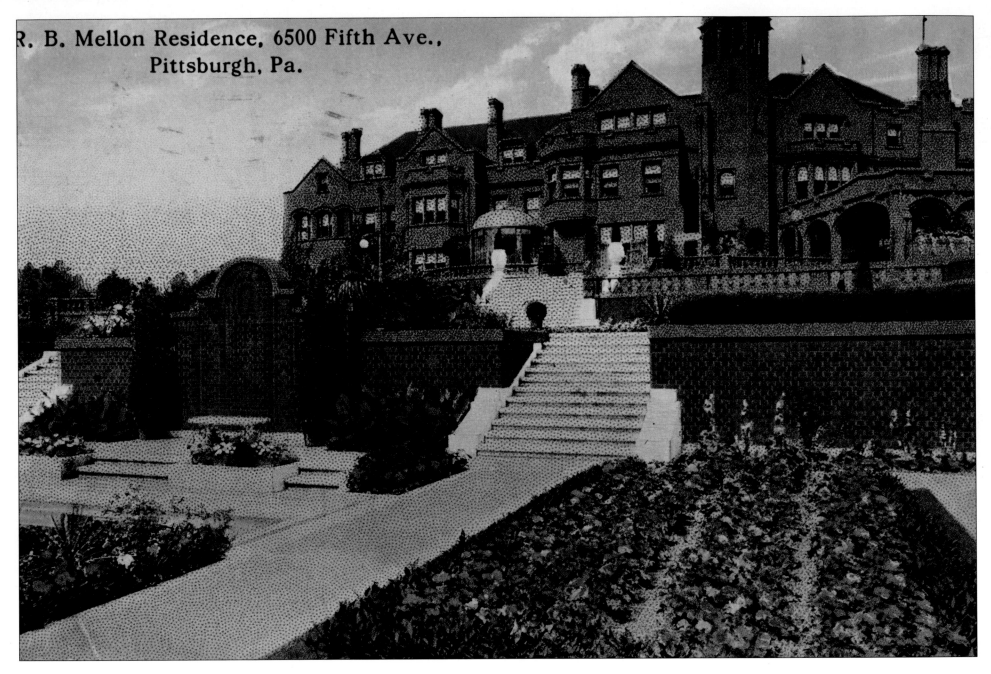

R. B. Mellon Residence, 6500 Fifth Ave., Pittsburgh, Pa.

Fifth Avenue east of the Oakland Civic Center was a municipal showplace, with many of the city's prosperous in residence, but no house quite matched that of Richard Beatty and Jennie King Mellon, at Fifth Avenue and Beechwood Boulevard in an area claimed for both Shadyside and Squirrel Hill. A work in the Tudor style by Alden & Harlow, it was finished in 1911.

It had a "butterfly plan" that offered a variety of views and abundant workmanship that included a marble staircase such as Victorian England had never seen. Its garden terraces toward Beechwood Boulevard were remarkable in their own right.

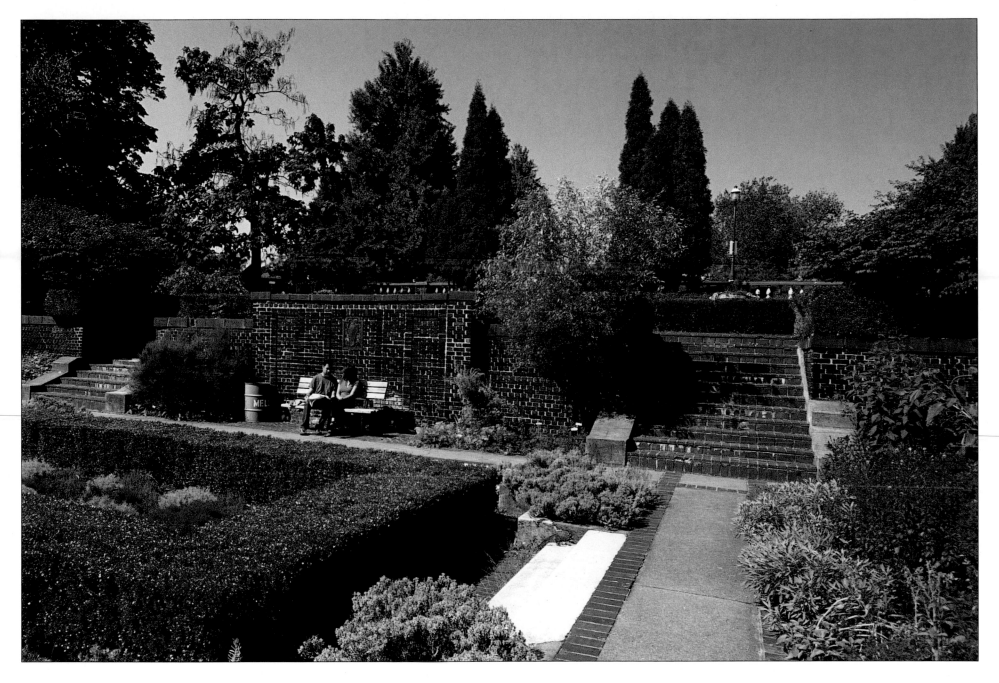

When the R. B. Mellon house came down around 1940, it was cannibalized
in a remarkable and clever manner, with much of its decorative work and
masonry reused in Mount Saint Peter, a Catholic church in the nearby town
of New Kensington. The terraces remain as one element of Mellon Park, a
favorite East End resource that adjoins the Pittsburgh Center for the Arts,
which is located in the Marshall house of 1912.

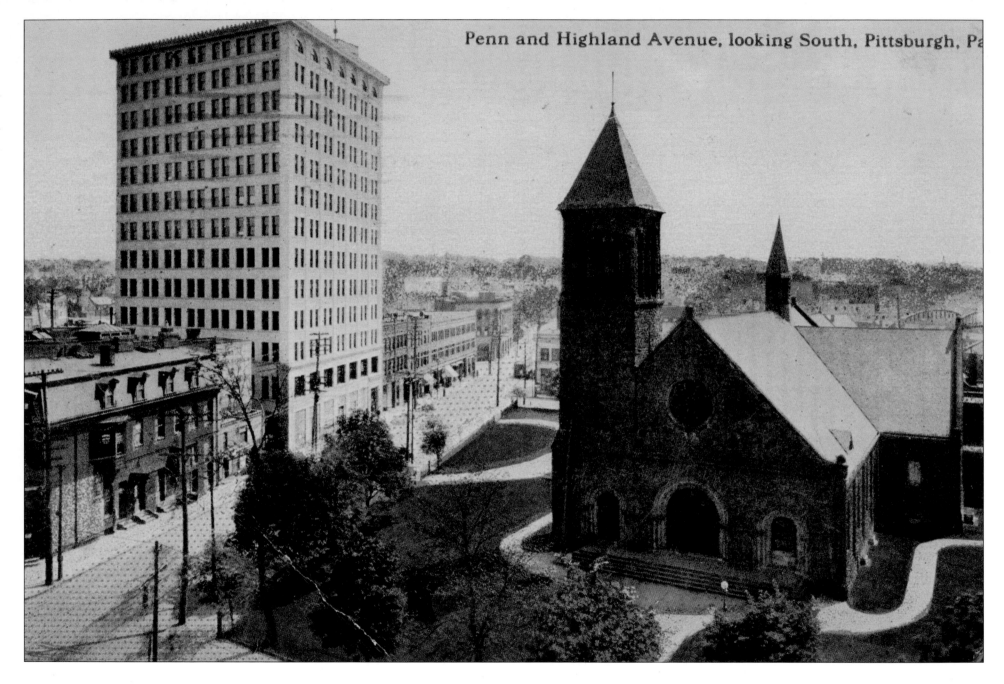

Penn and Highland Avenue, looking South, Pittsburgh, Pa

East Liberty had been a village early in the nineteenth century, and since 1819 a Presbyterian church has stood at its crossroads, the intersection of Highland and Penn Avenues. A second church on the site followed in 1847, a third in 1864, and a fourth, shown here, in 1887. This Richardson Romanesque building is by Longfellow, Alden & Harlow. Across Highland Avenue is the Highland Building, a building of 1911 by D. H. Burnham & Co., the Chicago office that designed twenty buildings for Pittsburgh and executed seventeen.

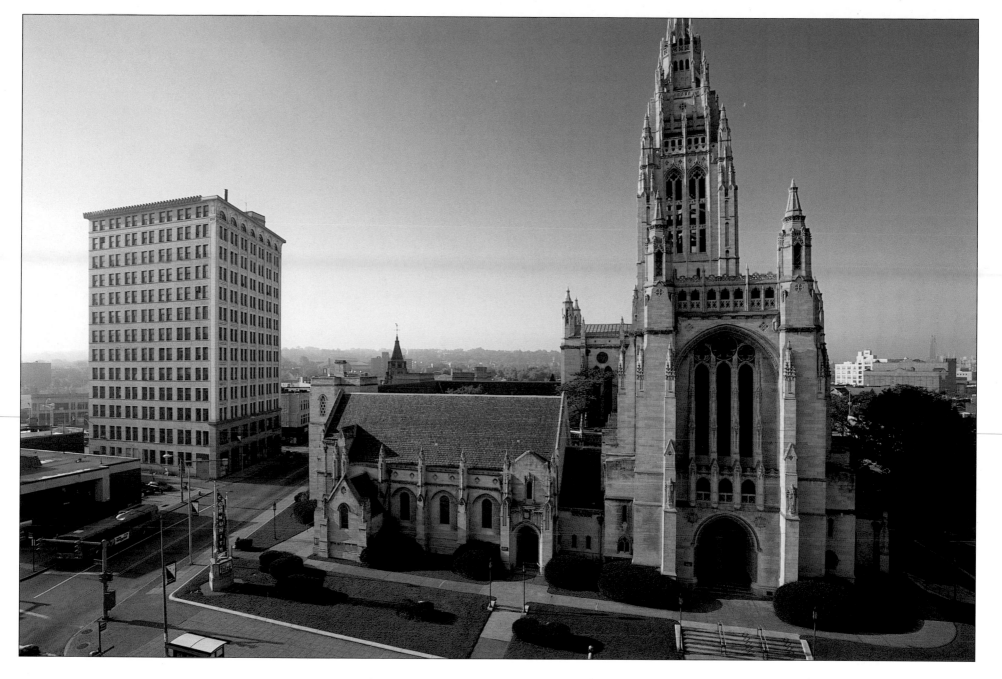

Ralph Adams Cram, a Boston architect who specialized in churches and schools, was chosen to design the fifth East Liberty Presbyterian Church, which was finished in 1935. With a city block to use and a lavish budget, Cram raised a cathedral-sized church with a 300-foot tower. An Anglo-Catholic, he seems to have found Presbyterianism inadequate for the

glorification of God. He wrote in his memoirs, "It was clearly specified that no Protestant inhibitions should be allowed to enter as deterrents…it is a simple fact that in half an hour, the church could be prepared for a pontifical High Mass, either of the Roman or the Anglican Rite."

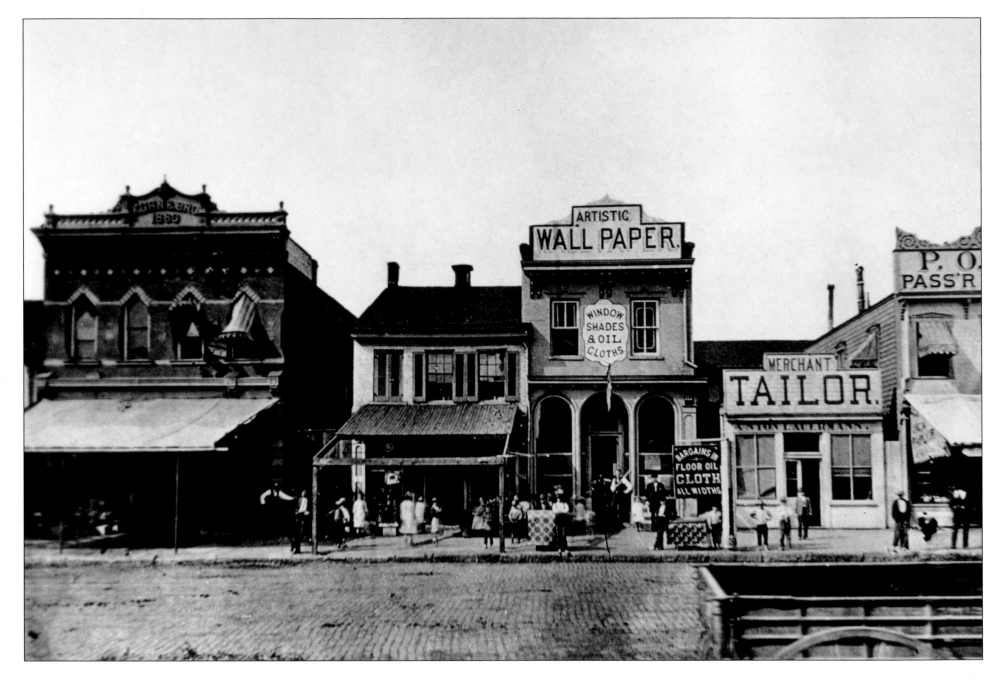

This is a view from the early 1880s of Penn Avenue across from the church. There is still a small-town look to the center of East Liberty, and it must be summer, as sidewalk canopies and window awnings are much in evidence. To the right is the office of the Pittsburgh, Oakland, and East Liberty Passenger Railway, a horsecar line that would be replaced by cable traction in a few years.

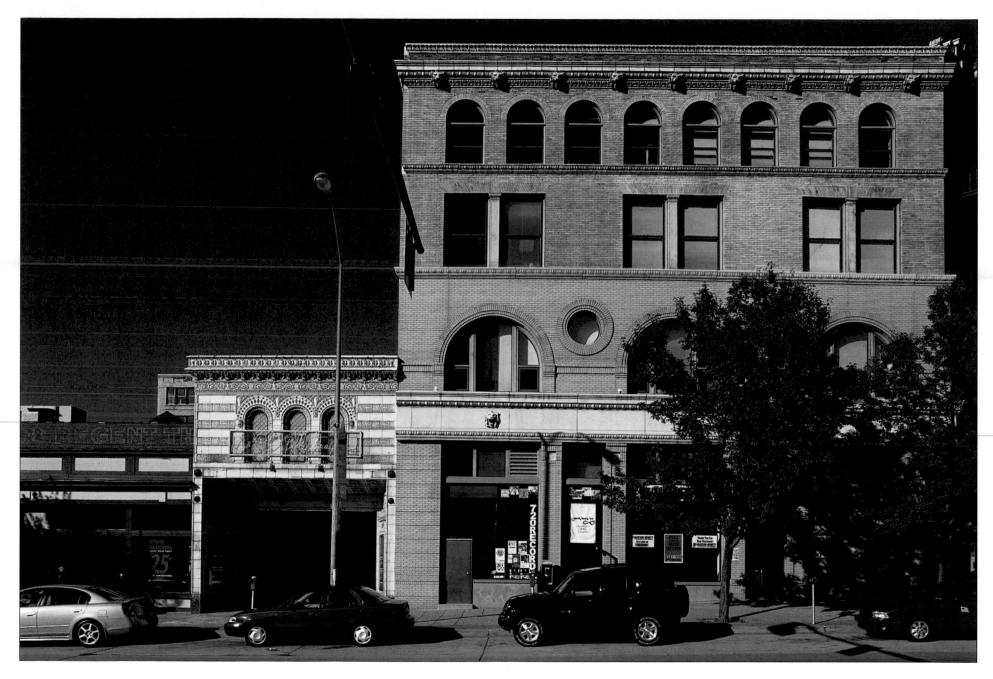

The little store row shown here maintains the old scale, as does the Regent Theater (today the Kelly-Strayhorn Theater), a survivor from 1919 of the silent-movie days. The Rowe store building at the corner with Highland Avenue ups the scale: a department store at the heart of a little city. The lower part was modernized a few decades ago, but has been tastefully restored to something similar to its original self.

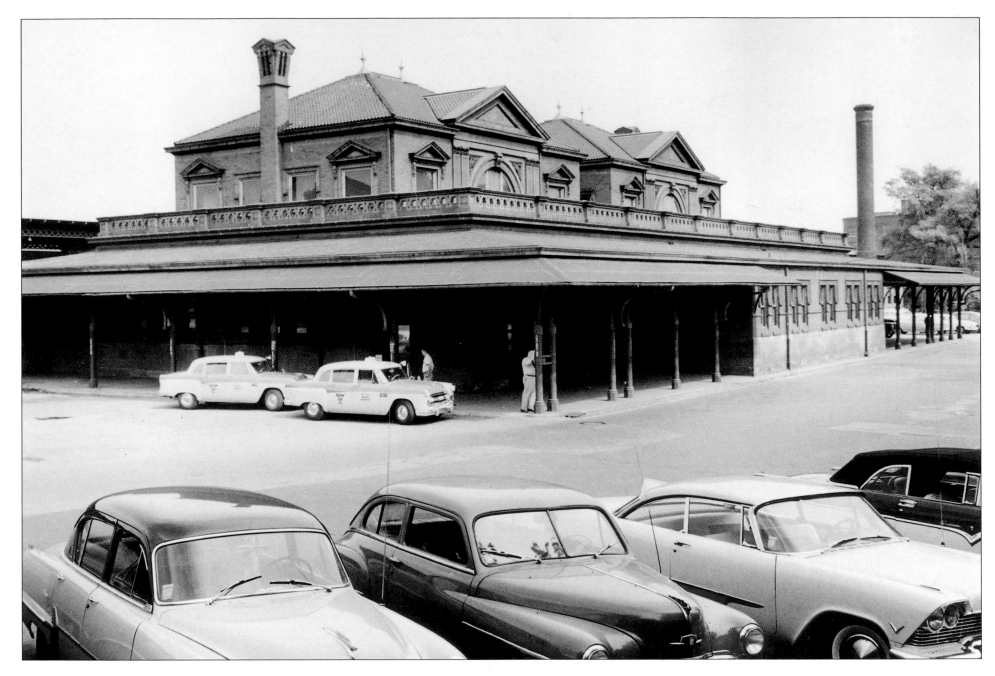

The first through train from Philadelphia reached East Liberty in 1852 after a fourteen-hour trip, and the former village became more and more of a commuter suburb, annexed to Pittsburgh only in 1868. Expresses regularly stopped at East Liberty, which became the station for the East End generally. The last station was built in 1905, designed by Furness, Evans & Co. in red brick and terra cotta. There were general and ladies' waiting rooms inside, the latter lined with white tiles and with a bed of plants at the center. The station yard was set apart from nearby Penn Avenue, neatly kept with flower beds and trimmed hedges. Here is the station in its last days.

East Liberty has undergone a lot of urban renewal, and in the process some handsome old architecture has come down. East Liberty Station has disappeared, and the current state of passenger rail in Pittsburgh demands no replacement. A Carnegie library has yielded to public housing. The area around the Presbyterian church, like the old Allegheny crossroads at Ohio and Federal on Pittsburgh's North Side, was given a mall treatment in the 1960s with no impressive results. Neighborhood organizations are working to revitalize the area, restore the original crossroads, and undo as much of the 1950s urban renewal plan as possible.

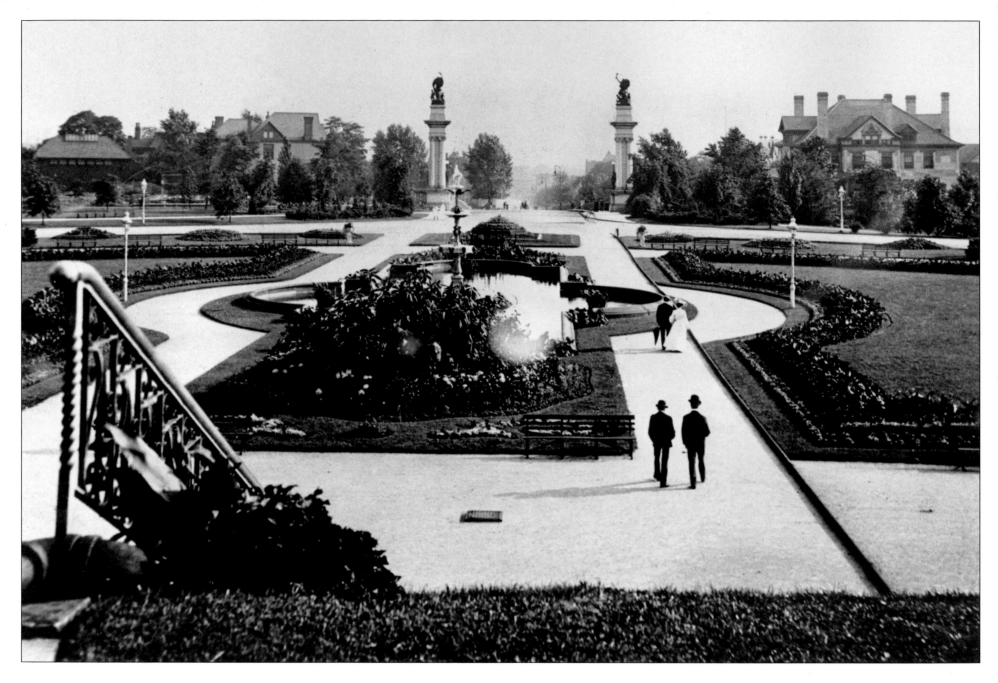

Edward Manning Bigelow, Pittsburgh's director of public works, began Highland Park in 1889, the same year he started Schenley Park. Highland Park is north of East Liberty overlooking the Allegheny River. One rationale for its existence was the protection of the main reservoirs for the city's water supply. This picture dates from around 1900, and the view is looking south from the bank of Reservoir Number 1 (which was elaborately planted with changing flower displays) toward the main entrance from Highland Avenue. The huge gate piers date from 1896 and bear Giuseppe Moretti's bronzes of wreath-waving ladies, babies, and eagles.

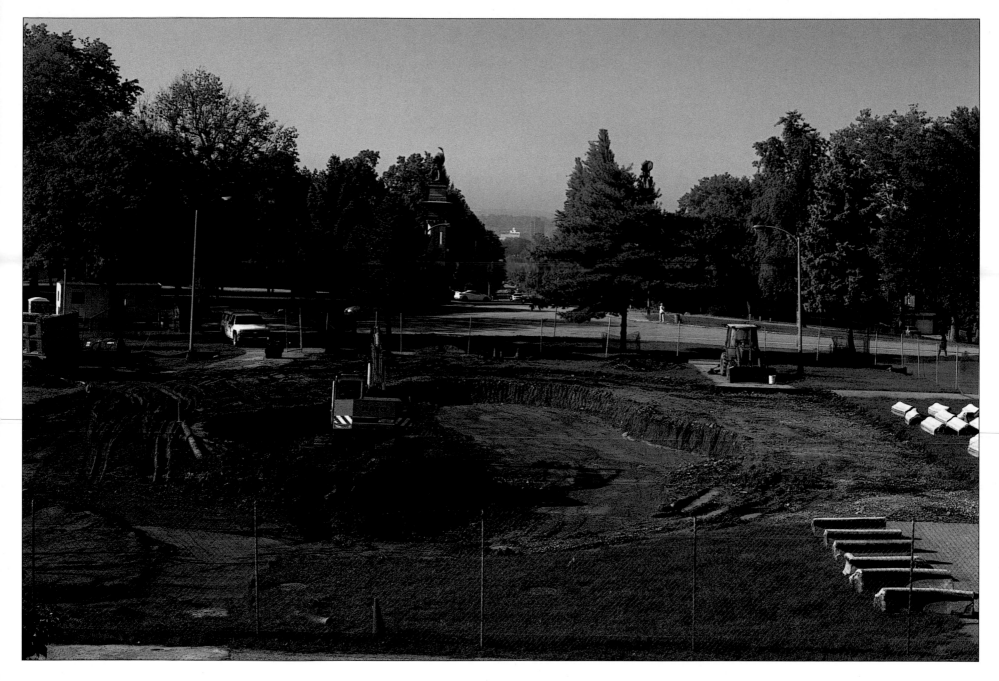

In the summer of 2003, the City of Pittsburgh broke ground on the first phase of the restoration of the Highland Park entry garden. The city is working with Highland Park community groups and the Pittsburgh Parks Conservancy to restore the park's entrance, fountain, reflecting pool, walkways, and gardens. Lighting, benches, and elegant trellises will be added. There had been talk of maintaining the Highland Park Reservoirs' purity with giant plastic sheets, but a new filtration plant and "babbling brook" landscape feature have been constructed instead, preserving the embankment top of Reservoir No. 1 as a pleasant place to walk.

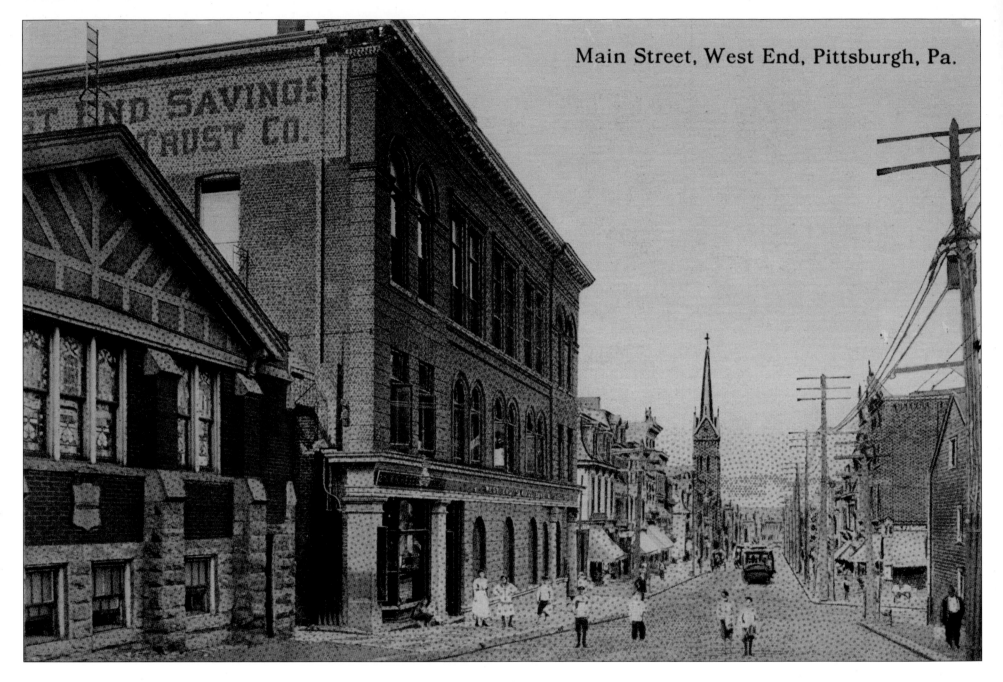

Main Street, West End, Pittsburgh, Pa.

The West End of Pittsburgh runs inland from the Ohio River, with Saw Mill Run as its own little river between steep hillsides. The streets were laid out in 1839 as Temperance Village, and until annexation by Pittsburgh in 1872, alcohol was indeed forbidden. This view looks northerly on Main Street. The Eleventh United Presbyterian Church, on the left, is one of the most interesting buildings in this scene: its congregation seems to have given up on the ascending Gothic promise of its buttresses and settled for a half-timbered gable over the front element and a brooch spire on the stump of a tower (beyond view). The most prominent building is the Classical Revival West End Federal Savings & Trust Company of 1915. St. James Church of 1884 is in the distance.

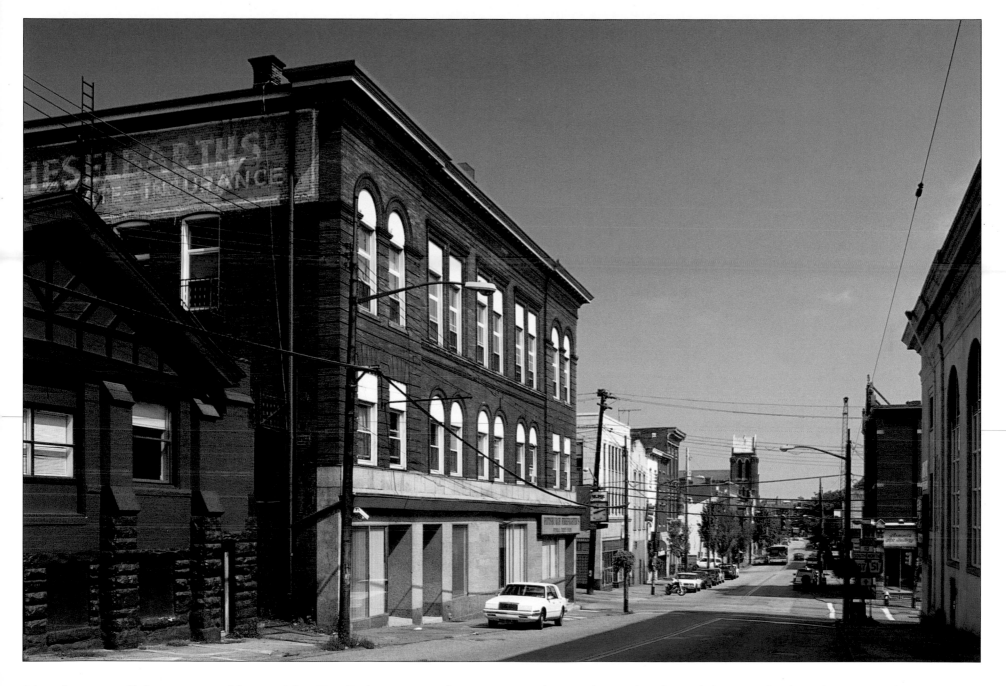

Main Street is still the commercial heart of the West End community, but some noticeable changes have occurred. St. James Church has lost its Gothic spire, due to a gasworks explosion of 1927 across the Ohio River. The Presbyterian church has lost its original windows, and West End Federal now houses the Pittsburgh Firefighters' Federal Credit Union. The stone-fronted bank building of 1926 on the right-hand side of the street has been renovated for office and retail use. The West Pittsburgh Partnership is working with merchants to implement a Main Street revitalization plan.

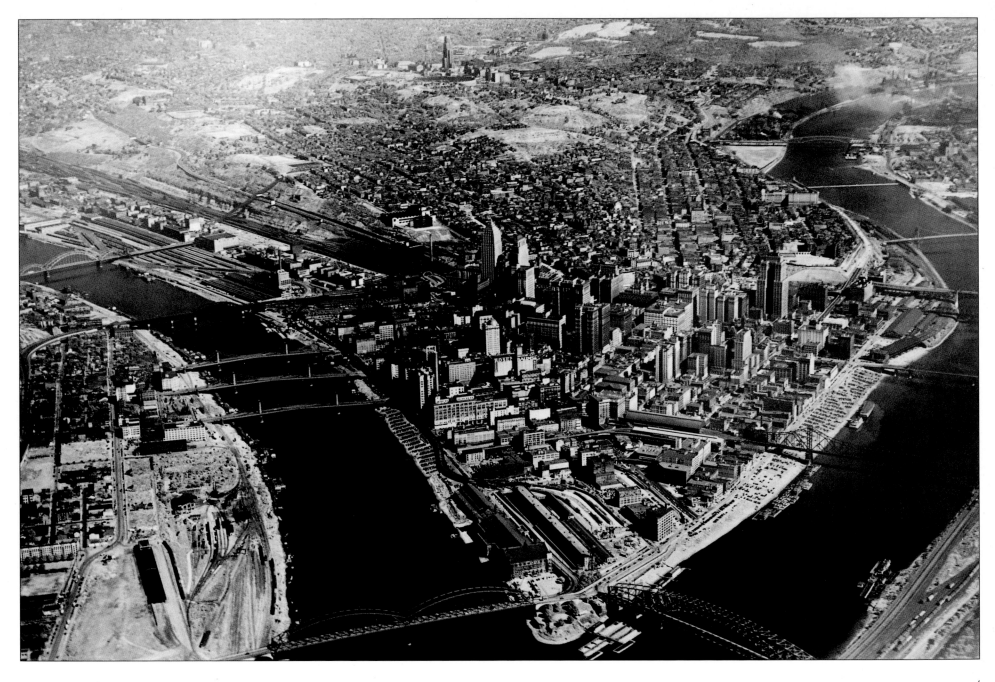

Here is a final overview of the city, most likely taken in 1937 since the Cathedral of Learning, far away in Oakland, appears complete but the Monongahela Wharf is still a sloping parking lot. The Point still has its tied-up barges and trees between the bridge abutments, and further inland the railroad shares space, uneasily, with the Blockhouse. The Three Sisters bridges on the Allegheny River are a decade old now, but the Wabash Bridge over the Monongahela River and the downtown terminal are still there. One can see trees and buildings far away, but this is still the Smoky City.

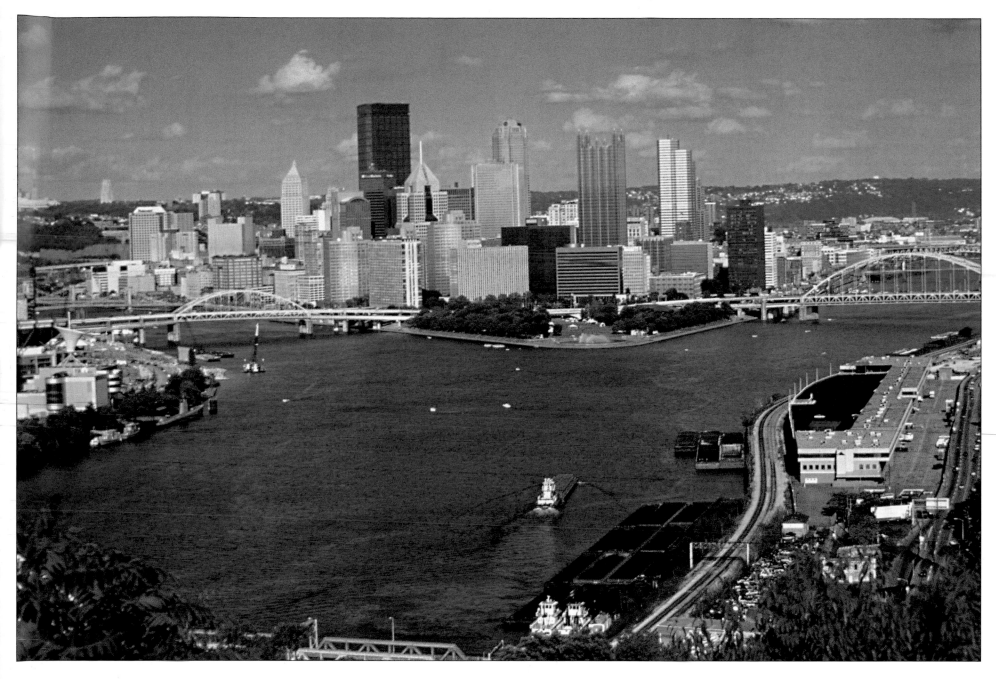

A comparable view today, from the West End Overlook 400 feet above the Ohio River, shows a city that has created its signature park and has more or less buried its old business architecture in newer and taller buildings, with the one built for U.S. Steel a signature of its own. The Carnegie Science Center and its submarine *Requin* are on the North Shore, and Heinz Field and PNC Park are beyond. Far away, as before, the Cathedral of Learning rises above the tree-covered hills and the little houses on their slopes. Nature is once again a surrounding, infiltrating presence in Pittsburgh.